THE ART OF CONTEMPORARY GLASS

FIRE
AND
FORM

WILLIAM WARMUS

NORTON MUSEUM OF ART

WEST PALM BEACH, FLORIDA

Fire and Form: The Art of Contemporary Glass is published on the occasion of an exhibition of the same title organized by William Warmus for the Norton Museum of Art, West Palm Beach, Florida, January 25–March 23, 2003.

Published by Norton Museum of Art
1451 S. Olive Ave., West Palm Beach, FL 33401
561-832-5196, fax 561-659-4689
E-mail: museum@norton.org
Web site: www.norton.org

Distributed by University of Washington Press
P.O. Box 50096, Seattle, WA 98145

Library of Congress Control Number: 2002116620
ISBN: 0-943411-39-4

The paper used in this publication is acid-free and meets the minimum requirements of American National Standard for Information Sciences—Permanence of Paper for Printed Library Materials, ANSI Z39.48-1984.

Endpapers and page 1: Dale Chihuly, *Untitled,* 1998 (details)
Frontispiece: František Vízner, *Blue Bowl,* 1971
This page: Dan Dailey, *Cardinal,* 1993
Opposite: Dante Marioni, *Gambo,* 2000 (detail; see p. 29)

Edited by Michelle Piranio
Designed by Jeff Wincapaw
Typeset by Marie Weiler
Color separations by iocolor, Seattle
Produced by Marquand Books, Inc., Seattle
 www.marquand.com
Printed and bound by CS Graphics Pte., Ltd., Singapore

CONTENTS

Lino Tagliapietra, the noted glass artist, mentions in this book the "role of breath" and its relationship to the "idea of perfect shape" in glass. In his groundbreaking book *The Shape of Time: Remarks on the History of Things,* first published in 1962, George Kubler advanced his theory of prime objects. He defined these as works that through "principal invention" transcend. Does the perfect breath create a perfect object?

If we search for prime objects in the history of glass we might cite, among others, the following creative inventions. There is the exquisite cantaloupe-shaped glass cup, created during the T'ang Dynasty (c. 669) for the tomb of Shi Hedan, which can be found in the Guyuan Municipal Museum in Ningxia, China. Or one could nominate the incredible stained-glass windows of Sainte-Chapelle in Paris, which were made possible by technological advances in architecture but surely surpass in creativity the work of all other glassmakers of the time. The Crystal Palace, created in London in 1851, is essentially a handblown glass building set into a cast-iron structure. Dale Chihuly takes these innovations further with his astounding pergolas, bridges, and columns, composed of hundreds of pieces of blown glass in various forms and colors. All were achieved through the breath of the artist.

The properties of glass—its fluidity, transparency, fragility, defiant durability, indeed, its sometimes contradictory properties—make it, at the very least, a fascinating medium that combines predictability with serendipity, technical properties with creativity, the artist's intellectual intent with the artist's liberating breath.

This book and its attendant exhibition stress individuality. Presenting the work of thirty-one contemporary artists inspired by 3,500 years of glassmaking, they give the reader and the visitor alike the opportunity to assess the history of glass in our time, its reflection of our society, and the artists' role in breathing time into shape. Without the artists who have created these works, there would be nothing to enjoy or learn from, and we are grateful for their visions.

Special thanks are extended to the collectors who have so generously lent works to this exhibition. It is difficult to part with something one cherishes, but our lenders have understood the benefit of sharing their contemporary artworks with the public. We must also thank many financial donors from across the United States who have assisted the Norton Museum in bringing this exhibition and book to fruition. In particular I acknowledge the supreme efforts of Doug and Dale Anderson, who as volunteers spearheaded this effort, working on the project literally every day for almost a year. Believers from the beginning, they saw us through to the end. The friends of Nicki Harris celebrated her birthday by contributing to the exhibition in her honor. My conversations about glass with Parks Anderson, Joanna Sykes, and Mark McDonnell were most informative. William Warmus has done an outstanding job in his role as curator and author. His knowledge of glass is enormous, but his ability to tell the story of contemporary glass is equally impressive.

Christina Orr-Cahall
Director, Norton Museum of Art

Fire and Form: The Art of Contemporary Glass was born in April 2002 when the opportunity raised by an unexpected opening in the exhibition schedule sparked the decision to survey the private collections of studio glass in south Florida, considered by some to be unrivaled in the United States. The concept was immediately embraced by Dale and Doug Anderson, among the best friends of the Norton Museum, and happily their enthusiasm and generosity were contagious. I extend my gratitude to them, and to many other lenders to the exhibition, including Joan and Milton Baxt, Linda Boone, Barbara and Howard First, Barry Friedman Ltd., Marc and Diane Grainer, Dr. and Mrs. J. Gretzula, Nicki and Ira Harris, Jean Heilbrunn, Heller Gallery, Jane and George Kaiser, Peggy and Rick Katz, Jr., Fraeda and Bill Kopman, Judy and Peter Leone, Myrna and David Leven, The Littleton Collection, Debbie and Bud Menin, The Metropolitan Museum of Art, Nina and Leon Nissenfeld, Claire Oliver Fine Art, Sheldon and Myrna Palley, Natalie Pelavin, Dani and Jack Sonnenblick, Bernard and Ina Wasserman, Sharon Oleksiak Weinberg, Florence and Bob Werner, Miriam and Julius Zweibel, and those who wish to remain anonymous.

The Andersons likewise galvanized their friends and fellow collectors in support of this splendid book, which stands both as an independent publication on the history of studio glass and as a record of the Norton Museum's exhibition. It is a genuine pleasure to pay tribute to them and the other principal donors, namely, Lisa and Dudley Anderson, Art Alliance for Contemporary Glass, Leisa and David Austin, Ann and Bruce Bachmann, Joan and Milton Baxt, Rebecca and Jack Benaroya, Maxine and William Block, Linda Boone, Andy and Charles Bronfman, Shirlee and Bernard Brown, Kate Elliott, Barbara and Howard First, Florida Glass Art Alliance, Alan H. Ginsburg, Glass Alliance of Los Angeles, Daniel Greenberg and Susan Steinhauser, Carol and Charles Grossman, Nicki and Ira Harris, Katya and Douglas Heller, Michael Heller, Kenn Holsten, Jane and George Kaiser, Sharon Karmazin, Peggy and Rick Katz, Jr., Susan and William Kolodner, Fraeda and Bill Kopman, Colleen and John Kotelly, Nancy and Philip Kotler, Rhea and Morton Mandell, Judy and Robert Mann, Bonnie Marx and Ken Saunders, Jane and Arthur Mason, Laurel and Bob Mendelsohn, Debbie and Bud Menin, Sara and Richard Mesirow, Ruth and Ted Nash, Sheldon and Myrna Palley, Natalie Pelavin, Pilchuck Glass School Trustees, Barbara and Warren Poole, Barbara and Rick Redmont, R. Duane Reed, Chris Rifkin, Elisabeth and Norm Sandler, Dorothy and George Saxe, Jon and Mary Shirley Foundation, Dan and Linda Rocker Silverberg, Jean Sosin, Barbara and Donald Tober, Florence and Robert Werner, Ann and Tony Wimpfheimer, and those who wish to remain anonymous.

This book never would have seen the light of day without the collaboration of Marquand Books, Seattle, who with utmost professionalism facilitated every aspect of its production. It is a privilege to thank Ed Marquand, Marie Weiler, and Jeff Wincapaw as well as independent editor Michelle Piranio.

Roger Ward
Chairman, Curatorial Department/Curator of European Art
Project Director, *Fire and Form: The Art of Contemporary Glass*

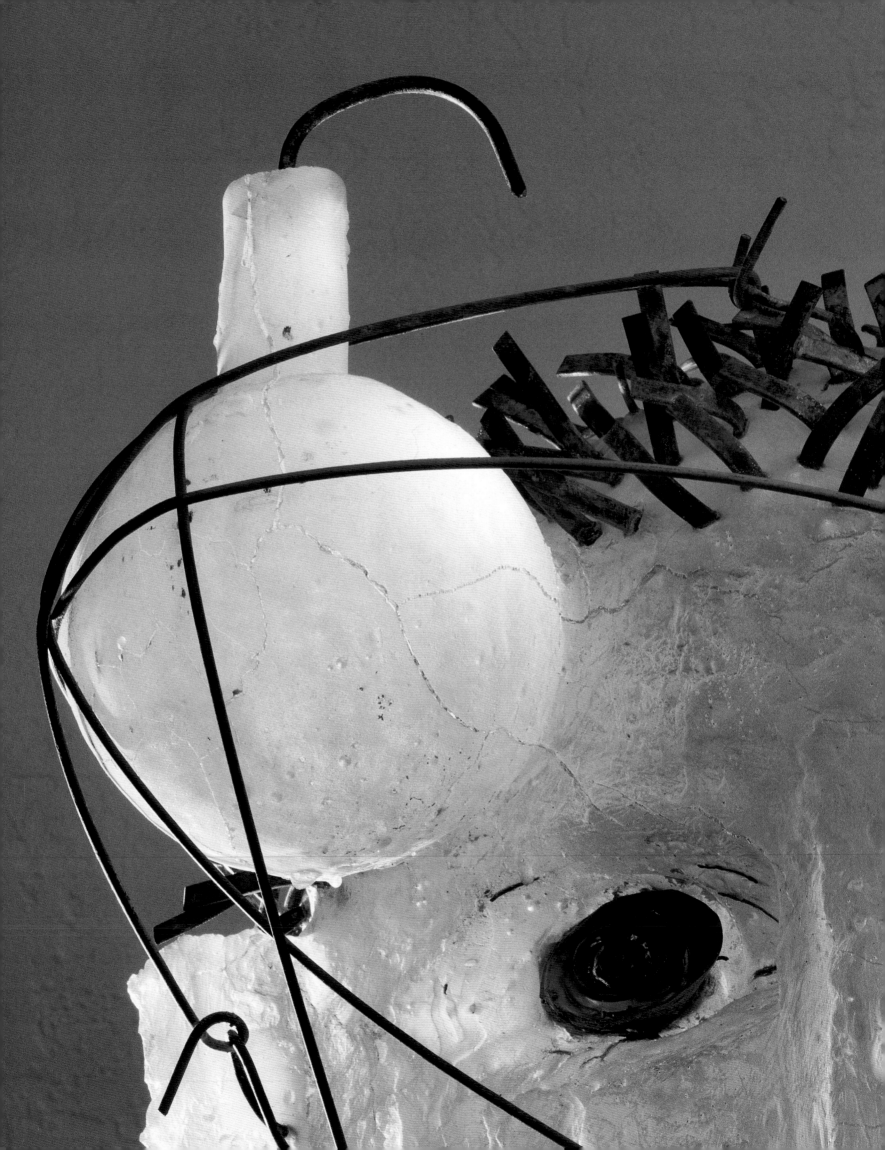

HYPER-
MEDIUM

To hold that one kind of art must invariably be superior or inferior to another kind means to judge before experiencing; and the whole history of art is there to demonstrate the futility of rules of preference laid down beforehand.

—Clement Greenberg, *Art and Culture*

Glass

is the buoyant medium. Phoenix-like, it literally emerges from fire and ash (and sand and a few other ingredients), and air plays a central role in giving it form. Hollowness abounds and is celebrated. The process of making glass can be extremely theatrical, the colors available are dazzling to the eye, and the final object is highly resistant to decay yet simultaneously rather fragile, like an aging diva.

In its effort to be recognized as a viable and vital contemporary art form, studio glass has benefited from the recent multiplication of media and art styles. Enduring pluralism characterizes the present art scene. Art making is now global and multimedia, with no single style ascendant. Contradictory approaches are widely manifest, even within the work of an individual artist. Who would have thought that advertising, song, the spoken word, and Barbie dolls would someday find a place next to canvas, bronze, and marble? Artists (and audiences) have become more adventurous and may even be described as *eager* to explore and enjoy versatile and unorthodox materials and processes, whether high-tech nanotechnology, low-tech plywood, or something in between, such as glass. The medium of studio glass is characterized by countless styles developed in many countries, and so glass artists are inherently comfortable with multiple working approaches (think big factories and tiny blowtorches) and techniques (casting, blowing, engraving). During the early stages of the art, in the 1960s and 1970s, this multiplexing was sometimes seen as a limitation, as if the emergent medium had a flawed, schizophrenic personality. Now it is perceived as a distinct advantage. Glass is called "the new bronze" because of its highly desirable flexibility.

Glass is one of a small group of transparent and fluid media. The others include water and cyberspace. All three share a "tele-vision" mode: objects embedded in these media can, under the right conditions of manipulation, remain visible at a distance; mistakes are difficult to conceal in such transparent realms. Spaces can be artificially compressed, as when a slab of glass is ground into a telescope lens that makes the far seem near, or a stream of energy is coded to transmit an image from one place to another. And a key to the aesthetic of such media is the phenomenon of flotation, whereby objects embedded within these media defy gravity and appear to float in space, visible from all angles. This rich complexity makes the transparent media very

(OVERLEAF)

HANK MURTA ADAMS
Bomb Boy, 2000
(detail; see p. 75)

challenging to the artist. They possess an openness, almost a nakedness, that inspires, as Herbert Muschamp has noted, both desire and aggression.[1]

And what sorts of art stories might be told in glass? Almost any type of story artists want, or need, to tell. That is among its chief attractions in an age of relentless artistic invention. In fact, it is a thesis of this book that studio glass artists have contributed significantly in four areas of creative innovation: abstraction, realism, the investigation of natural forms, and what I call stagecraft—the theatrical presentation of artworks to an audience.

Many of today's studio glassmakers are perfectly at home in a world where artists are expected to explore and merge diverse cultural influences. A single work might fuse Japanese formalism, Italian technical and coloristic bravado, and American edginess of expression. This phenomenon of pluralism that emerged during the decline of formalism (primarily Abstract Expressionism) in the early 1960s emphasizes context over object: politics, fashion, psychology, religion, and geography have all become essential elements in appreciating the meaning and the quality of an artwork. Today, the dividing lines between high and low art have been largely erased, and the old meanings of kitsch and avant-garde have been obscured by a junglelike growth of academic theories that analyze art from every conceivable angle and continuously discover new species of art objects. And the speed with which the artist moves, in the form of adaptability, has become important. In the absence of any one defining style, all styles and all media compete for attention.

Despite the attractions of pluralism, some key artists using glass remain unapologetic formalists who insist on beginning and ending with the art object. They seek to create sculptures that exhibit clearly articulated boundaries and that indulge integrity of form. The goal is to make something truly beautiful in an old-fashioned way, and to tempt age-old desires: the eye's delight in delicate color, the hand's hunger for rich texture. Some of this work is not afraid to appear costly and elitist. And though some of it is brittle, even fragile, it is also defiant and purposefully difficult. In the end, the viewer must find his or her way to the object itself (a reproduction just won't do!), stand close to it, look at it, or even caress it. Formalist art is all about this challenge of appreciating and experiencing a definite object in all its lonely perfection. Formalists are the curmudgeons of the art world, but they can be endearing curmudgeons.

Glass Enters History

The natural history of glass begins dramatically wherever there are volcanoes, whose fiery eruptions emit rivers of molten rock including obsidian, a darkly colored and highly opaque glass that was worked by prehistoric and ancient civilizations into a variety of tools. The Roman historian Pliny passed on the legend that mirrors made from obsidian reflect only shadows, not images. Through a glass darkly? In a tremendous

reversal of scale, contemporary glass required the development of very small furnaces—portable volcanoes, so to speak—so that artists could make glass in their own studios.

It was around 1500–1600 B.C. that the human hand became actively involved in the direct creation and shaping of molten glass. Archaeologists theorize that the production of ceramics precedes glassmaking and that early glass was almost an accidental by-product of ceramic glazing, which is a glassy process. Glass and bronze or gold were sometimes used together in antiquity, and there is conjecture that metalwork and glass works were created in the same workshops, as they shared similar techniques such as core-forming. Perhaps the metal oxides that are part of bronze casting were appropriated by ancient glassmakers as coloring agents. When the first objects made purely from glass began to appear, it was in the Near East and ancient Egypt, where glass was sometimes made from ingots imported from abroad. Much of the best-preserved evidence about the role of glass in ancient societies comes from the capital city of Pharaoh Akhenaten, known today as Amarna, circa 1350 B.C.

There is evidence, such as the excavated compound of the sculptor Tuthmosis, to indicate that glass was used at Amarna in what we would today describe as a small workshop setting. Maybe these ancient studios looked a little like the earliest contemporary glass studios, some of which had dirt floors and primitive glassmaker's equipment (the log bench and tent that formed the studio in the early 1970s era of the Pilchuck Glass School north of Seattle come to mind). Glass was expensive to produce, requiring large quantities of scarce fuel to fire the furnaces, and working with it while in a molten state demanded great skill. Glass was considered an elite substance and a signifier of status, comparable to gold or silver, and it is probable that the material's rarity contributed to its prestige and its use primarily in the royal compound. This established a pattern that has continued to this day: glass remains among the most expensive artistic materials.

Significantly, Egyptian royalty favored vivid colors in the decoration of palaces and tombs, and the flamboyant and intense colors available in glass vessels and inlays probably satisfied this aesthetic need. Glass was also recognized as an ideal *ensemble* player that sculptors could use to create complex *multimedia* works of art. The lapis blue glass inlays in the funerary mask of Pharaoh Tutankhamen coexist easily with the solid gold matrix. Today, artists such as Dan Dailey and Dale Chihuly produce intensely colored, flamboyantly crafted sculptures in workshop settings that would be the envy of the ancient Egyptians.

Ancient Egyptian glass was mostly cast or formed on a solid core, and it predates the invention of glassblowing. The earliest blown glass objects date from the first century B.C. and were created in the Roman Empire. Blowing is a fast process, and there

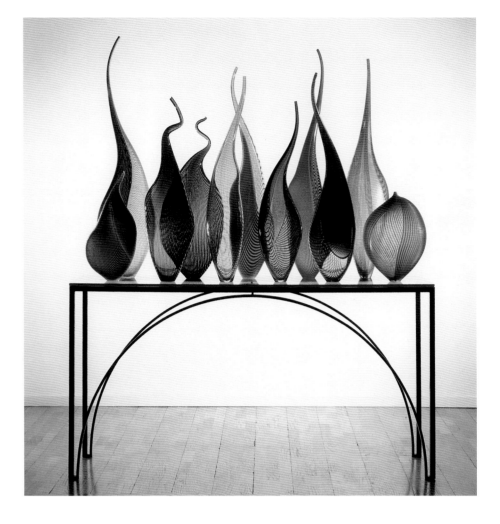

LINO TAGLIAPIETRA
Samba do Brasil, 2000
83 x 70 x 22 in.

was something of an explosion of interest in making glass for everything from drinking cups to souvenirs of gladiatorial contests to cinerary urns. Some of these works were signed by the artists who created them, most notably the molded glass vessels of Ennion, a few of which are marked "Ennion made me."[2] The Romans also excelled at casting glass, producing extraordinary small-scale sculptural portraits of emperors and members of the noble classes. But the technology of the time did not allow for the production of artworks of significant scale. Perhaps that is why ancient glassmaking is sometimes called a "minor" art; but does size really matter in things artistic?

The invention of glassblowing unleashed a rapid development in the medium. As Donald Harden noticed, in *The Glass of the Caesars,* "There must have been some experimenting before glass-blowing became accepted and well understood by glass-workers . . . but . . . within twenty or thirty years they proved capable of developing almost all the many inflation techniques still present nearly 2,000 years later in the workshops of their modern successors."[3] It is possible to argue that a similar pace of innovation was not achieved again until the "invention" of studio glass after World War II. Artists such as Lino Tagliapietra and Dante Marioni are direct successors to the phenomenal masters of ancient Rome.

As Rome fell, traditional glassmaking declined. The Middle Ages would have been a true dark age but for the medium: stained glass was invented, and it satisfied an urgent need for lighted (yet sheltered) space within the great (but at times glacial) cathedrals that were rising throughout Europe. Abbé Suger, who is credited with the development of the Gothic style, thought of stained glass as perfect for symbolizing the entrance of spiritual light into the hearts of mankind. Thus glass became a premier art form, an atmospheric art full of mystery for the most spiritually inclined, a cinematic art capable of telling stories to one and all. The flat glass panels of Judith Schaechter illustrated in this book appear as if dragged out of the Middle Ages, except that her narratives would have caused riots in the cathedrals.

If the Italian Renaissance saw the revival of, and gradual improvement upon, many of the lost techniques of glassmaking known to ancient Rome, it was the late nineteenth and early twentieth centuries that laid the most direct groundwork for contemporary glass. The Art Nouveau and Art Deco artists Emile Gallé, René Lalique, and Louis C. Tiffany, together with the visionary entrepreneur Paolo Venini, collectively explored and experimented with many of the processes and themes that have been adapted by contemporary artists. Nature became a supreme source of inspiration, whether in the form of a dying orchid (Gallé) or a voluptuous peony blossom (Tiffany's lamps). They willed their glass to come to life and flow like lava (Tiffany) or melt like ice (Lalique), and loved accidental effects and the look of ancient weathered glass. Small parts were composed into gigantic wholes or details were made so microscopically small that their effect became decadently precious and dreamlike. All four were masters of the ensemble and stagecraft nature of glassmaking, assembling skilled teams of individuals to execute their ideas, sometimes employing famous architects and sculptors as designers (Venini enticed the architect Carlo Scarpa to create handsome designs in fused glass). Chihuly is frequently described as the Tiffany of the twenty-first century because he creates on a grand scale and delights in theatrical presentation.

But glassmaking—especially glassblowing—is a difficult art to learn, and the equipment required to make it is expensive. By the time of World War II, the traditions of artistic glassmaking were in danger of dissolving: Tiffany, our nation's premier artist using glass, had died in 1933 and his work was long out of fashion. Glassmaking with artistic pretensions had been replaced by "industrial design" as practiced in factories. What to do?

I consider the founding event of contemporary glass to be the creation by Harvey K. Littleton, in 1942, of a small glass sculpture representing a nude female torso. This was done not in the solitude of an artist's studio but within the high-technology Vycor Multiform laboratory at Corning Glass Works (now Corning Inc.), about as far away as you can get from the spirit of the artist's realm. And Littleton considered the first work

he made there an unsatisfactory object, not a work of art. It certainly has the appearance of a derivative copy, appropriated from an ancient classical model and made from a figure Littleton had shaped first in clay. Littleton's progress in glass was interrupted by his service in the Army Signal Corps during World War II, but he kept up his work on glass intermittently thereafter, always with the goal of encouraging more aesthetic experimentation among glassmakers; and a subsequent torso, cast in 1946, became his first exhibited work. By 1962 Littleton was able to conduct a series of workshops (with scientist Dominick Labino and others) at the Toledo Museum of Art that are generally thought to mark the birth of studio glass.

What makes the 1942 object significant is that Littleton willed it into being, in the process anticipating the trajectory of contemporary glass. It was a point of conception, even if the gestation period was twenty years long. The rest would come later: the small furnaces (1962), the educational programs (1960s and 1970s), the museum and gallery exhibitions.[4] Perhaps Littleton's willfulness is the defining aspect of the contemporary glass movement—artists using glass are not noted for their reticence! Littleton, a Corning native, was influenced in this regard by Frederick Carder, the founder of Steuben Glass, who was something of a rebel and very strong willed.

Today we appear to have come full circle from Littleton's earliest attempts to free art from industry, as artists (and not just those using glass) are ever more intent upon exploring the connections between art and science and technology, producing artworks that appear to have emerged from laboratories or factories, even as the appropriation of imagery from any age, era, or culture is accepted as an authentic method of art making. Glassmakers have been doing this, well, virtually forever, and so it is satisfying to see that the trajectories of the various parts of the art world are at last intersecting in fruitful ways. Perhaps one day this convergence will produce a seamless realm of art forms: the domain of the hyper-medium.

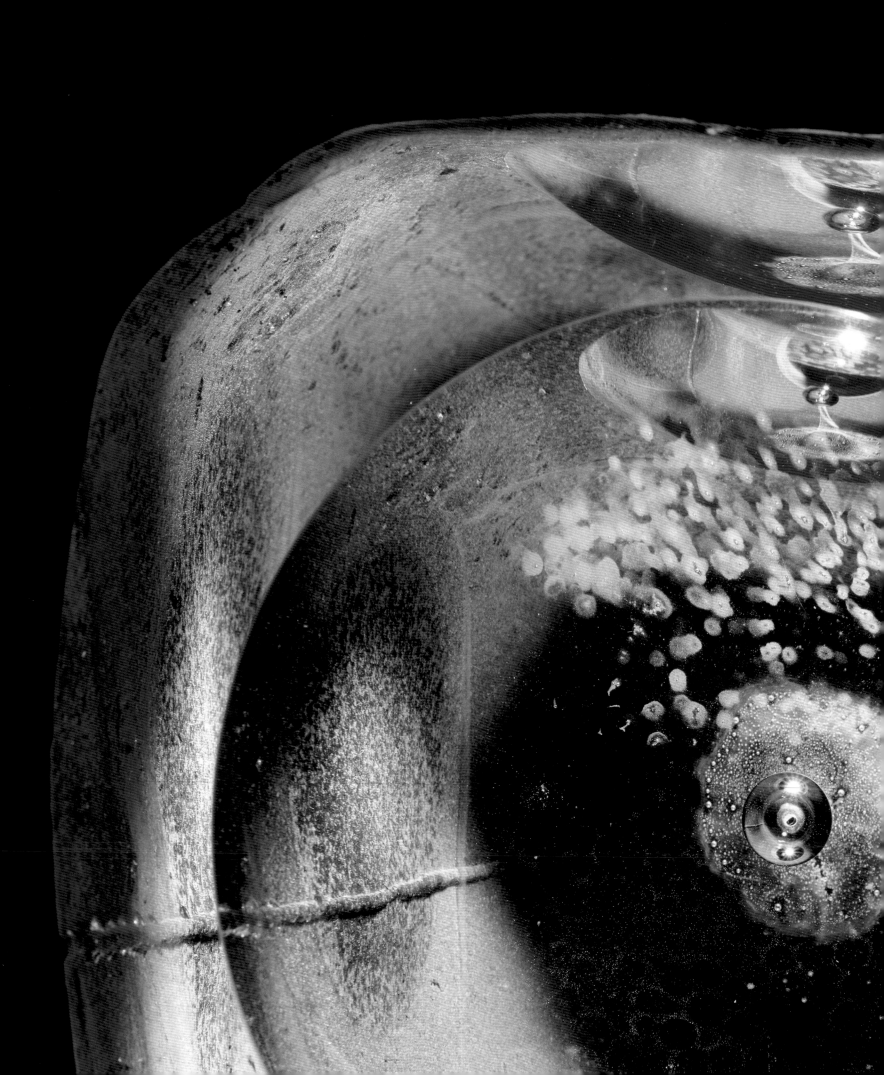

One explores deeper than the nerves or heart of nature, the womb or soul, to the bone, the careless white bone, the excellence.

—Robinson Jeffers, *Gray Weather*

Artists

and nature have an ambivalent relationship. The natural world has always provided the artist with subject matter and raw materials, although the answer to the question of whether nature herself might be regarded as a work of art remains sublimely enigmatic. Naturalism as an artistic convention blossomed in Europe and America in the nineteenth century and included the writers Honoré de Balzac, Émile Zola, Thomas Hardy, and Jack London. These artists reacted against the escapism inherent in other art forms and in earlier literature and embraced the emerging evolutionary theories of Charles Darwin. A pragmatic artistic realism regarding the natural and human worlds seemed healthy, whereas anti-naturalism was viewed as decadent, artificial, and sterile. Balance was essential: when art and science interfered with nature too deeply and disrupted her rhythms, monsters were born; witness Mary Shelley's *Frankenstein* of 1818.

The image of Frankenstein flags a continuing obsession: how to probe nature forcefully without creating monsters or destroying the fabric of life. The twentieth-century writer Vladimir Nabokov offered an unusually lucid observation, echoing a passage from the Bible, when he wrote that "the glory of god is to hide a thing and the glory of man is to find it."[5] Some artists use glass because they find in this material a deep connection to nature, and an especially elegant and nondestructive way to explore natural forms. The early twentieth-century scientist D'Arcy Thompson was among the first to notice this profound relationship:

> The alimentary canal, the arterial system including the heart, the central nervous system of the vertebrate, including the brain itself, all begin as simple tubular structures. And with them Nature does just what the glass-blower does, and, we might even say, no more than he. For she can expand the tube here and narrow it there; thicken its walls or thin them. . . . Such a form as that of the human stomach is easily explained when it is regarded from this point of view; it is simply an ill-blown bubble. . . . The Florence flask, or any other handiwork of the glass-blower, is always beautiful, because its graded contours are, as in its living analogues, a picture of the graded forces by which it was conformed. It is an example of mathematical beauty, of which the machine-made, moulded bottle has no trace at all.[6]

(OVERLEAF)

STEVEN WEINBERG
Brant Point Lobster Pot Buoy, 2002
(detail; see p. 20)

In the same way that nature takes a tube and twists it into a living heart, the glass-maker has an opportunity to create a vessel that mirrors nature. It seems almost unfair that the process of glassmaking should enjoy such a privileged relationship to the natural world. But it does.

There is one very big problem with this idea of simplicity resting at the heart of nature and of glassmaking: even if both begin with tubes, as Thompson theorized, you must still *do* something with those dumb tubes in order to instill life into them. And once a simple process is set into motion, complexity cascades like an avalanche. Few artists are able to control the process and maintain a deep and meaningful connection to natural forms. As the critic Clement Greenberg wrote, "The work of art eludes you the way a pellet of mercury does. . . ."[7]

One notable success is Venetian artist Lino Tagliapietra (pp. 34–35). Widely considered the preeminent glassblower working today, he has the technical skill to work glass and the intellectual capacity to direct the flow of expression and shape it into poetry. Tagliapietra describes his artistic program this way: "I have a total and exclusive relationship with glass, which I take from the furnace and bring into shape progressively. It is the center, the motor of the whole action. I follow it; I give it birth just like a midwife who must accompany natural movements." He finds the medium almost intoxicating: "Nothing is flexible like glass, nothing has the beauty of glass. The combination of air, fire, water. Even gold has nothing to compare with glass. It is absolutely the most expressive material on the planet."[8] But unlike Greenberg's mercurial art, glass has the useful property of cooling into a solid mass after it is shaped. Glass retains the memory of its elusive liquid state in a solid form that is not elusive.

I once spoke to Tagliapietra about the role of breath in his work and he replied that it makes possible "the idea of perfect shape. The relationship of front and back in each object, connected by color, is very important. And that is mainly an issue of shaping by breath. And the shape must be connected to the shadow. Sometimes I want to leave a tiny space in the vessel, like a lens, where you can see through, see the light. If you can give the artwork a kind of profundity, it is like seeing deeply through the water of the glass."[9] In that cascade of sentences you can see the artist's struggle to connect perfect breath to perfect shape, skill to art. The tools he uses are blowpipes and blowtorches, but just as important are elements of color, front and back, shadows and lenses.

Dante Marioni (who could also occupy a place in the chapter about abstraction and color that follows) honed his Venetian glassblowing skills after studying with Tagliapietra, creating a lean, unembellished body of work that personifies a minimalist spirit, although, as critic John Perreault has noted, "No minimalist would use such gorgeous color." In his *Mosaics* (p. 28), he fuses many small glass tablets into a mosaic sheet, rolls the sheet up into a cylinder, and then blows and forms it until he

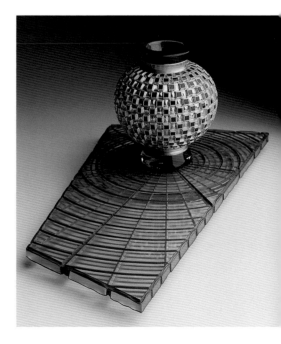

MICHAEL M. GLANCY
Gold Lodestar, 1990
7 x 17 x 8½ in.

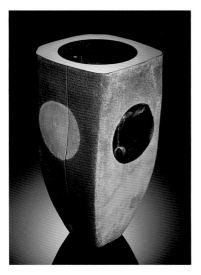

attains a hollow vessel. These are perhaps the least modest of Marioni's works and the most naturalistic: they evoke aggregates of cells and seem to be all about partitions, as might be found in the wing of a dragonfly, a honeycomb, a colony of coral.

The sculptures of Steven Weinberg seem to be complete opposites of Tagliapietra's work, save for the shared connection to nature. Whereas Tagliapietra explores hollowness and lightness in blown forms, Weinberg casts glass and emphasizes the weighty and crusty aspects of the medium. Yet Weinberg also explores buoyancy and its intimacy with water. Look at the detail on page 21 and you'll be staring down into symbolic ocean depths, through the top of one of Weinberg's *Buoys.* Critic John Brunetti observes that this is "a horizontal cut across the top . . . that allows one to peer into their solid, capsule-shaped bodies. Given slight depressions, this edge implies the waterline and allows Weinberg to submerge us within the pressure of the sea."[10]

Paul Stankard is widely considered to be one of the finest paperweight makers, but the work illustrated on pages 31–32 is one of his *Orbs*—a glass sphere embedded with a glass flower that is intended to be viewed from all sides. These are not miniatures, but sculptures appropriate in scale to their subject matter. His approach is so direct and simple that it is almost startling. Stankard says, "People who think that we've lost Nature have never walked down a highway and studied the wild flowers,"[11] and so he offers us a dollop of glass enclosing the viscera of nature. According to his mother, Stankard ate flowers as a child. Today, he has sublimated that desire by making flowers rather than eating them, and the sharpness and clarity of his flora are a mark of their success in his eyes: they should look real, and if they are true to nature, then they are by definition spiritual.

Michael Glancy magnifies nature in order to reveal its underlying structure (pp. 22–27). He uses electron microscopes to inspect the eyes of insects; geology inspires him with its stratifications and crystallizations; and the vortex of randomness and chaos theory not only fails to intimidate him but provides a template for much of his work. Glancy's two-dimensional sketches contain his musings on all of these matters, and he has found that sketching on glass is best suited to his ambitions. These became the flat glass panels that form sculptural bases for his artworks, and their structures unfold into and inspire the vessels that sit astride them. It is as if the two-dimensional universe had unfolded and warped itself into three dimensions. Recently, I spoke with Glancy about Stephen Wolfram's controversial new book, *A New Kind of Science,* because the patterns on Glancy's sculptures reminded me of the illustrations of cellular automata in that book. Wolfram is convinced that some of his automata can, when run on a computer, produce patterns and structures we associate with life (for example, the patterns on seashells), but he stops short of claiming that these

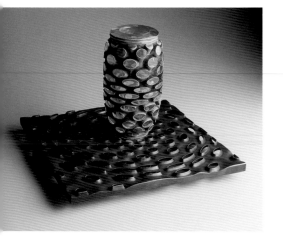

computer programs will someday come to life. Glancy's take is a little different: "I view the inanimate objects I make as damn near alive."

Beyond an interest in the techniques of glassmaking, Tagliapietra, Marioni, Weinberg, Stankard, and Glancy share a strong curiosity about the forces of nature and how these might be presented artistically. Although the work of each is technically assured and perfected, it is born from a willingness to take a risk by plunging beneath the frenetic surface of nature, to strike down to the bone in pursuit of what is distinctly natural, and to harvest there inspiration for their work. This is what poet Robinson Jeffers called "the excellence"; he had an inkling that nature harbors a stillness at its center that is key to its distinctiveness, and ultimately to its brilliance. For these artists, the result of distilling this essence is so deeply linked to the natural world that it can sometimes seem hyper-realistic, as if the artist were merely copying nature (people often mistake the glass flowers enclosed in clear glass in Stankard's work for real flowers). Perhaps this burden of intense naturalism is itself distinctive to some work in glass, and many of the crowning achievements seem almost too obvious or effortless: a small blossom, a simply shaped vessel, a massive lens. We should not lose sight of the accomplishments of these artists, which have been to focus our attention back to nature and to the processes of nature. That is itself the excellence.

STEVEN WEINBERG
Brant Point Lobster Pot
Buoy, 2002
(top view; see p. 20)

MICHAEL M. GLANCY *Vis Vitalis,* 1999
13 x 18 x 18 in.

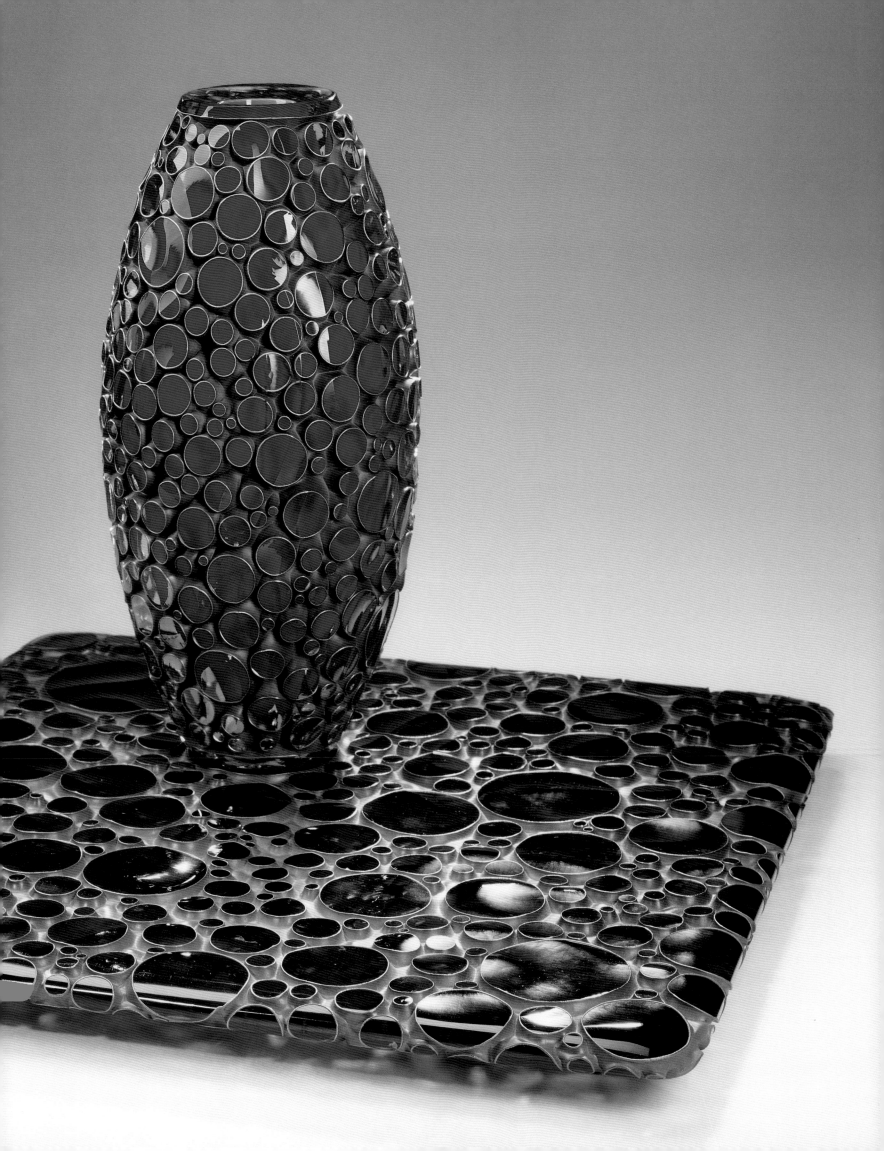

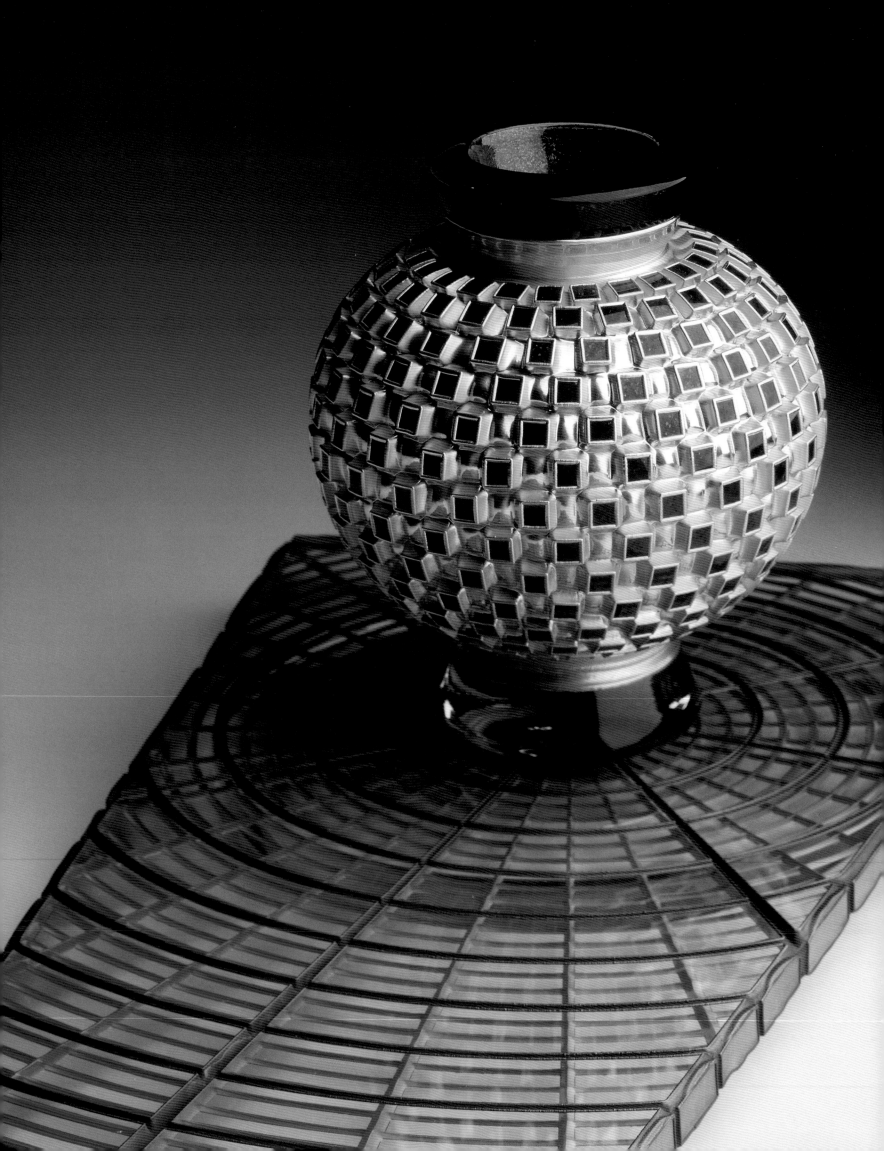

MICHAEL M. GLANCY *Gold Lodestar,* 1990
(detail; see p. 19)

Contracting Expansion, 2000
9 in. high x 15 in. diam.

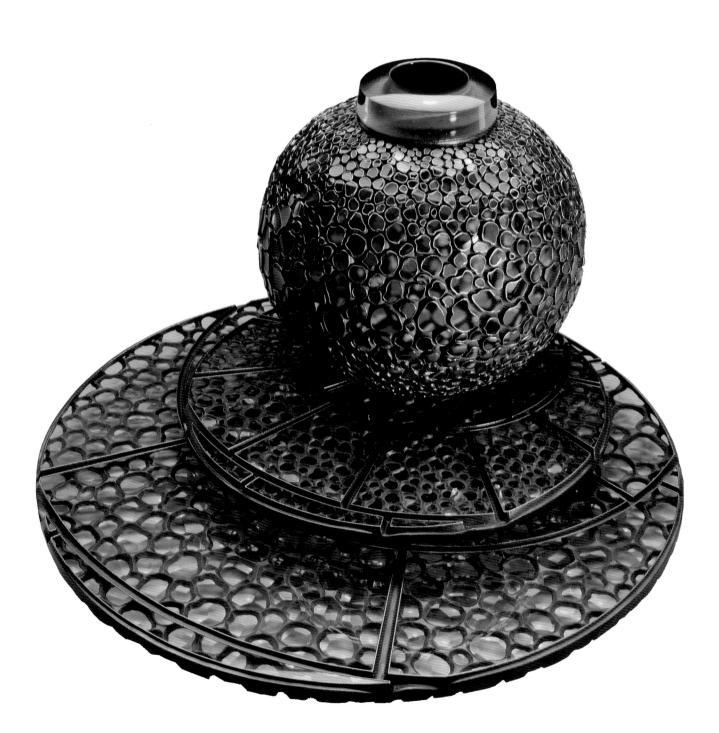

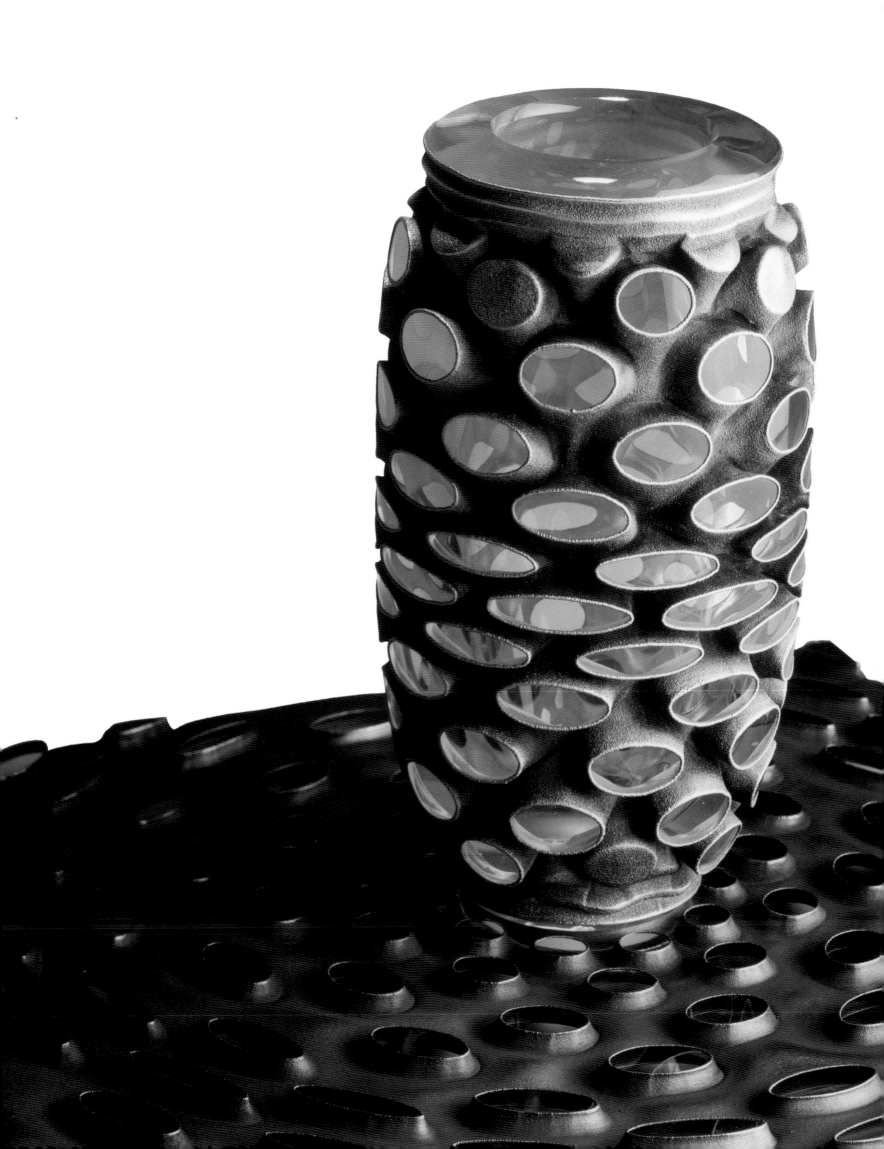

"I view the inanimate objects I make as damn near alive."

—Michael M. Glancy

MICHAEL M. GLANCY *Term Sinkronosity,* 1983
(detail; see p. 20)

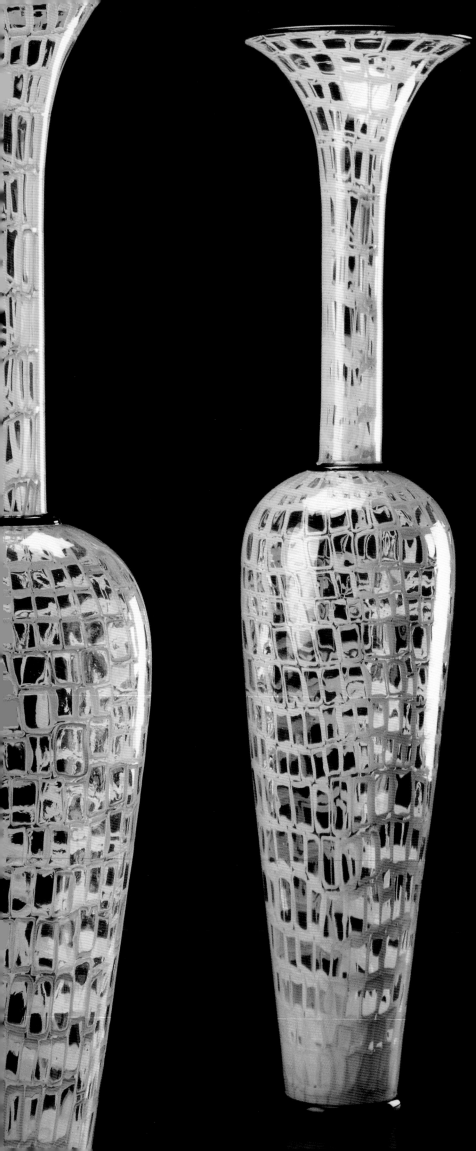

"When I get them right, the Mosaics are my favorite things to make. These objects came out of the interest that Dick Marquis and I share in the work of the Italian architect and glass designer Carlo Scarpa."

—Dante Marioni

DANTE MARIONI *Yellow Mosaic Vase,* 1997
35½ in. high x 8 in. diam.

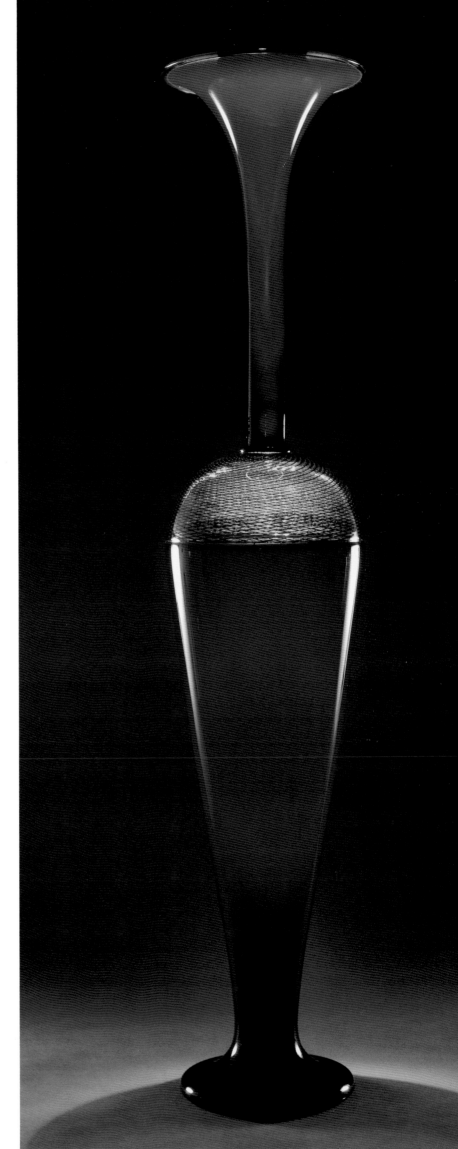

Gambo, 2000
36¼ in. high x 7½ in. diam.

PAUL STANKARD *Morning Glory and Orchids Orb,* 2002
5½ in. diam.
(front view)

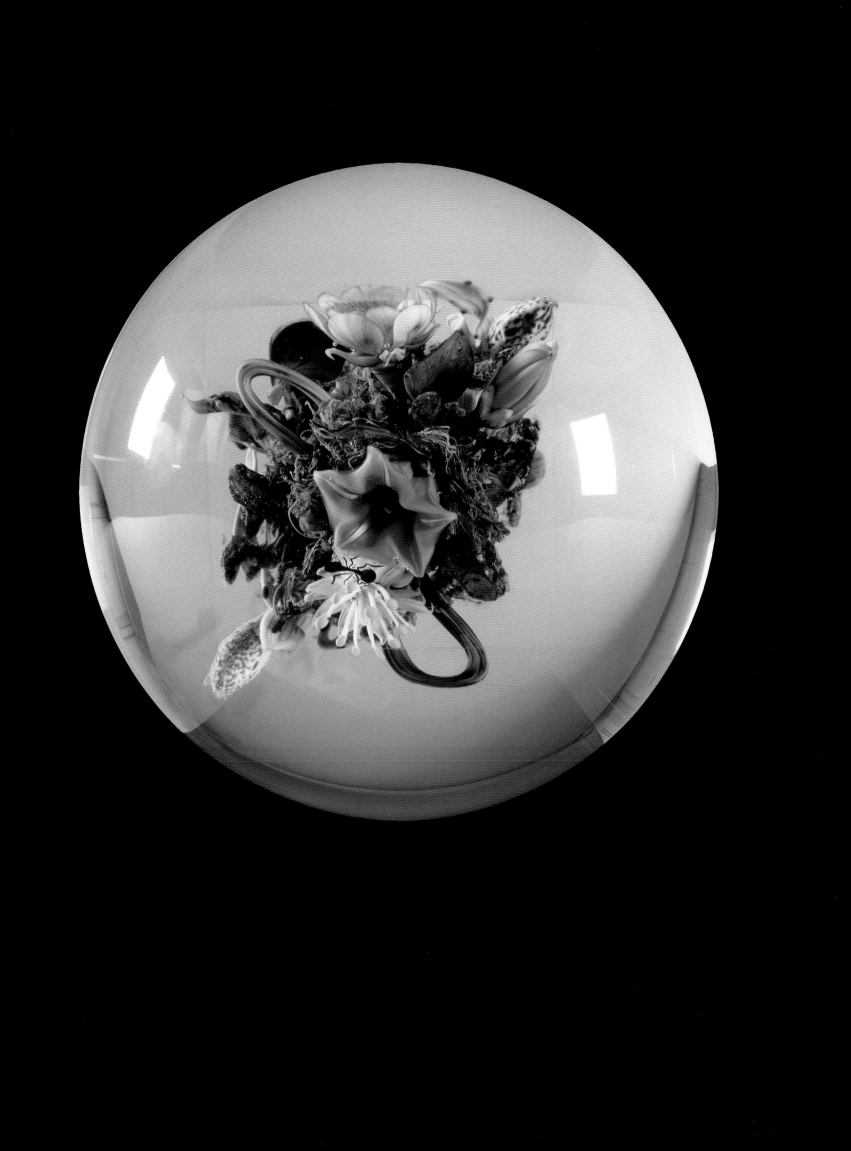

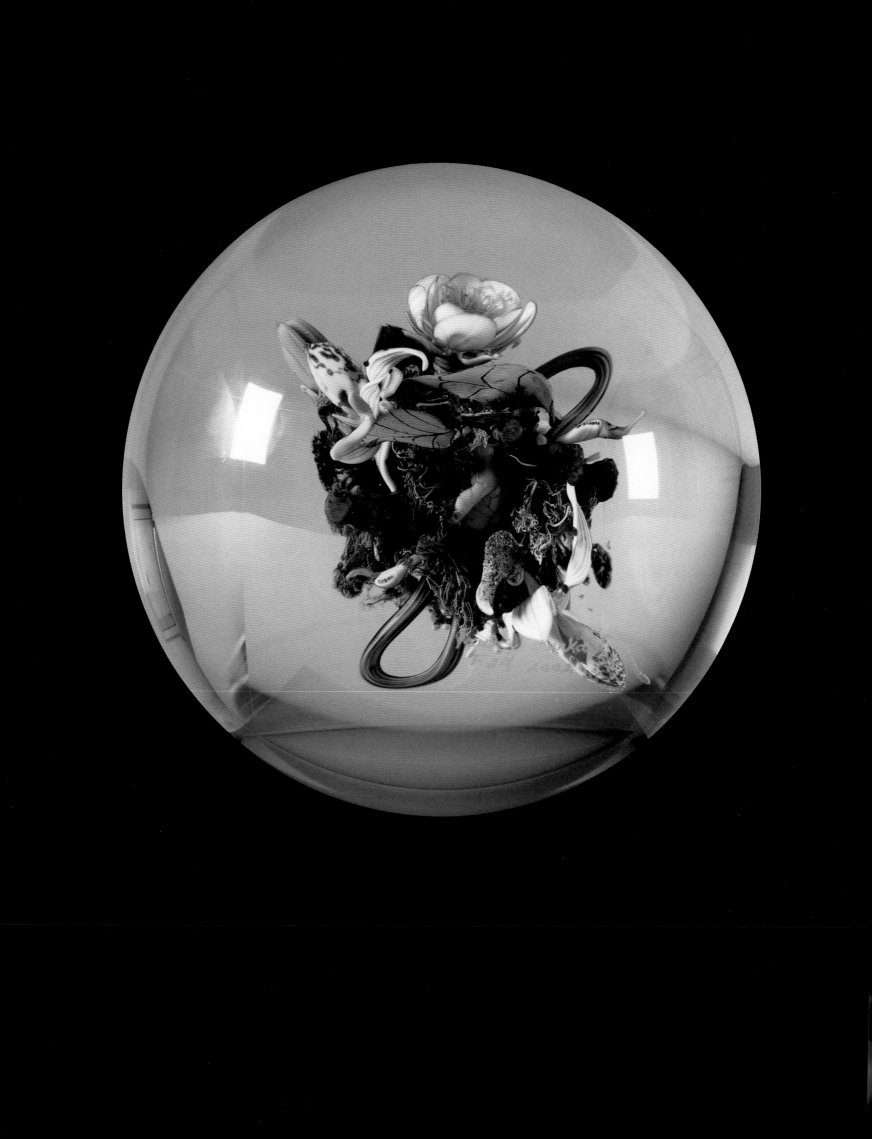

"A Latin motto on the ventilation hood over [Stankard's] workbench reads Laborare est Orare, *to work is to pray. All of it, the earth spirits, the word canes, the insects, the flower blossoms themselves, are words, and his botanicals and paperweights are prayers rendered in glass."*

—Ulysses Grant Dietz, Curator, The Newark Museum

PAUL STANKARD *Morning Glory and Orchids Orb,* 2002
5½ in. diam.
(back view)

(OVERLEAF)

LINO TAGLIAPIETRA *Samba do Brasil,* 2000
(detail; see p. 13)

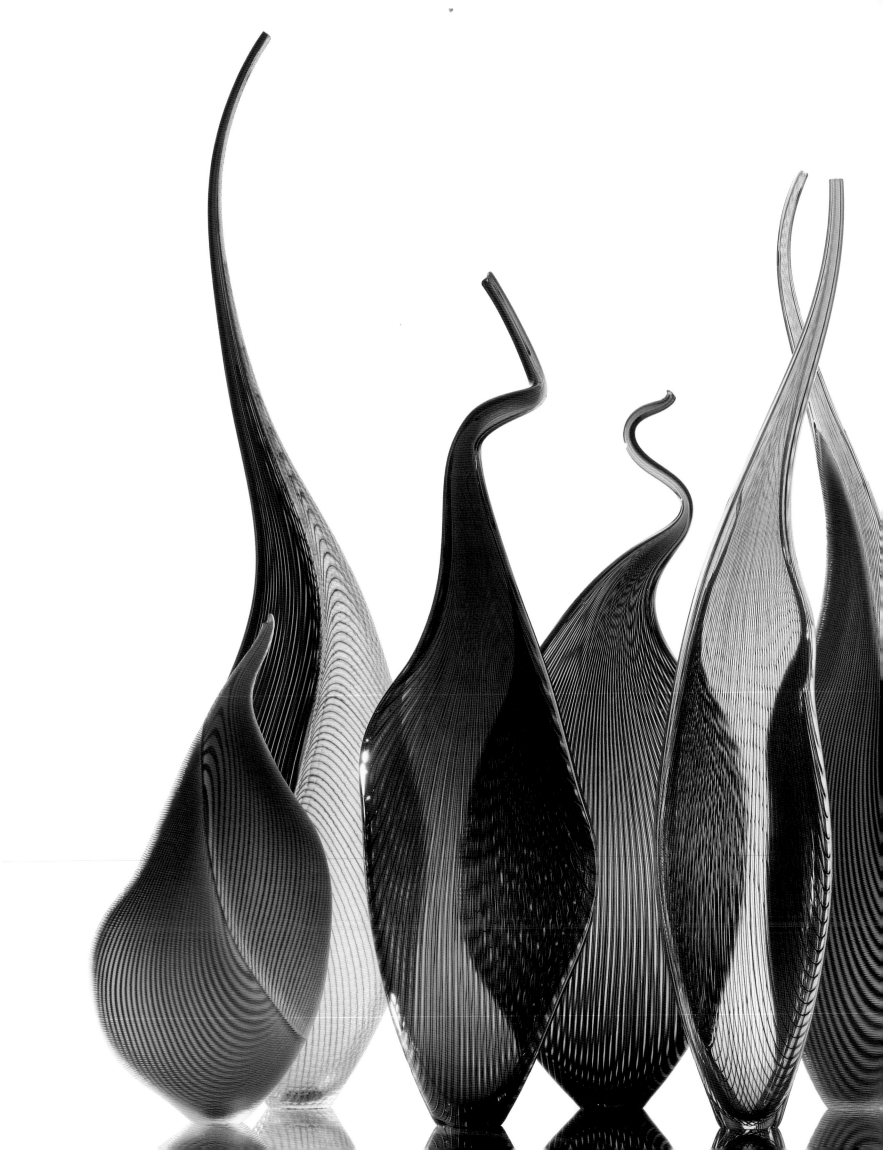

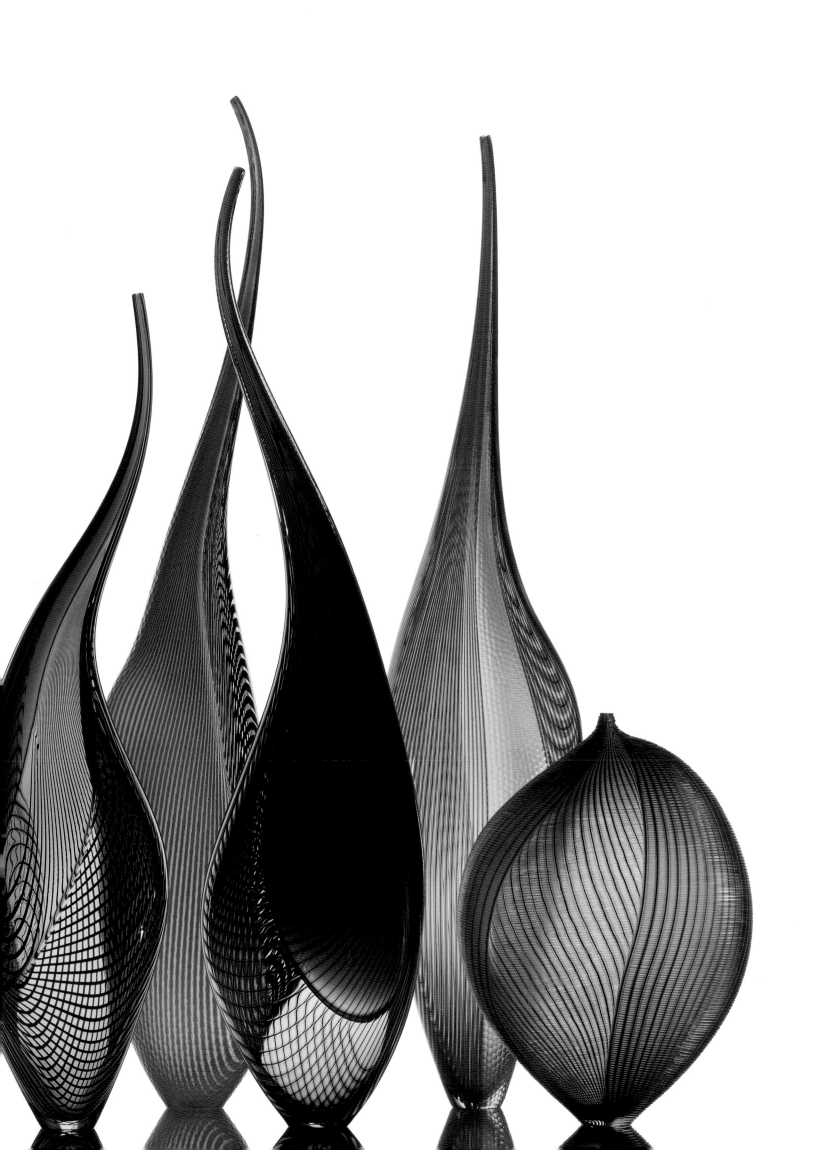

STEVEN WEINBERG *Brant Point Lobster Pot Buoy,* 2002
(detail; see p. 20)

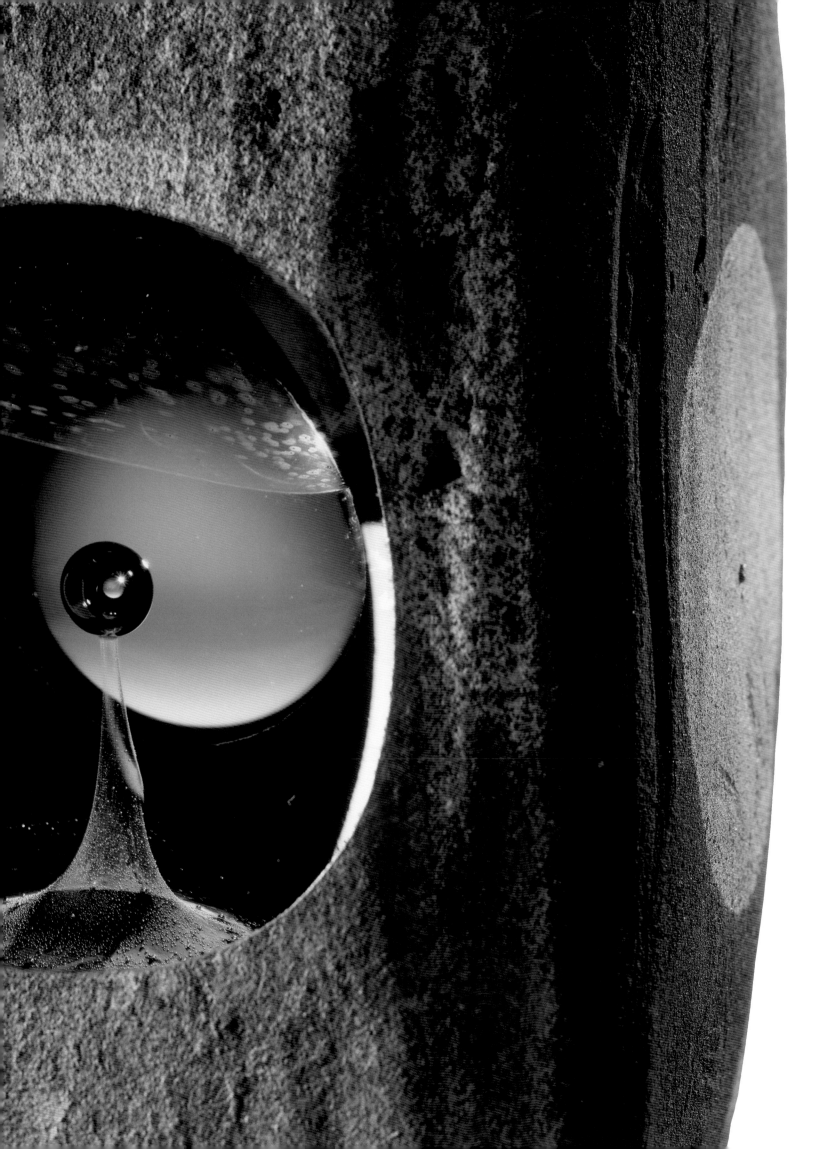

SINCE had a tenuous, sometimes confrontational relationship with representational forms of art. Some people say that it intimidates them, that they don't understand the meaning of abstract works. Some critics complain that the audience for abstract art is minuscule compared to that for representational art, and that the average viewer lacks the tools to appreciate nonrepresentational works. But you don't need to be an expert to appreciate and enjoy the evocative power of shapes and the emotional impact of colors.

Assembling the artworks for this exhibition required me to visit approximately two dozen private collections in southern Florida, and I soon became aware of how abstract painting was effortlessly integrated with sculpture in many homes: a Morris Louis might hang near a Chihuly; a Kenneth Noland next to a Ben Tré; a Jules Olitski near a Libenský and Brychtová. Both types of artwork live for light, and Florida continually bathes and renews them under its sometimes dramatically harsh, sometimes soothingly therapeutic sun. Moreover, there are no wall labels in private collections to separate and classify works by artist, genre, style (though this is occasionally disarming for a curator if you don't recognize every artist in the house). However, the apparent chaos of the rooms would soon dissipate and the experience would take over: I became literally immersed in art. I was floating from collection to collection. It occurred to me that, at some level, it mattered less who made these things than that the experience of them was allowed to happen free from gravity, from the tug of everyday art-world concerns such as authorship, condition, provenance.

Tom Patti's five-part sculpture, which opens this chapter, straddles the line between nature and abstraction, perhaps even suggesting a composite genre of "organic" abstraction. It might be pieces of beach glass or transparent stone worn down by ocean surf, polished to reveal geological strata. Made as a commission for a collector on the occasion of his fiftieth birthday, it contains fifty "layers" of fused glass sheets: here, a stratigraphy of human time replaces geologic time. The work is scaled to the human hand, but that represents the limits of its realism, its connection to some meaning that can be easily articulated. The work is not so much "about" anything as it is an opportunity to experience the visual and tactile worlds freshly, and to enjoy that experience. I stress that it is possible to read too much into abstraction, and in doing so to limit the experience. If anything, abstract work should challenge us to read less into experience, to seek escape velocity from daily cares.

The getaway route to abstraction taken by the founders of studio glass was almost a straight line. Despite Littleton's brief forays into realism (see chapter 1), he segued rapidly into abstraction. This may have been due to a desire to distance the emerging medium from the tradition of functional vessels that, in the late 1960s, seemed to hold

it back from entrance into high-art circles. From an art-historical viewpoint, the emergence of studio glass had the pleasant effect of extending the realm of abstraction into a new and potentially powerful sculptural medium. Glass artists shared with the minimalists working in paint, steel, and bronze an exploration of the effects of gravity and the use of industrial processes and materials. Glass additionally offered tantalizing new options to those interested in color and shape.

For example, if the color-field painter Morris Louis could achieve stunning effects by staining paint intimately and deeply into the fibers of the canvas, until the color seemed to glow from within, then imagine how exciting it must have been for Littleton to realize that he could experiment with glass *sculptures* (as opposed to vessels) that appeared stained with color throughout their mass, every layer visible to the eye. One of the goals of the painters had been to free color from gravity and structure—Jules Olitski even spoke of his wish to find a way to spray color into the air and coax it into staying in place. So they began to experiment with the framing of their canvases, sometimes making them diamond-shaped or constructed with irregular edges. The aim was to liberate color from structure, and the results were at times interestingly asymmetrical, echoing the awkward wooden framing that held the canvas in place. Ultimately, the pressure of the intense color fields these artists had unleashed was rupturing the frail canvas membranes upon which they were painted.

Looking at such artworks, Littleton and his students—Marvin Lipofsky and Dale Chihuly among them—came to realize that they could use their breath to stretch a glass canvas that, without exactly defying gravity, seemed to seduce the forces of gravity and enlist them in support of color. Most significantly, these glass artists had found a medium that could metaphorically absorb, display, and even celebrate shock waves of intense color without rupture, much as high-lead-content glass is used in specialized windows to absorb X-ray radiation while allowing light, and images, to pass uninhibited.

One thing that might have initially attracted collectors to this work was the relative rarity of interesting and ambitious small-scale sculptures of any sort during the post–World War II era. The works discussed here are mostly what we would call "table top" sculptures, and unlike much contemporary sculpture, which is intended to be moved by crane or forklift, they can be lifted with your hands. Even Chihuly's recent massively scaled sculptures, such as his chandeliers and the Seaform ceiling he is creating for the new wing of the Norton Museum, are assembled by hand from smaller components. An intimacy with color was achieved that was lacking in other art forms, and artists such as Laura de Santillana and Toots Zynsky continue to explore it profoundly. Santillana collapses the glass bubble as if seeking a vacuum, and turns her vessels into breathless projectors of color (pp. 60–61). Zynsky pioneered an entirely new way

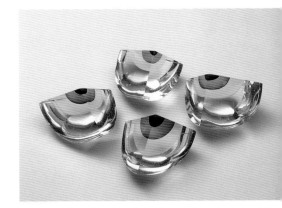

HARVEY K. LITTLETON
Lemon/Orange/Blue Hemisphere Quarters, 1980
each 3½ x 4 in.

MARVIN LIPOFSKY
Kentucky Series 2000–01 #5, 2000–2001
15 x 14 x 15½ in.

Series IGS VI 1997–98 #1, 1997–98
12½ x 21 x 18 in.

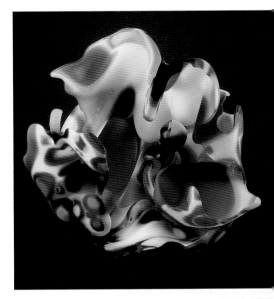

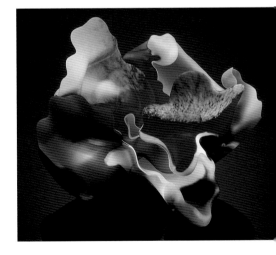

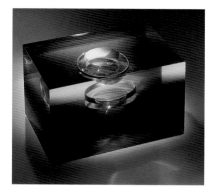

TOM PATTI
Red Lumina Echo, 1991
5 x 4 x 3 in.

of creating vessels from strands of glass fibers that are fused together. The result? Imagine if all the individual color-impregnated hairs from an artist's brush could be woven into sheer air (pp. 64–67).

There are also geometric and architectural approaches to abstraction in glass, in which color plays a more controlled and compositional role. Whereas Santillana creates nongeometric works that are about color ethereally squeezed and diffused and projected, Patti, in his geometric mode, compresses color between narrow planes that are precisely defined and then extruded out to our eyes (pp. 56–59). Whereas Littleton organically twists color and Zynsky stretches and threads it, with all the looseness those processes imply and celebrate, František Vízner shapes color with infinite care and patience as he carves by hand abstract vessels from blocks of solid glass (pp. 62–63). Jaroslava Brychtová, Stanislav Libenský, Howard Ben Tré, and Daniel Clayman all cast abstract color using molds to control shape, and they frequently work on an architectural scale, or at the scale of the big things that go inside buildings as furnishings or outside them as monuments (pp. 43–51). Here, abstraction melds into realism, and the tug of war between the two becomes the point: Ben Tré gives us not simply a basin, but a massive one that holds color instead of water. The critic Arthur Danto observes that "Ben Tré uses glass to represent glass. . . . He uses beauty . . . to exemplify what it would mean to live in a society defined by beauty."[12]

Libenský and Brychtová use abstract color symbolically as well as structurally to evoke a reaction or suggest a mood: "Definitely, there is a symbolism in our colors. . . . We have made heads with red coloration. Those were a kind of violent shock. We have used blue for other themes, as metaphors of hope or open space, or for views through space" (Brychtová). "In our most recent pieces we are trying to choose colors that are as light and as sublime as possible. We prefer glass that has almost no color, which has only a slight shade of warmth, or something cold in it, but which is possibly not color" (Libenský).[13]

Truthfully, most works of art are seldom purely this or that but revel in a delicious ambiguity, as elusive as Greenberg's drop of mercury, driving art critics insane and inspiring poets. The fused planes of glass in Patti's work, for example, may also be read as horizon lines, as if these creations compress within their transparent skin many layers and multiplex views of the landscape, forming a mass that is the scale of the human hand or brain: the landscape in your hand, the universe in your mind's eye. So maybe there is no such thing as abstract art, maybe all abstraction should be called realism: after all, what could be more concrete (and should be less intimidating) than color and form?

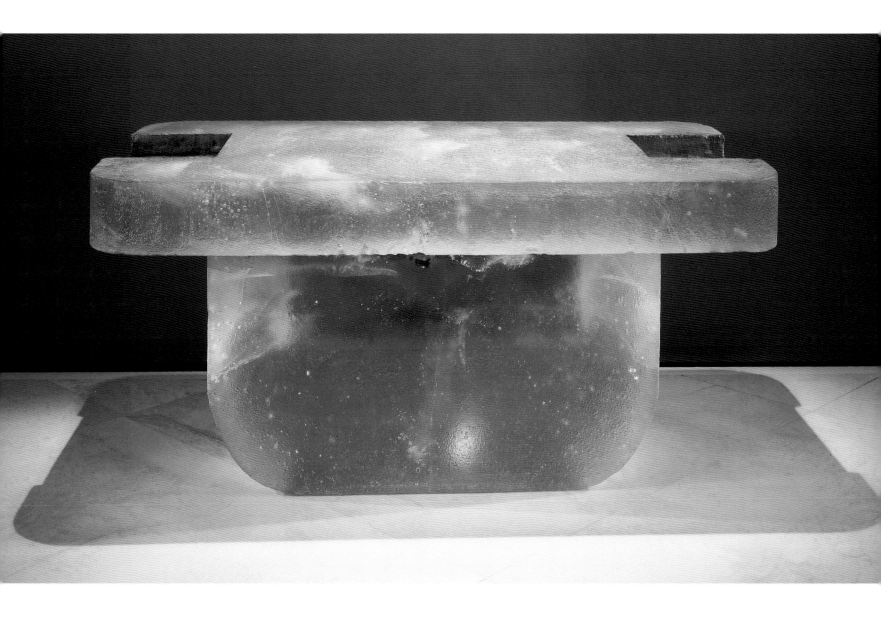

HOWARD BEN TRÉ *Bench 12,* 1991
Cast glass, bronze powder,
16¹³⁄₁₆ x 36⅛ x 19¹⁵⁄₁₆ in.
Collection of Nicki and Ira Harris
Photo: © C. J. Walker

HOWARD BEN TRÉ *Boone Basin,* 2002
Sculpture: 31¾ x 20 x 15 in.
Base: 24 x 20 x 15 in.

"Ben Tré uses glass to represent glass. . . . He uses beauty . . . to exemplify what it would mean to live in a society defined by beauty."

—Arthur C. Danto, art critic

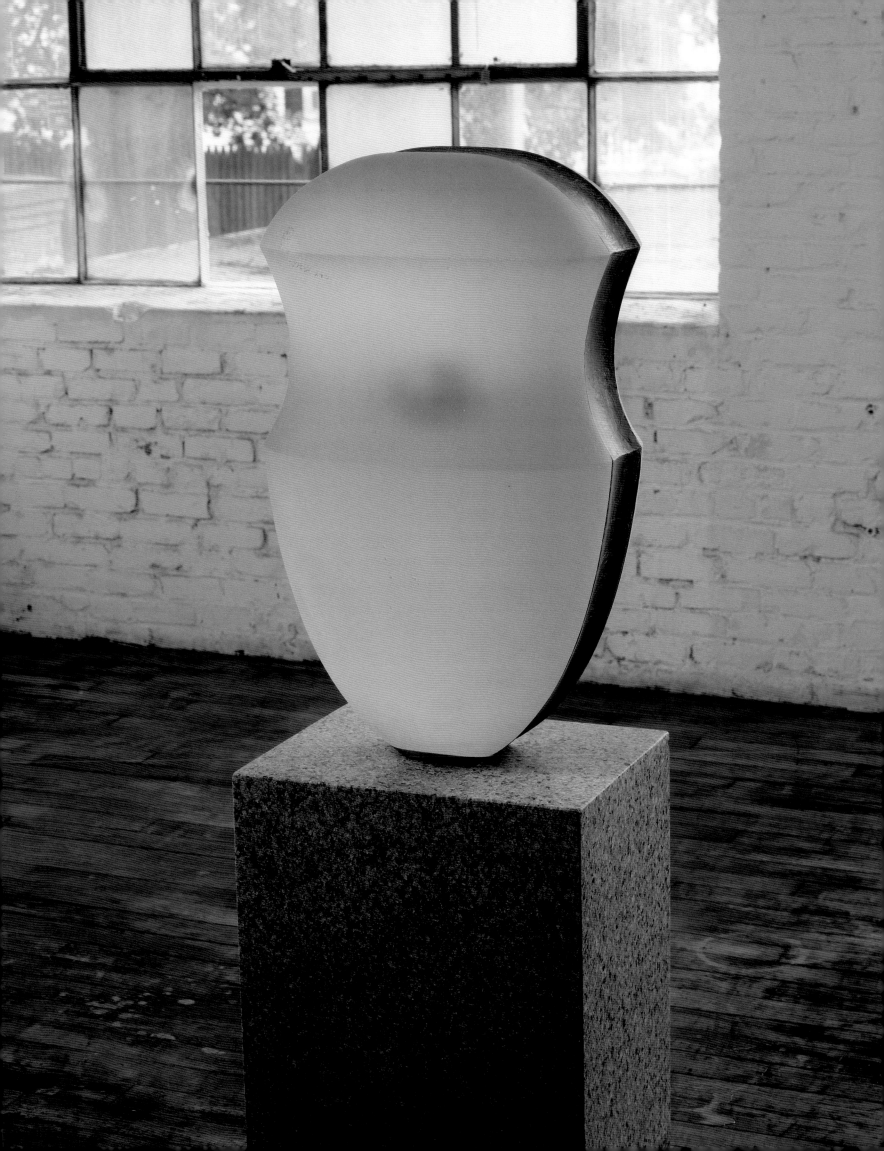

DANIEL CLAYMAN *Untitled,* 1989
14¼ x 12 x 3½ in.

Hearth, 1989
9 x 6⅞ x 2¼ in.

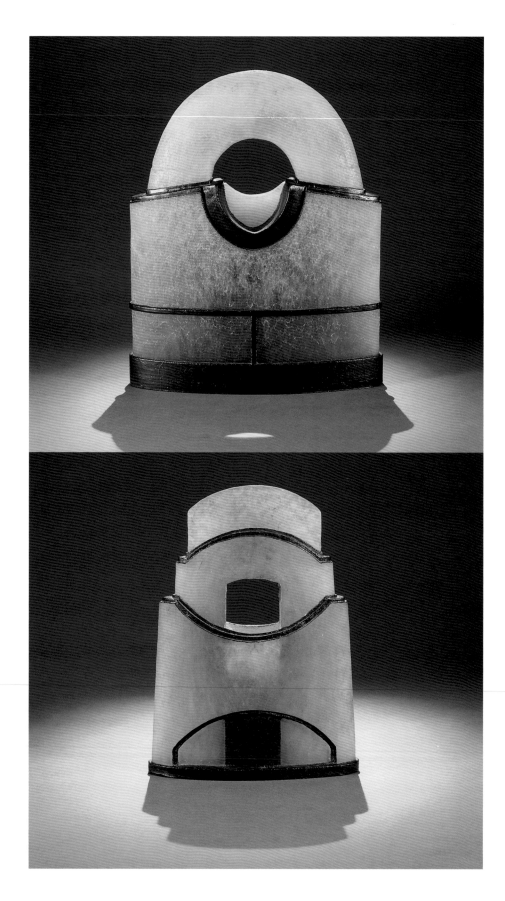

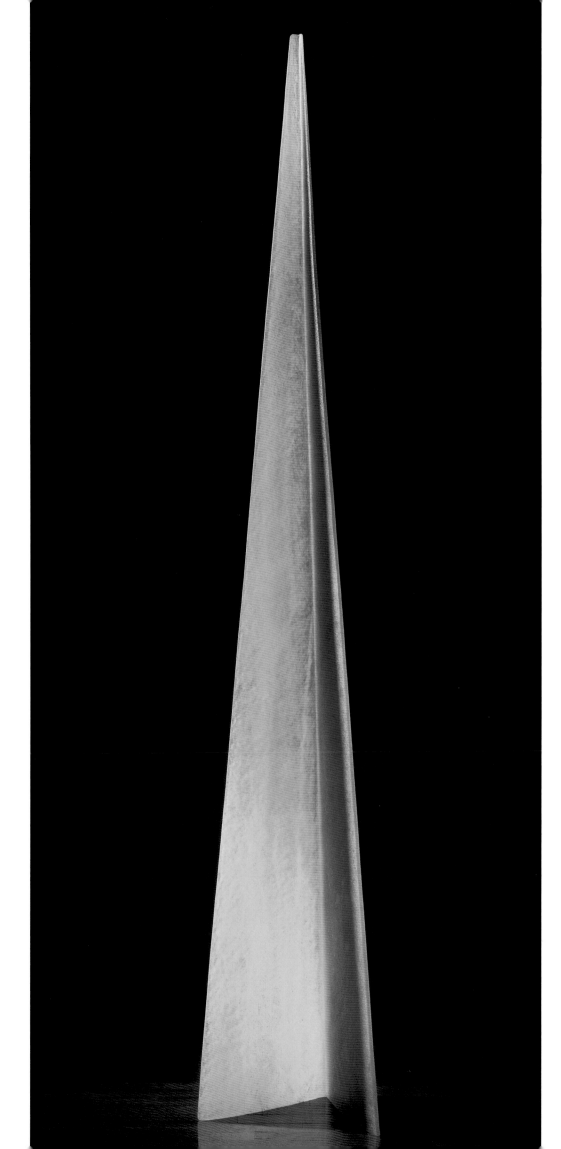

Diverge, 2002
96 x 17½ x 13¼ in.

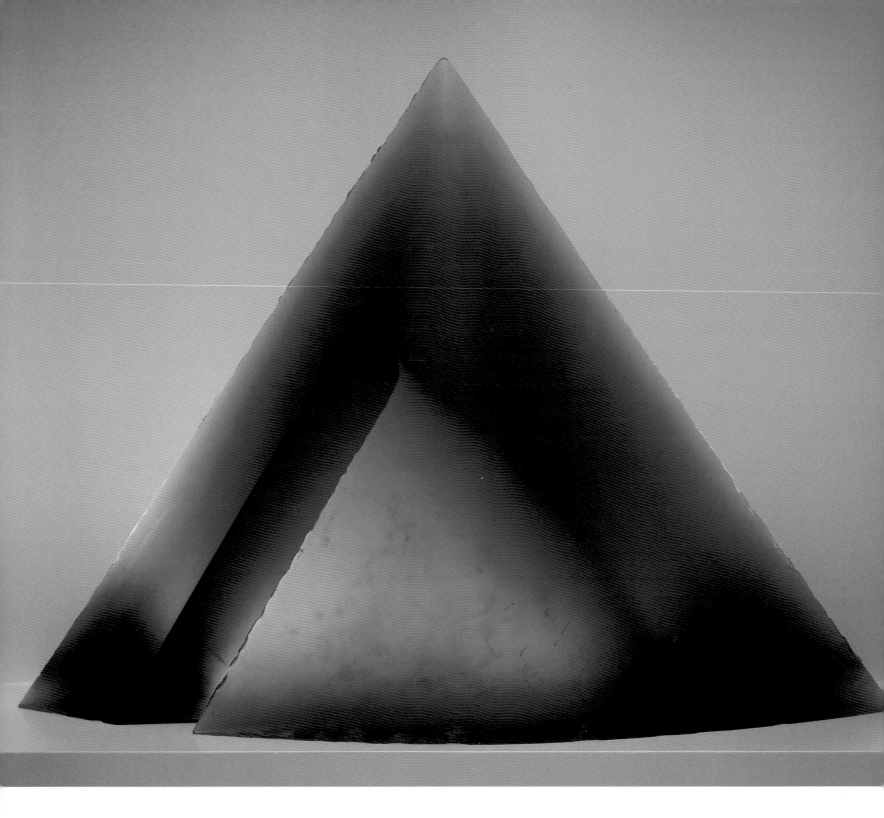

STANISLAV LIBENSKÝ
AND
JAROSLAVA BRYCHTOVÁ

(OVERLEAF)
Taking Off, 1994–99
23½ x 47 x 19½ in.

Through the Cone, 1995–97
36 x 49 x 10 in.

CHAPTER THREE 50

"Definitely, there is a symbolism in our colors. . . . We have made heads with red coloration. Those were a kind of violent shock. We have used blue for other themes, as metaphors of hope or open space, or for views through space."

<div align="right">—Jaroslava Brychtová</div>

Light Space, 1994
16 x 32½ x 5¾ in.

MARVIN LIPOFSKY *Kentucky Series 2000–01 #5,*
2000–2001

Series IGS VI 1997–98 #1,
1997–98

(details; see p. 41)

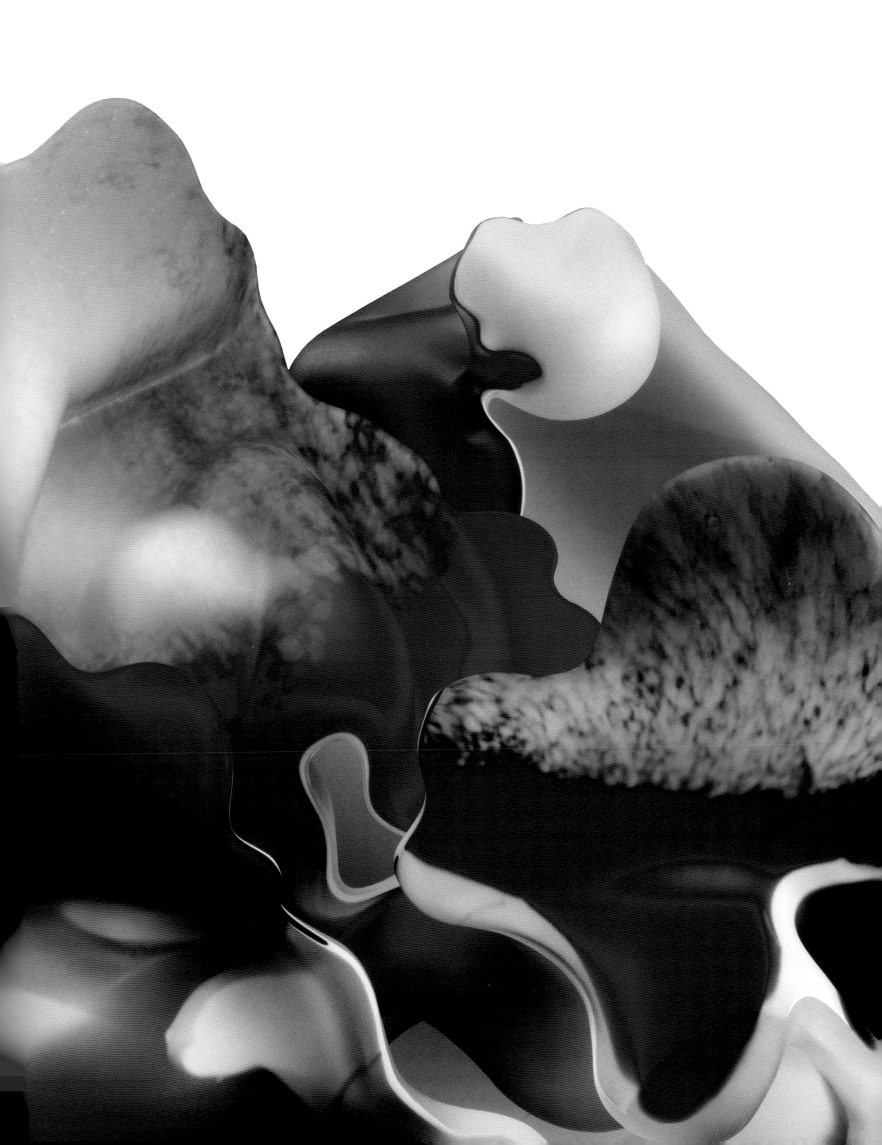

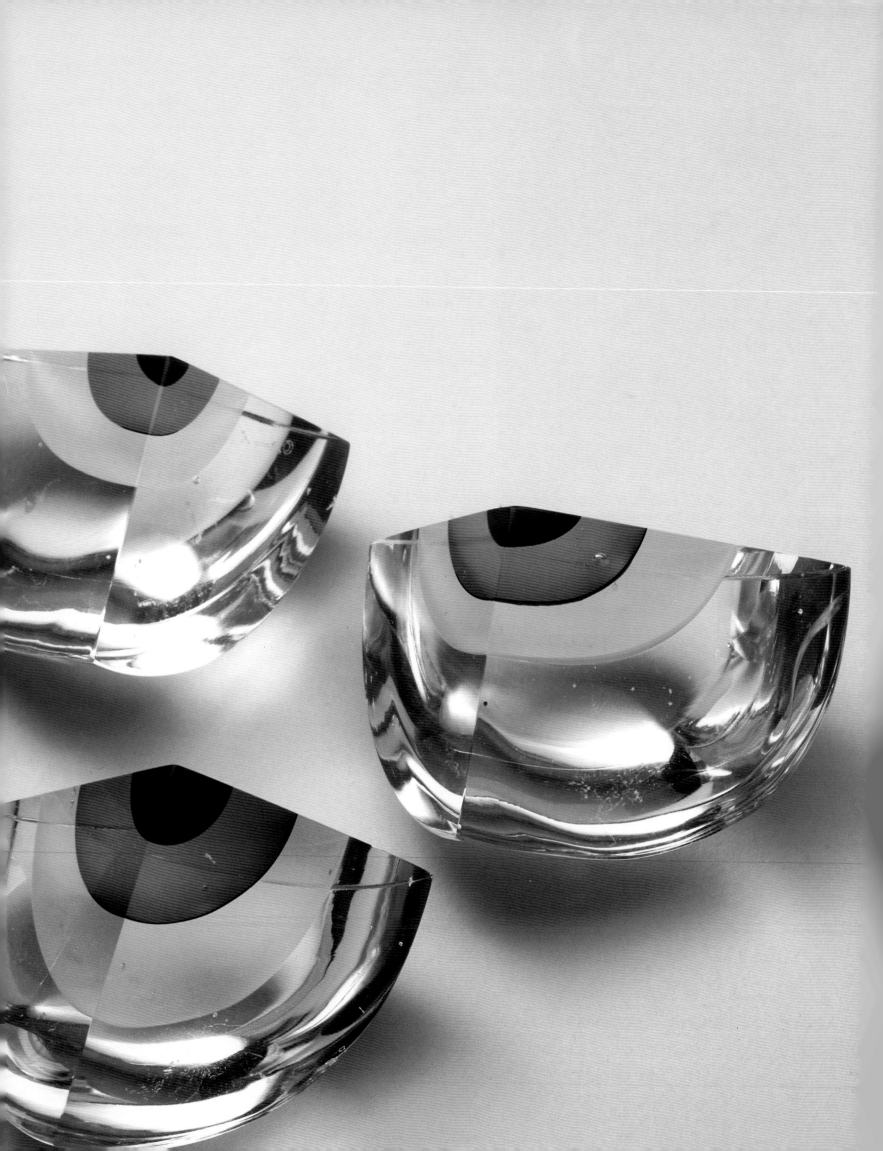

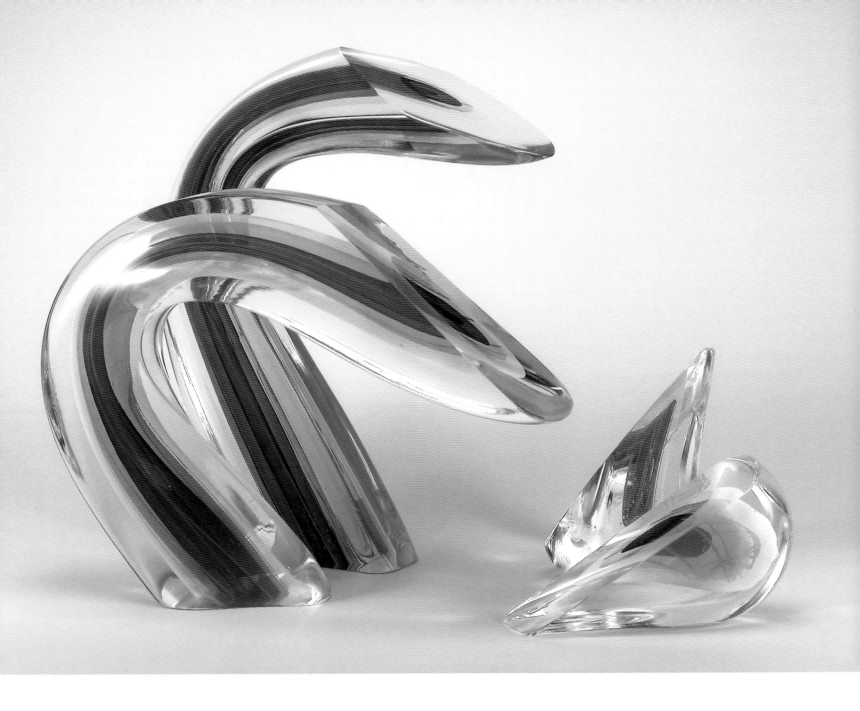

HARVEY K. LITTLETON

(OPPOSITE)

*Lemon/Orange/Blue Hemisphere
Quarters,* 1980
(detail; see p. 41)

*Yellow Ruby Sliced Descending
Forms,* 1985
approx. 20 x 14 x 15½ in.

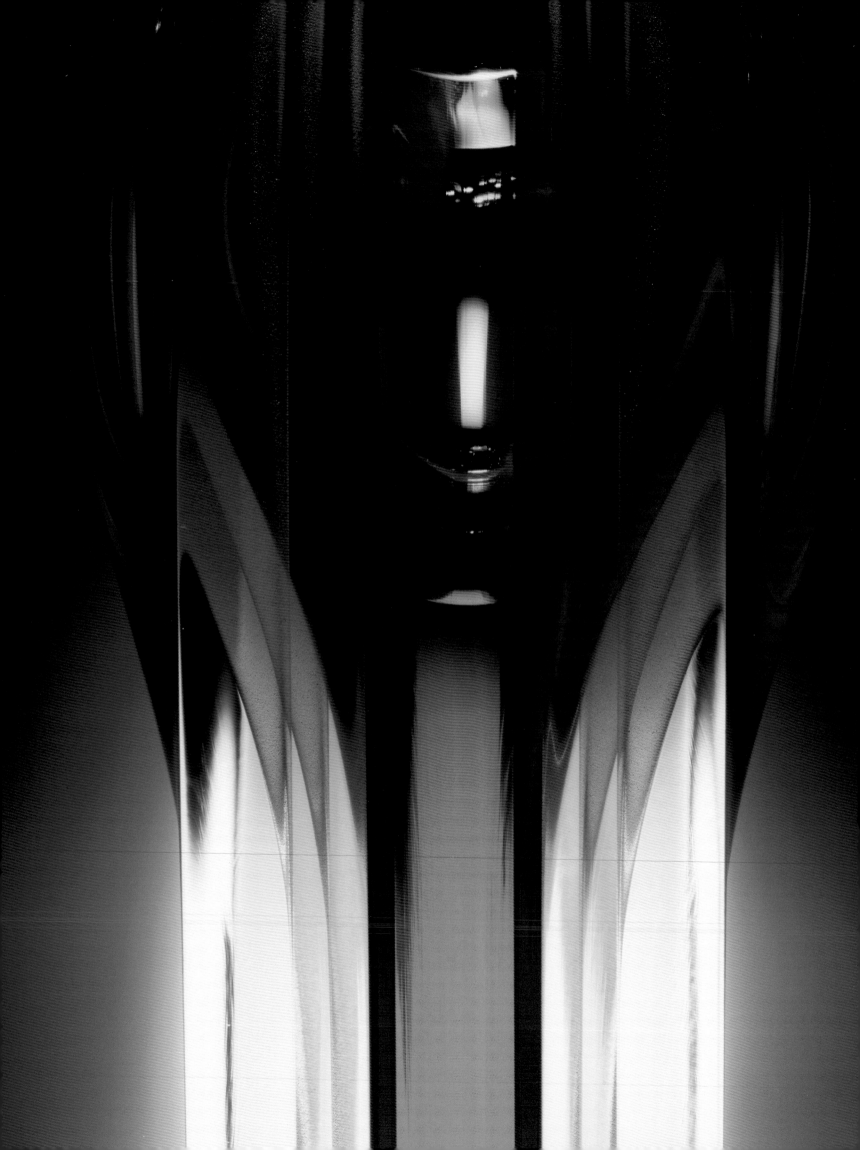

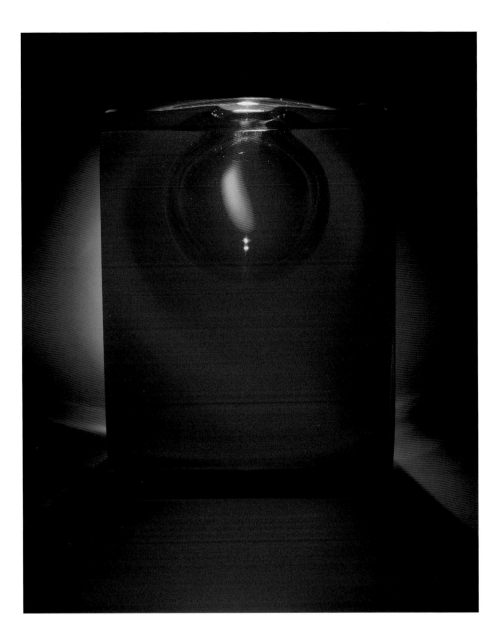

(OPPOSITE AND ABOVE)
TOM PATTI *Ascending Red,* 1990
5¾ x 4⅜ x 2¾ in.

(OVERLEAF)
Red Lumina Echo, 1991
(detail; see p. 42)

(PAGES 60–61)
LAURA DE SANTILLANA *Two Reds,* 2001
15¾ x 18½ x 1¹⁵⁄₁₆ in.

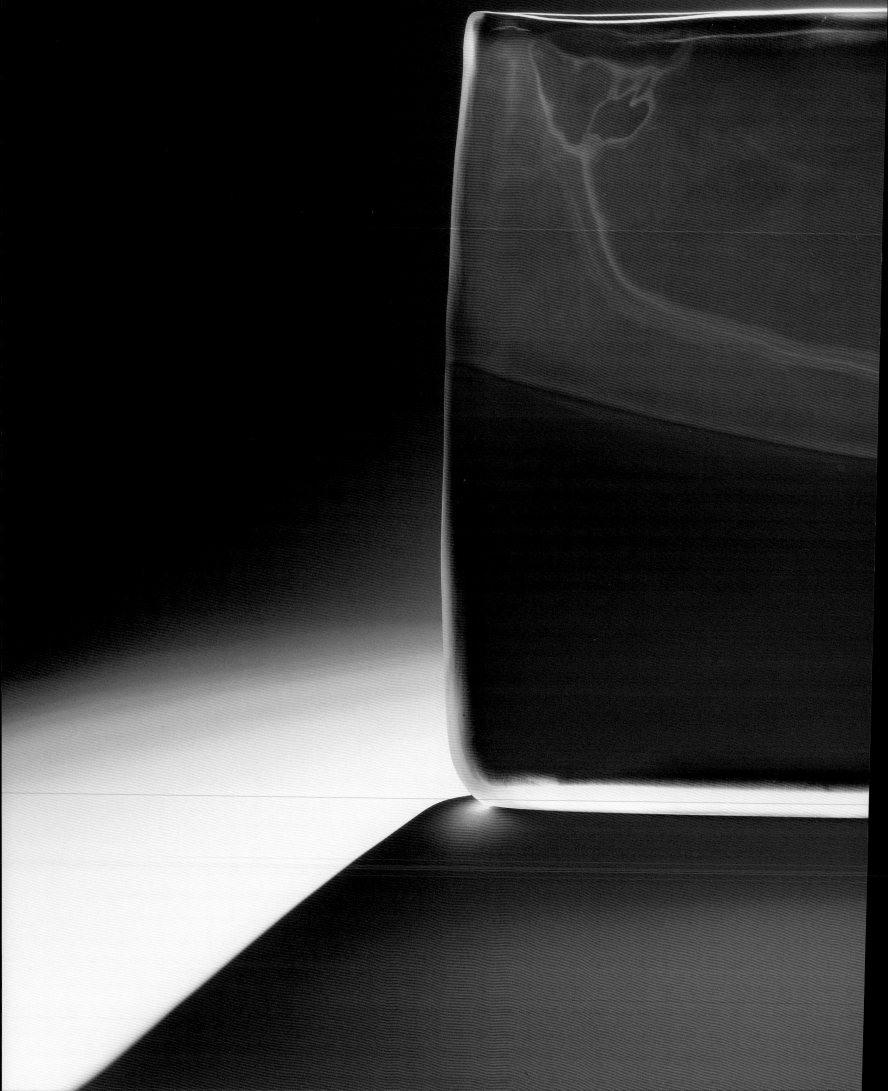

FRANTIŠEK VÍZNER *Turquoise Bowl,* 2000
4½ in. high x 11 in. diam.

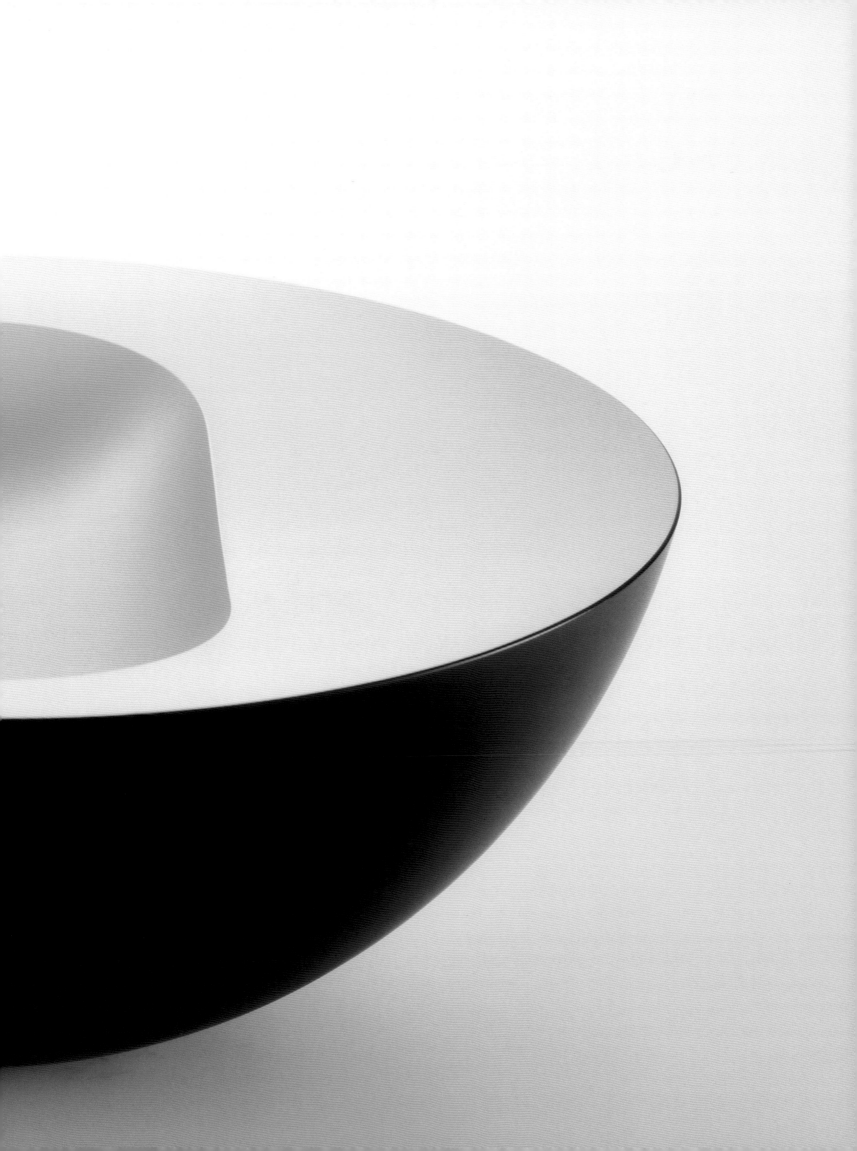

TOOTS ZYNSKY *Dreaming Chaos,* 1998
11 x 18 x 11½ in.

Passagero Nuovo Serena, 1999
10¹⁄₁₆ x 20½ x 10¼ in.

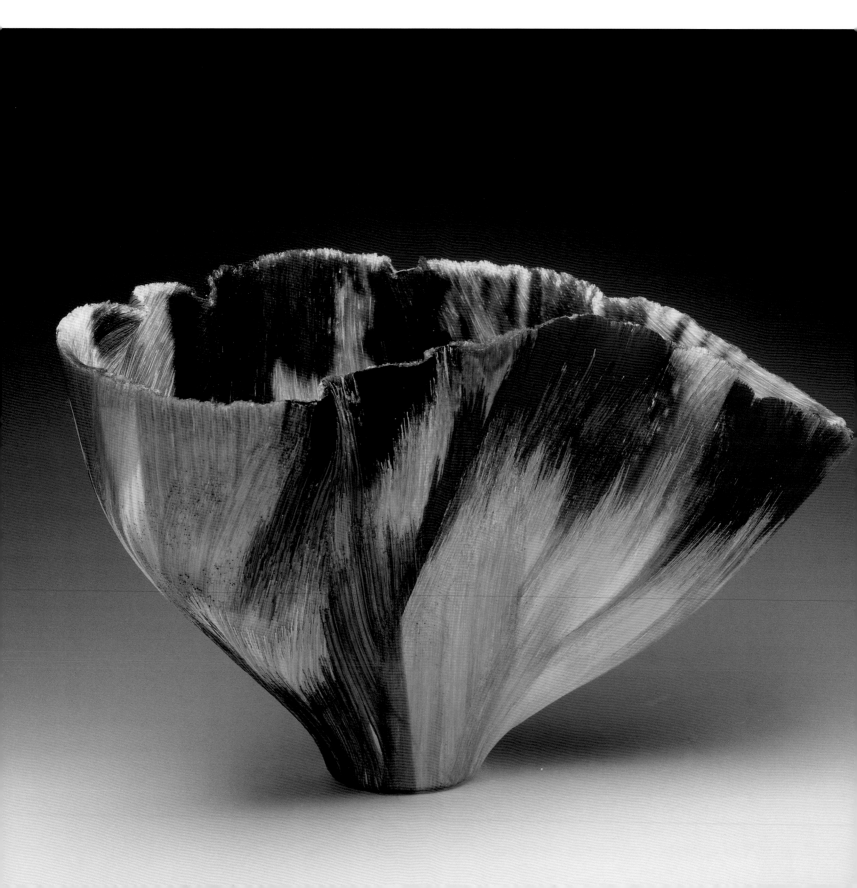

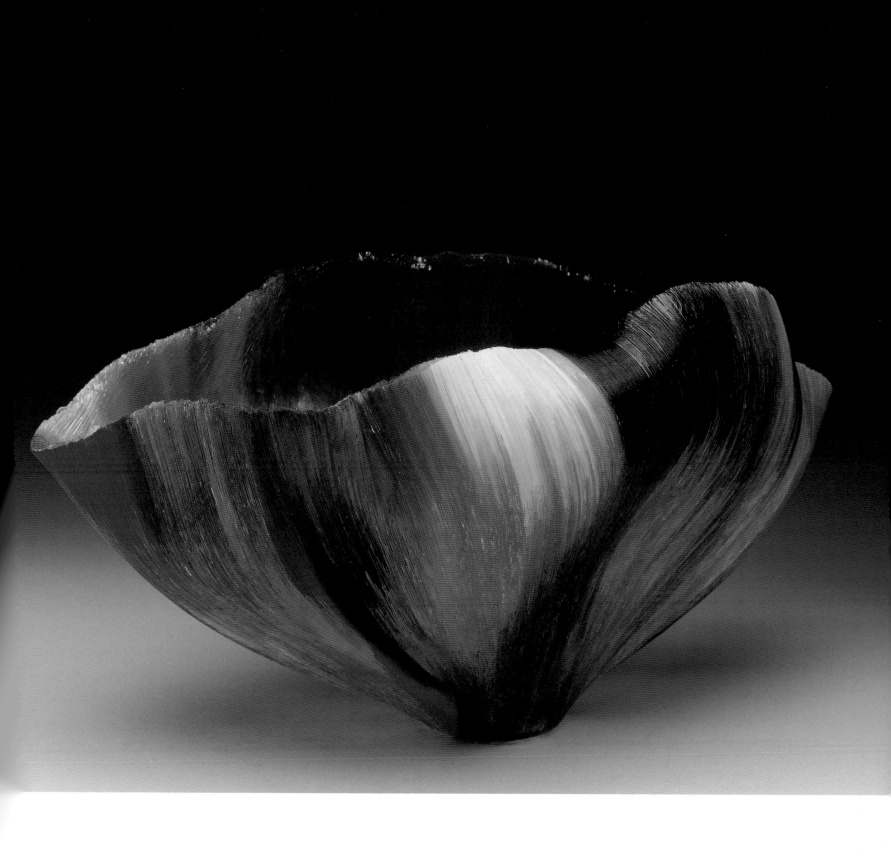

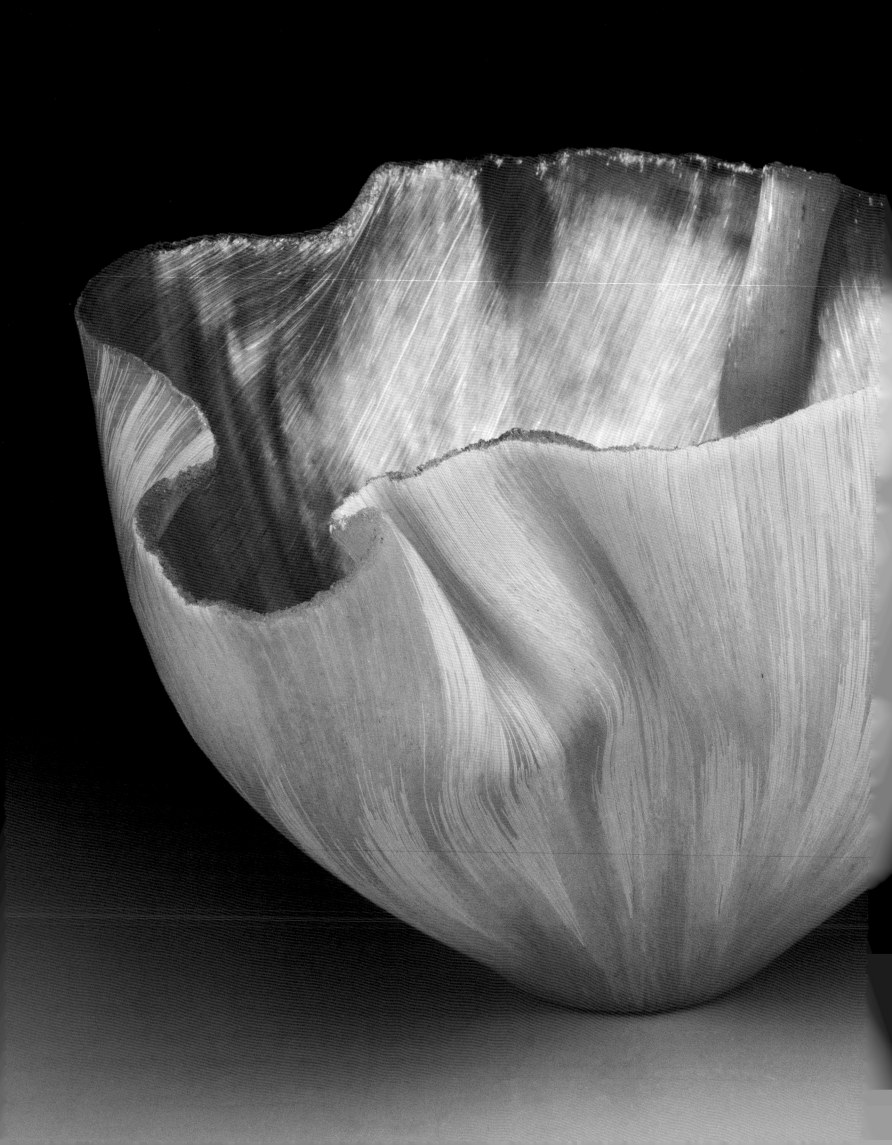

TOOTS ZYNSKY *Cantica Serena,* 2001
9¼ x 16¹⁵⁄₁₆ x 13³⁄₁₆ in.

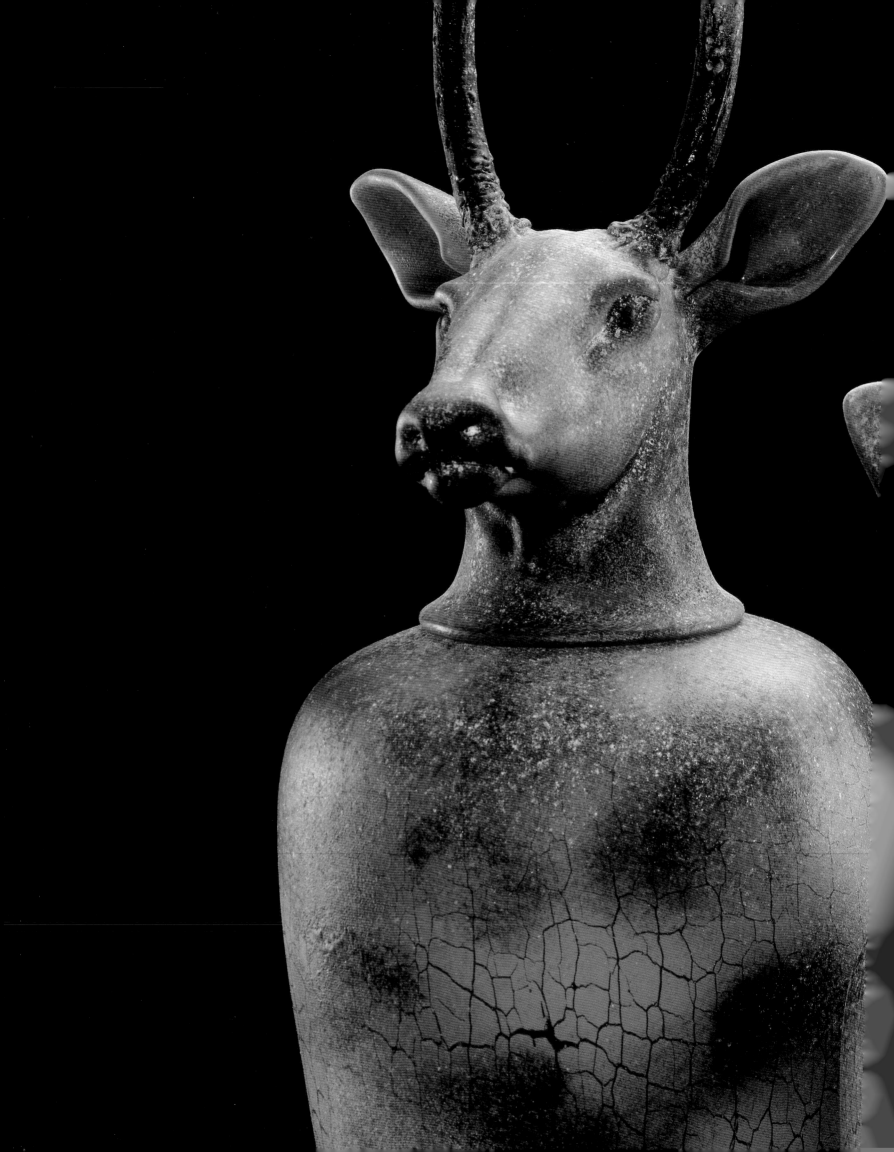

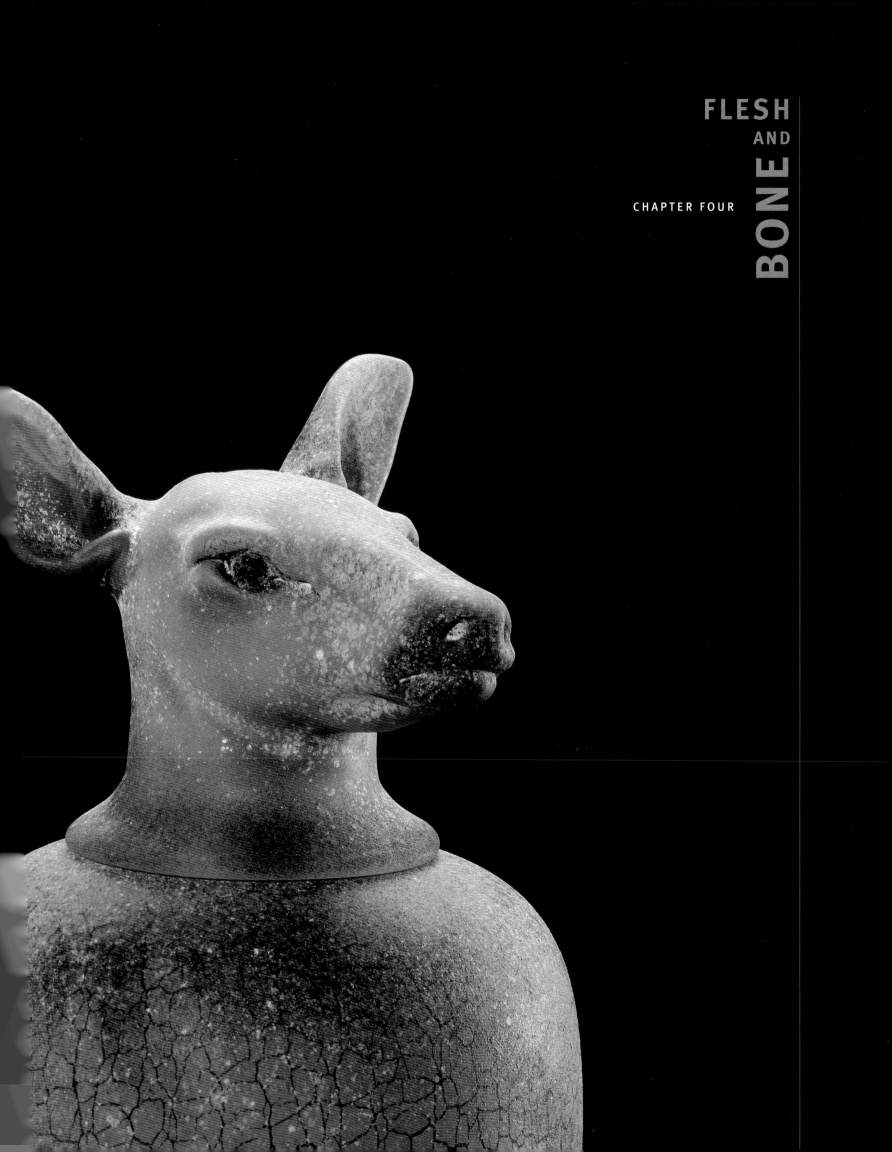

What is known is never written. . . . Speech will never stain the blue.

—Lawrence Durrell, *The Prayer-Wheel*

Human
character is an enigma. Individuals are never static; their personalities change over time. Nothing is more problematic for the historian or the artist than the interpretation of personal character and the exploration of individual passions. The problem comes down to this: how to celebrate the plurality that so enriches character while creating a stable and sharply focused portrait? You don't want puppets attached to strings, you want flesh-and-blood, vitally alive creations. Edward Gibbon summed up the struggle this way: only "reason and virtue pursue a steady uniform course, while extravagant wanderings of vice and folly are infinite."[14] Most richly developed characters contain a mixture of virtues and vices, some hidden deeply, some on flagrant public display. But how to simultaneously depict what is underneath and what is on the surface?

If Durrell was correct, and what is known can be shown but not written, then sculpture has an advantage when it comes to representing truth and temperament. And there is no better medium for exploring character both three-dimensionally and under the skin than glass, whose translucency can be precisely calibrated by the artist, allowing a variety of depths of psychic penetration.

The work of Scandinavian artist Bertil Vallien comes immediately to mind (pp. 94–97). Many of his heads and cast figures consist of a static, even bland, outer shell combined with a Y-shaped or rectangular polished "window" that provides a clear view into the interior. One head is frosted, with no facial details, but a window placed squarely where those facial features would normally be reveals a smiling face within. Sometimes the inner life is more turbulent and the portals that allow us to peer inside begin to resemble those of a fortress or a prison, holding an icy northern light within frozen outer walls. Vallien even talks about how "glass eats light." Unlike Vallien, whose work is icy, mystical, and muted (speech will never stain his blue), sculptor Hank Murta Adams makes rough, massive works that have the subtlety of a hammer: one figure has a bomb wired to his right temple, the other a bit piercing the mouth (pp. 73, 75). In contrast to Vallien's subtle interiority, Adams' approach is to create like a volcano, symbolically throwing boulders of glass out of molten interiors and using eruptions to adorn the features of his potent and all-too-real sculptures.

Sometimes you don't need the human face or a gesture to explore character. Sometimes one of the implements that form an extension of the hand or the mouth suffices to set up a story. Richard Marquis offers us three teapots and an oversized pill

(OVERLEAF)

WILLIAM MORRIS
Canopic Jars: Elk (Spike) and
Elk (Cow), both 1993
(details; see p. 86)

resting on a woven bag (pp. 84–85). They are all emblazoned with details from the American flag. The gathering of these four works was at least initially unintentional. While visiting collections in Florida, I began to realize that several collectors had acquired the artist's flag-motif teapots and other objects (all are nonfunctional), and I was drawn to the sweetness (or in one case bitterness) of this devotion to the flag. These works are not about patrioteering (cashing in on the patriotic): they were made long before September 11, 2001. Rather, I see the three teapots as commemorating sweetness and domesticity and the oversized capsule as representing the big pill of patriotism that is hard to swallow and bitter, but is medicine indeed.

Jay Musler provides us with a string of goblets suitable for toasting most of the themes in this book: they are treated as canvases for the display of Musler's uniquely abstracted color sensibility, they twist organically and seem to have grown from the same ground as the grapevine, and yet they throw down a challenge to take them up and drink from them, if you dare. Therman Statom, in his wall panel of nine playing cards (pp. 92–93) and other works, suggests that the mundane instruments of every-day life—a deck of cards, a chair, a ladder—can be made into art. And so he imitates them in glass, paints them abstractly, and generally coaxes them into becoming works of art. As critic Regina Hackett observes: "Therman Statom's glass houses are the essential metaphor for vulnerability. To protect himself from stone throwers, he has nothing to offer but his beauty, his blue scribbles of paint on the wall, his glass chunks."[15]

Bringing diverse inanimate components together and willing them to life is a specialty of Ginny Ruffner, who delights in making connections. What are we to make of a work such as *Mae Clean Floor* (p. 91)? It captures and visualizes in three dimensions the first words of a child, a moment that resonates with the artist, who had to learn to speak all over again after an automobile accident. As Ruffner has said, "Who would understand this moment better than me?" According to the collectors who commissioned the sculpture, "The letter N stands for our grandson Nicky, surrounded by children's blocks that spell out the phrase Mae Clean Floor. A vacuum symbolizes Mae, who cleans the house. Pearls symbolize the child's grandmother. The hibiscus symbolizes Florida, where we live."[16]

Several artists in this book are represented by what might be called "iconic" work: artworks that are, in the minds of collectors, quintessential or indispensable or break-through objects. Ancient Egypt inspired several of them. William Morris gives us his interpretation of canopic jars—containers that held the internal organs of the mummi-fied deceased—although he crowns his with depictions of animal heads rather than gods (p. 86). Dan Dailey has created a wall frieze, titled *Nude on the Phone,* suitable (technically if not thematically) to decorate a palace in ancient Amarna, although it

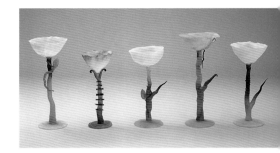

JAY MUSLER
Sinister Series, 1993
each approx. 9¼ in. high x 4¼ in. diam.

DAN DAILEY
Nude on the Phone, 1985
42 x 36 in.

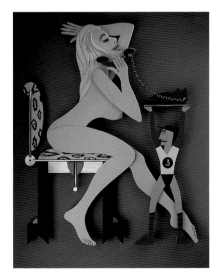

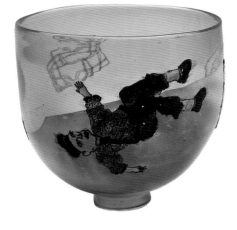

would probably be more at home in one of those Art Deco palaces described so eloquently by F. Scott Fitzgerald in *The Great Gatsby.*

Morris' *Canopic Jars* and Dailey's wall panel share a high degree of technical finesse and a very sophisticated approach to color. The canopic jars are shaped by hand from molten hot glass, with exquisitely subtle facial expressions. Dailey's work is brash, but the devil is in the details: these are extraordinarily deluxe (a word the artist favors) assemblages of glass and metal, each detail drawn by hand beforehand and then intricately cut from flat glass and arranged into a mosaic that springs to life as flesh and blood. Unlike most studio glass artists, who emphasize a high-gloss sheen, Morris prefers a muted, smoky, and matte palette. And Dailey, rather than applying color in thin veils, uses sheets of glass in which rich, solid color permeates to the very edges. The masterful attention to detail endows these works with an integrity that commands instant respect. As Dailey says, "Beauty is in the making."

The innovative works of Joey Kirkpatrick and Flora Mace were highly unusual, and unlike anything in the history of glassmaking, when they were created in the 1980s, and they remain unparalleled in 2003. The figures that adorn their vessels are made from wire drawings that have been filled in with transparent glass, as if they were stained-glass window panes (pp. 80–81). It is as if each figure, made from wire twisted into shape and animated by the artist, had magically absorbed the lifeblood of color into its skeleton. Rarely have metal and glass been so skillfully and effectively melded together.

But is it possible to improve on flesh and bone? Isn't that the unspoken desire at the heart of realism in art? If art is capable of capturing the character locked inside flesh and bone, can it then dissect character and transcend its frailties? And should such uncharted territory, marked on antique maps simply by "Here be monsters," even be explored?

Two artists contribute concluding thoughts to this arena. Nicolas Africano (pp. 76–77) and Janusz Walentynowicz (pp. 99–101) both show us mysterious women posed in classical form: silent, isolated, meditative perhaps. Glass is used here to blur and obfuscate rather than to focus and clarify, but it is also used to reflect, literally and symbolically. We live in an era when animate humans are merging with inanimate devices even as inorganic objects are on the verge of coming to life. These two artists understand the modern condition where flesh and bone converge with transparent media such as glass and cyberspace, and art converges with life.

HANK MURTA ADAMS *Birdie,* 1996
33½ x 15 x 12 in.

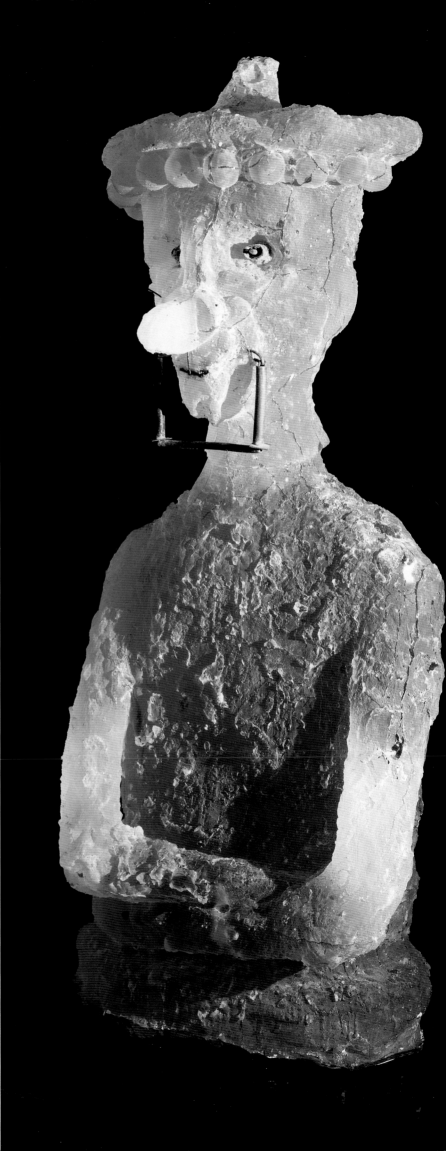

"Adams' approach is to create like a volcano, symbolically throwing boulders of glass out of molten interiors and using eruptions to adorn the features of his potent and all-too-real sculptures."

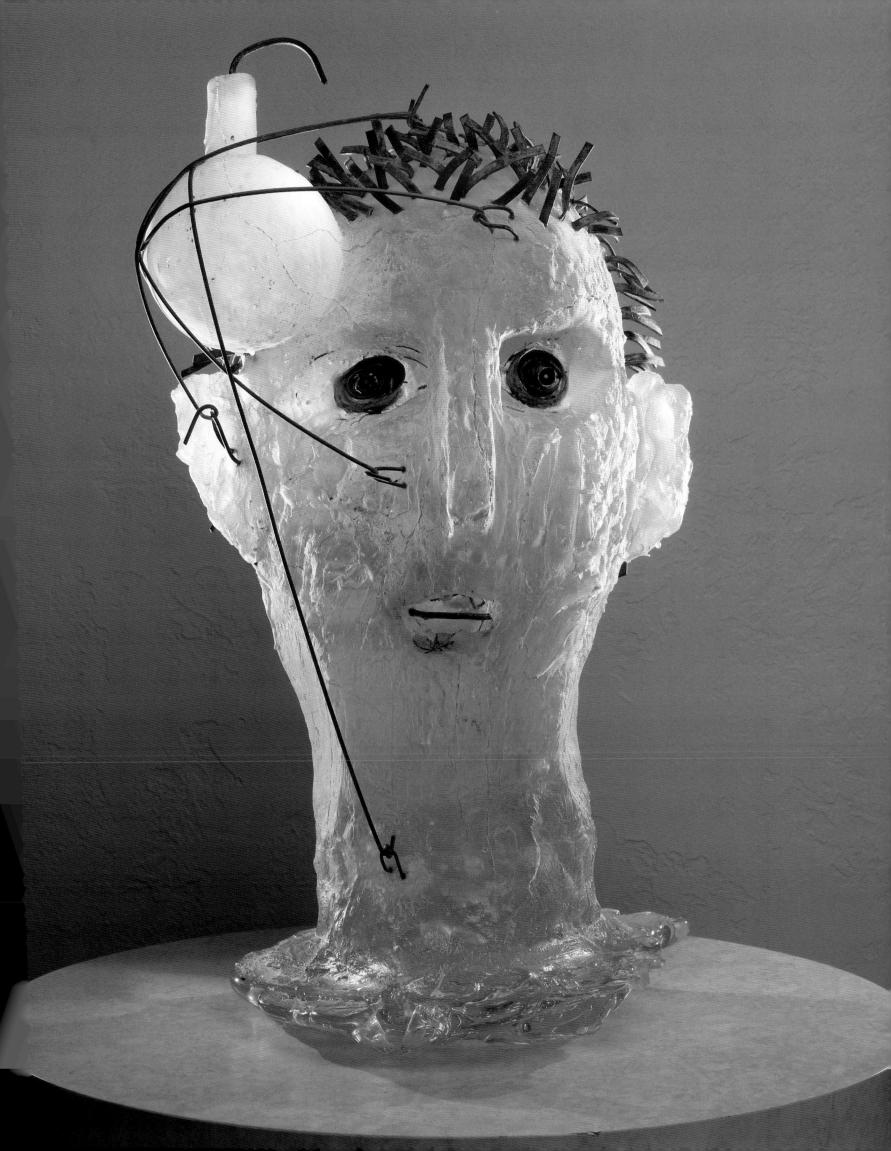

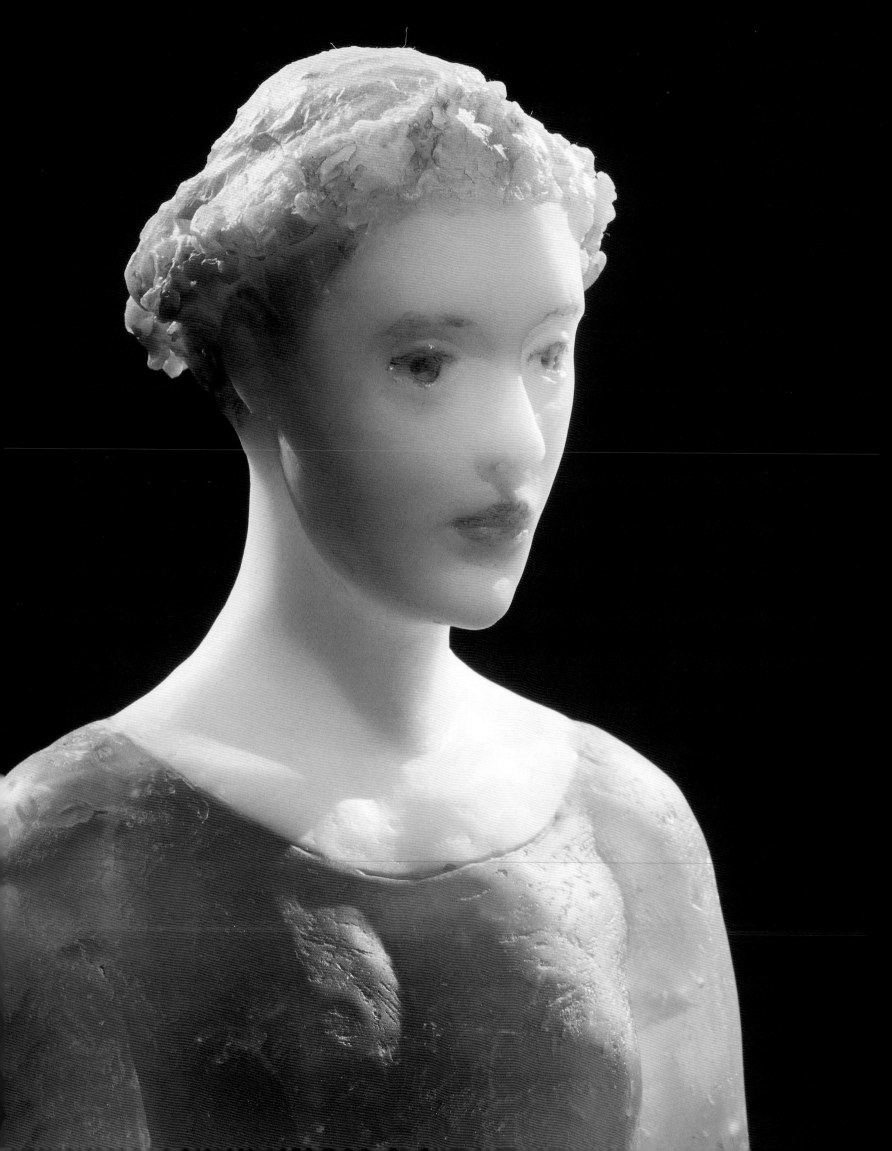

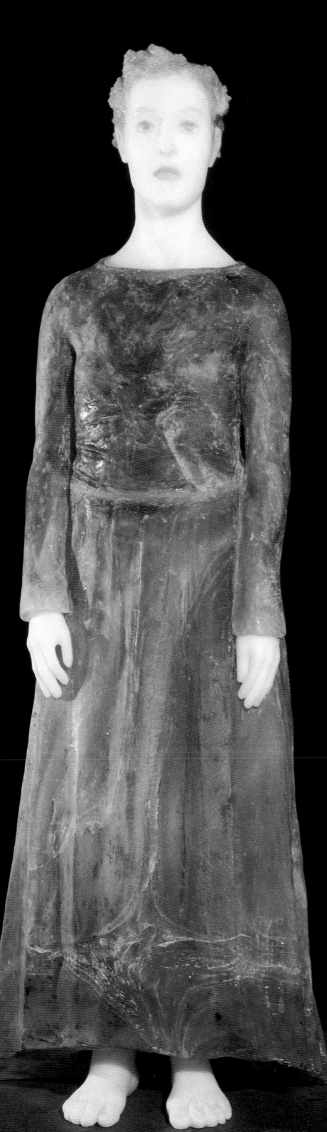

NICOLAS AFRICANO *Patience* (rose dress), 1999
(detail; see p. 72)

Untitled (rose skirt and shirt), 2000
42 x 14 x 10 in.

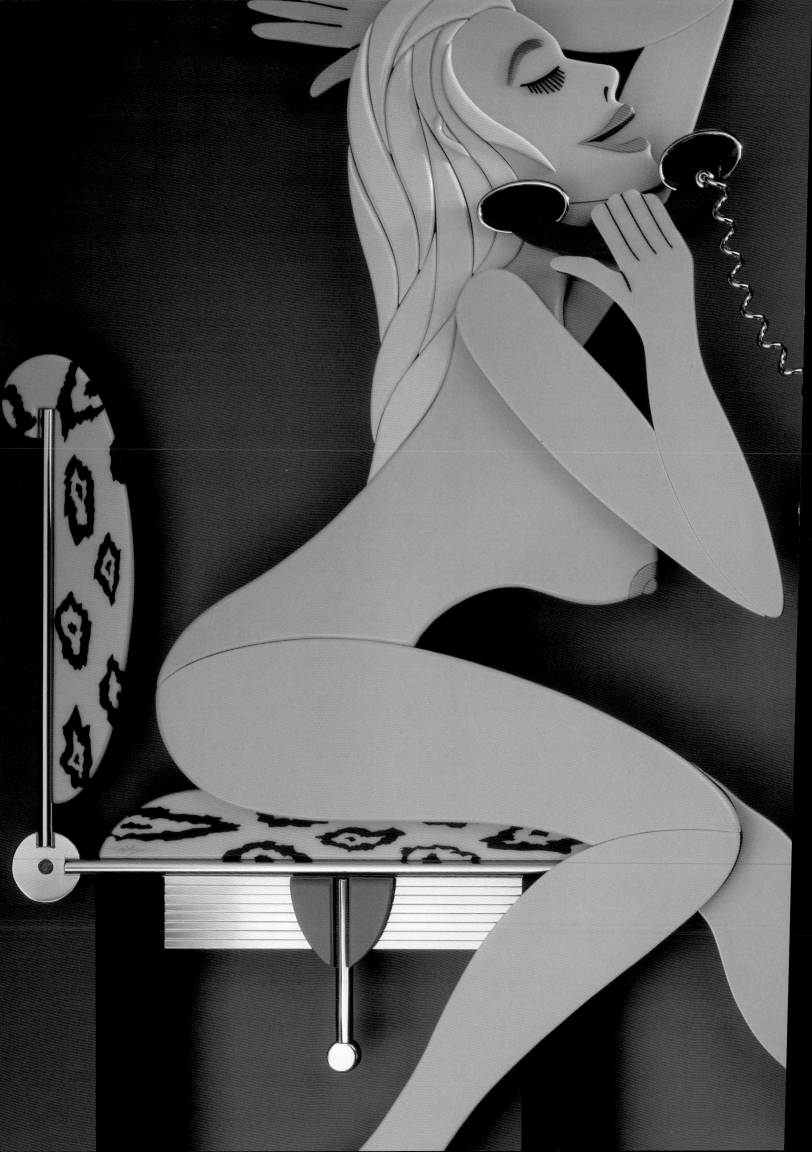

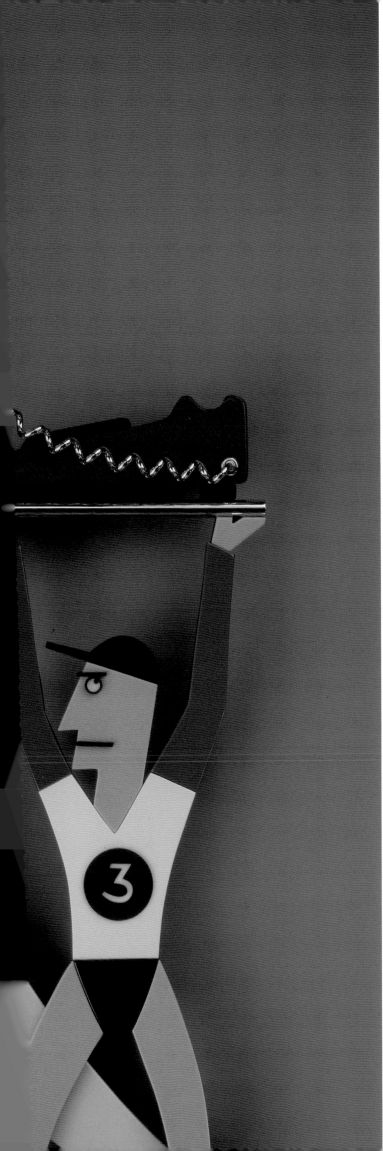

DAN DAILEY *Nude on the Phone*, 1985
(detail; see p. 71)

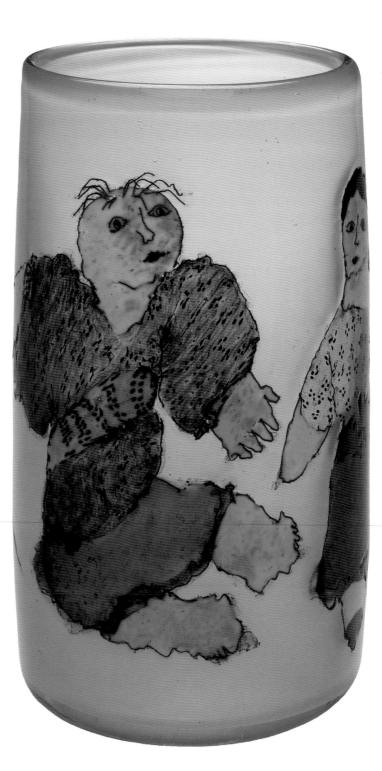

JOEY KIRKPATRICK AND FLORA MACE *The Conversation,* 1983
11¾ in. high x 6½ in. diam.

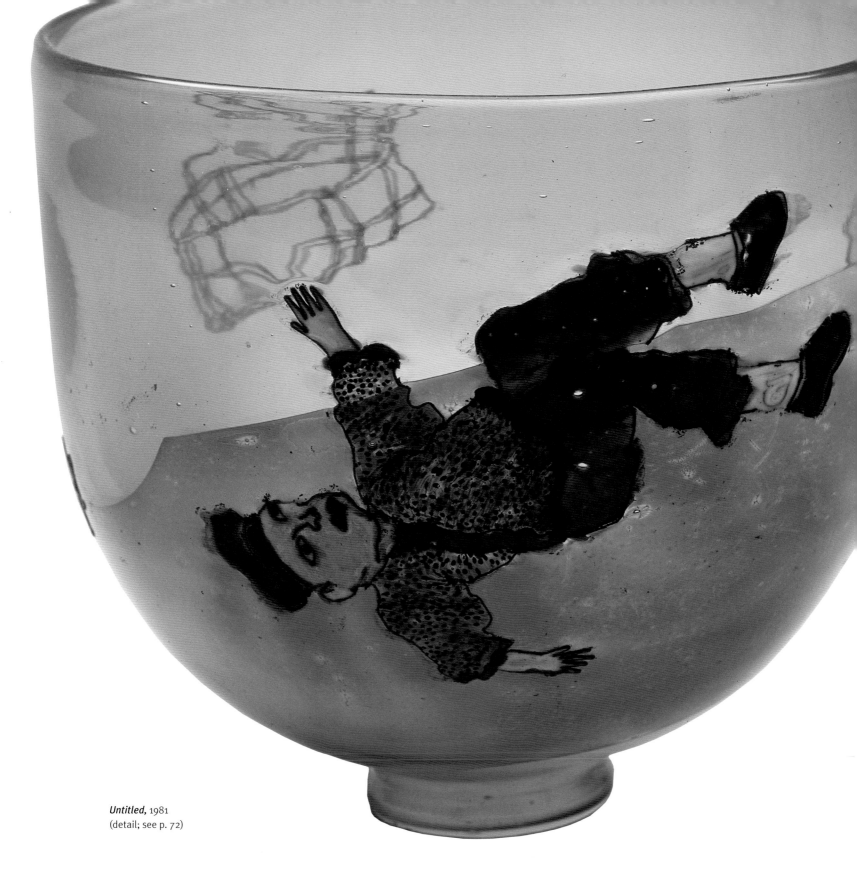

Untitled, 1981
(detail; see p. 72)

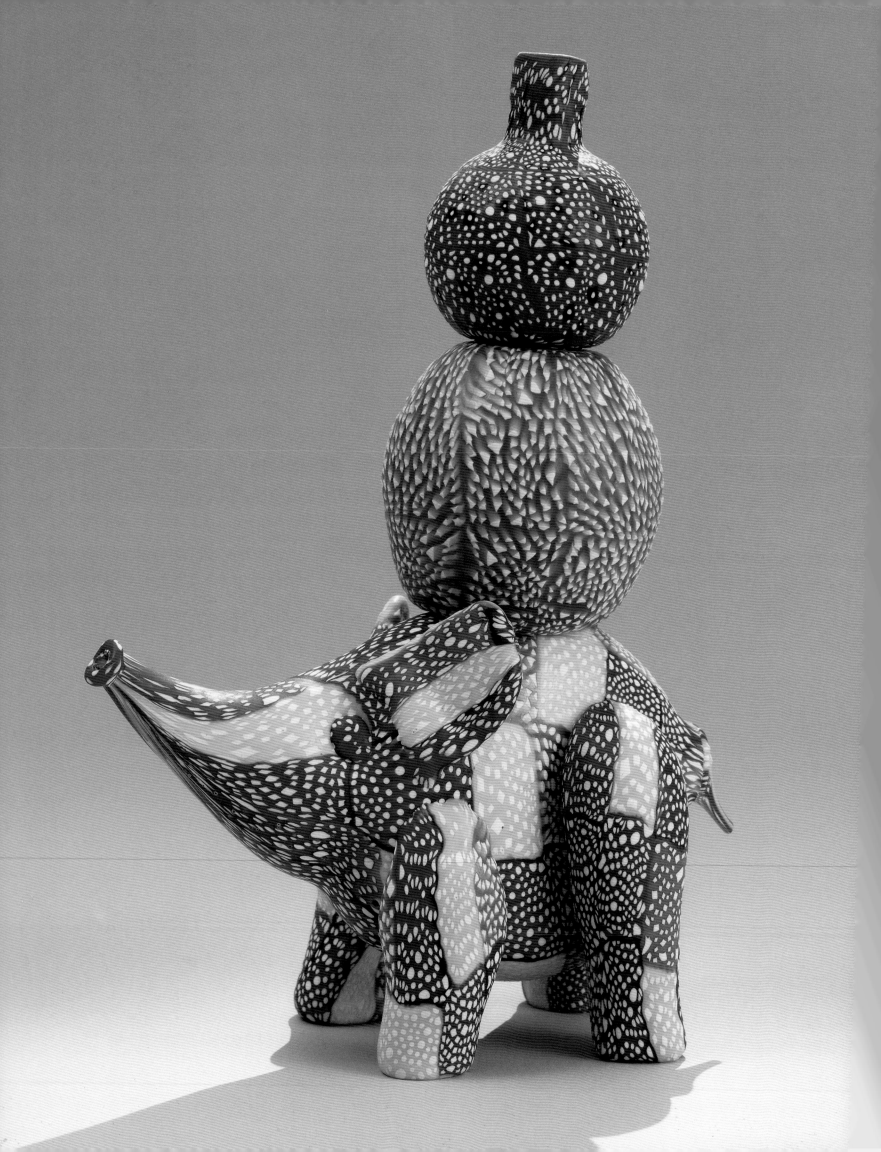

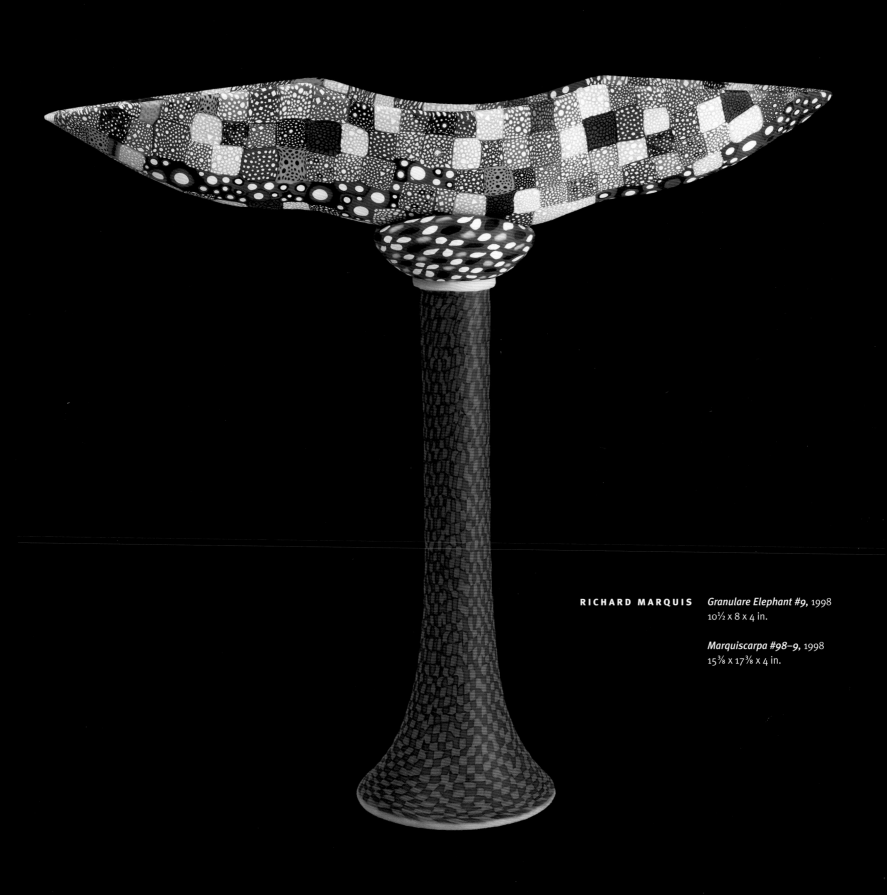

RICHARD MARQUIS *Granulare Elephant #9,* 1998
10½ x 8 x 4 in.

Marquiscarpa #98–9, 1998
15⅜ x 17⅜ x 4 in.

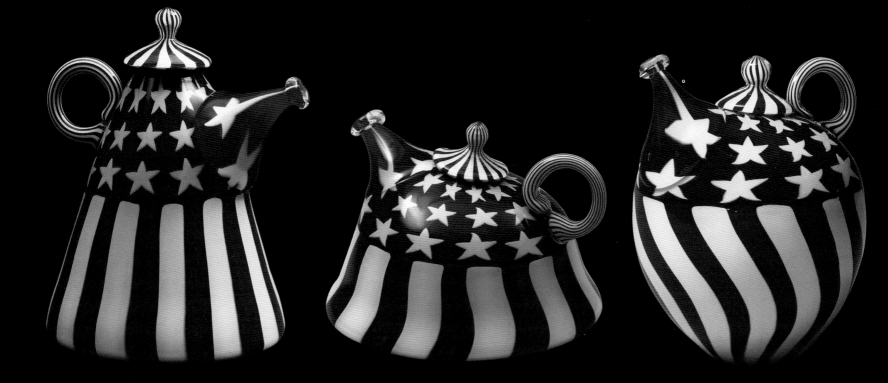

RICHARD MARQUIS

Retro Stuff: Stars and Stripes Teapot, 1997
6 x 5¾ x 5 in.

Stars and Stripes Teapot #12, 1997
4⅛ in. high x 6 in. diam.

Stars and Stripes, 1997
6 x 5¾ x 5 in.

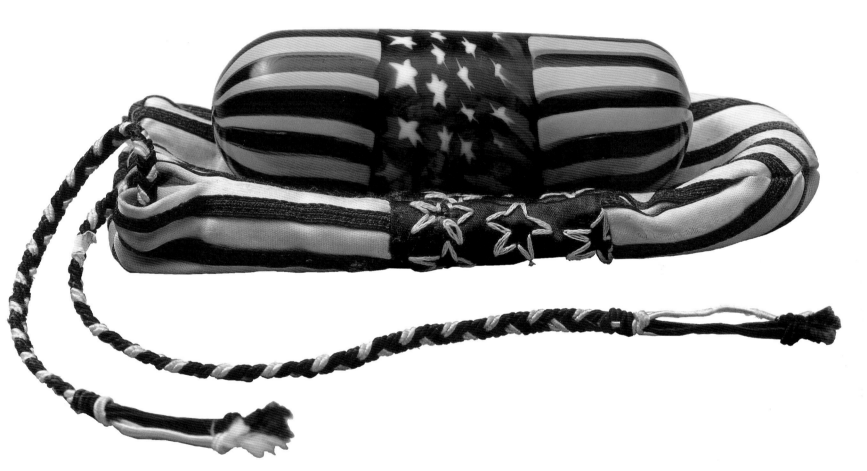

*American Acid Capsule with Cloth
Container,* 1969–70
4 in. wide x 1¼ in. diam.

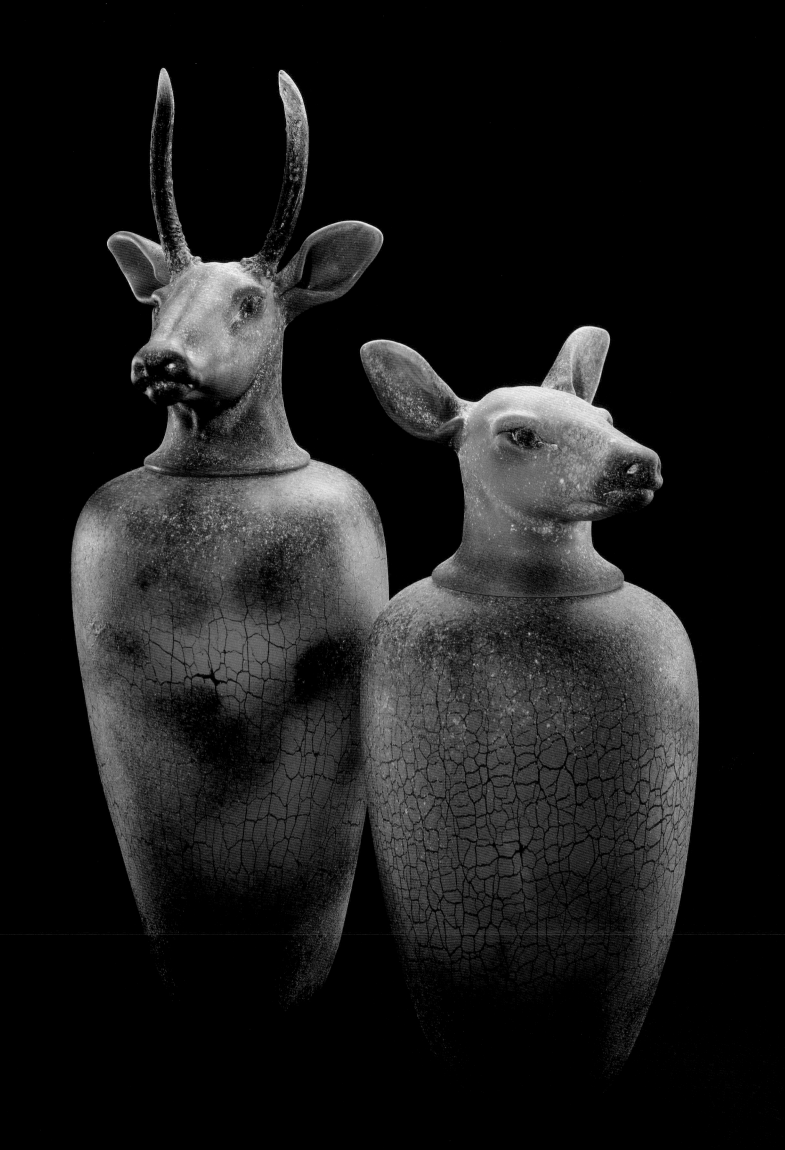

"Wouldn't you love to find *something like this?"*

—William Morris

WILLIAM MORRIS *Canopic Jars: Elk (Spike)* and
Elk (Cow), both 1993
Spike: 35½ in. high x 14¼ in. diam.
Cow: 30½ in. high x 12 in. diam.

(OVERLEAF)
JAY MUSLER *Sinister Series,* 1993
(detail; see p. 71)

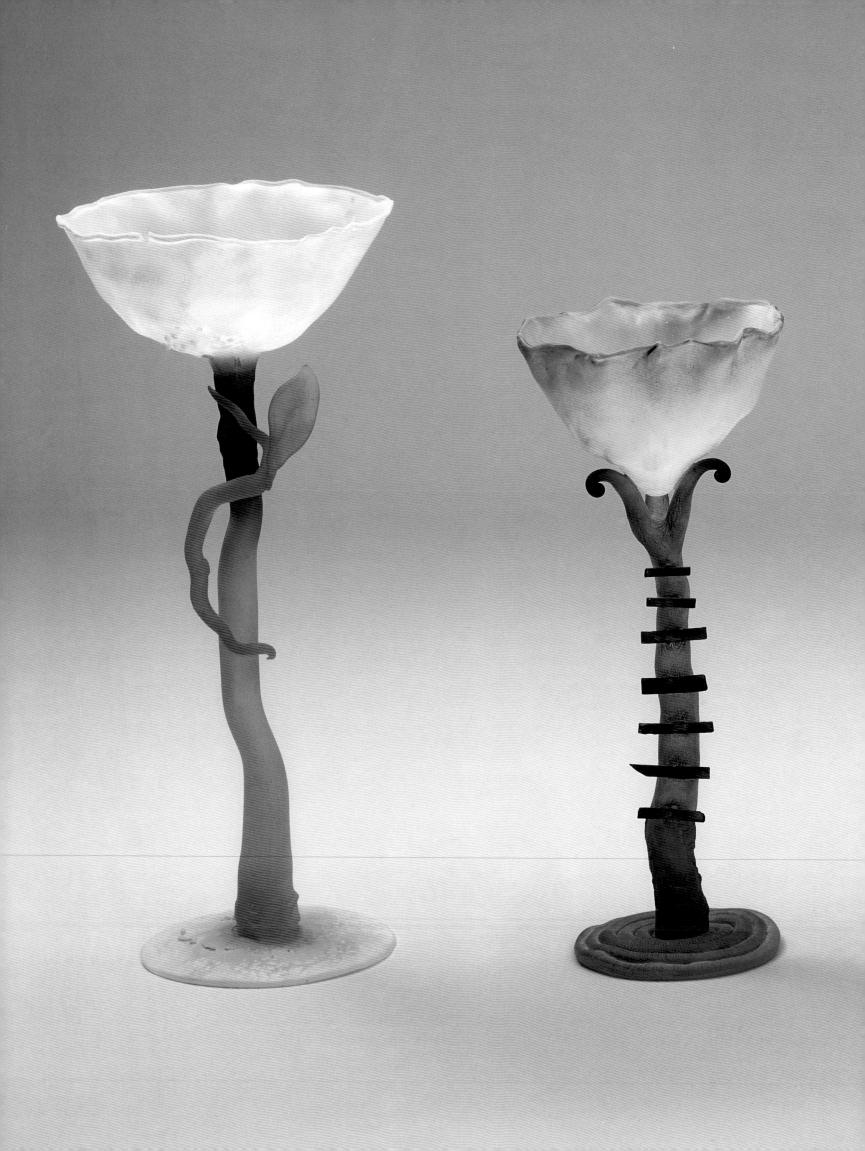

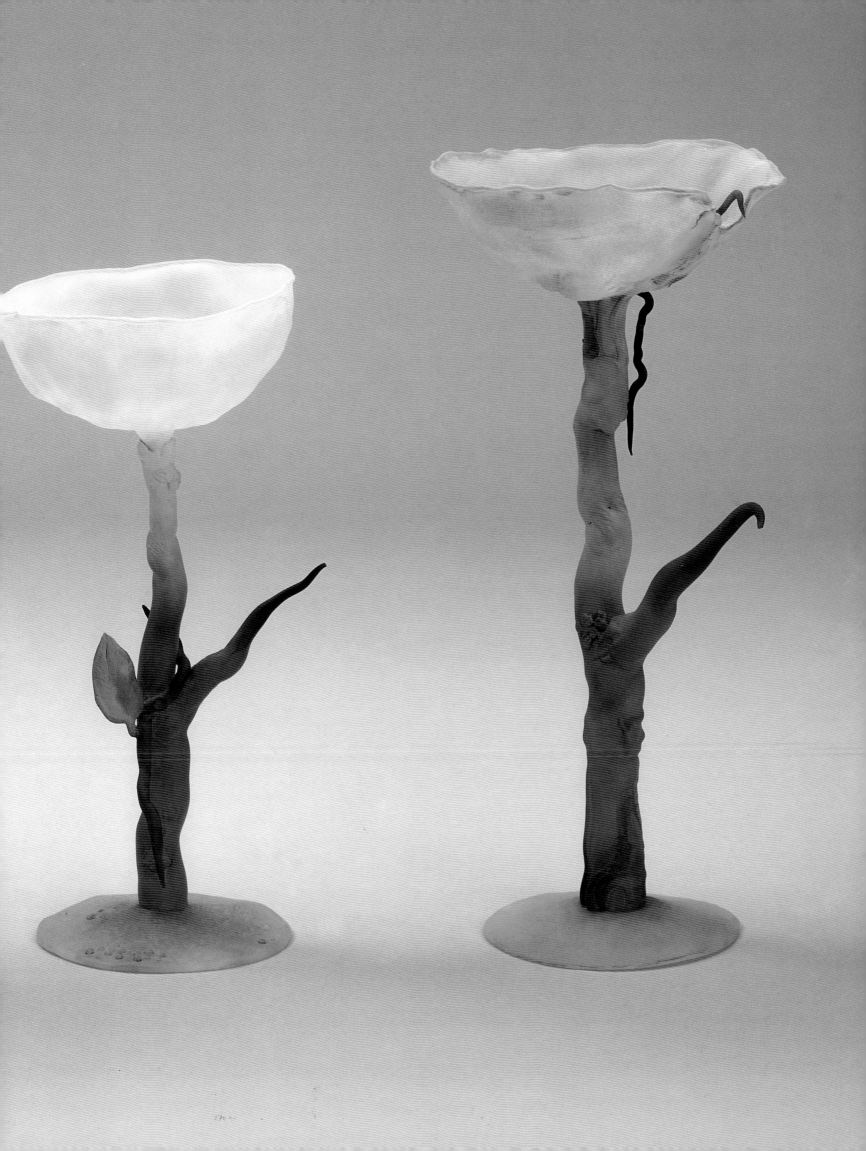

GINNY RUFFNER *Norton Palm Trees,* 1997
17 x 21 x 16 in.

The Drive-In of My Motivations, 1989
13 x 23 x 8 in.

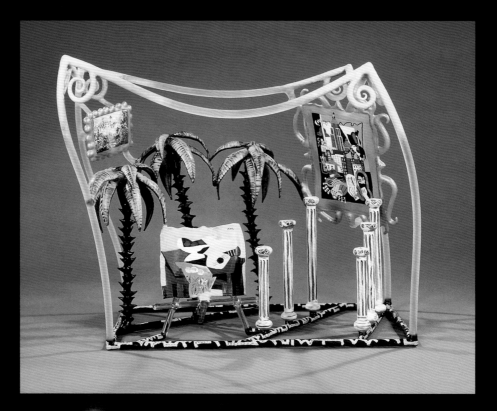

Mae Clean Floor, 1996
15 x 18 x 7 in.

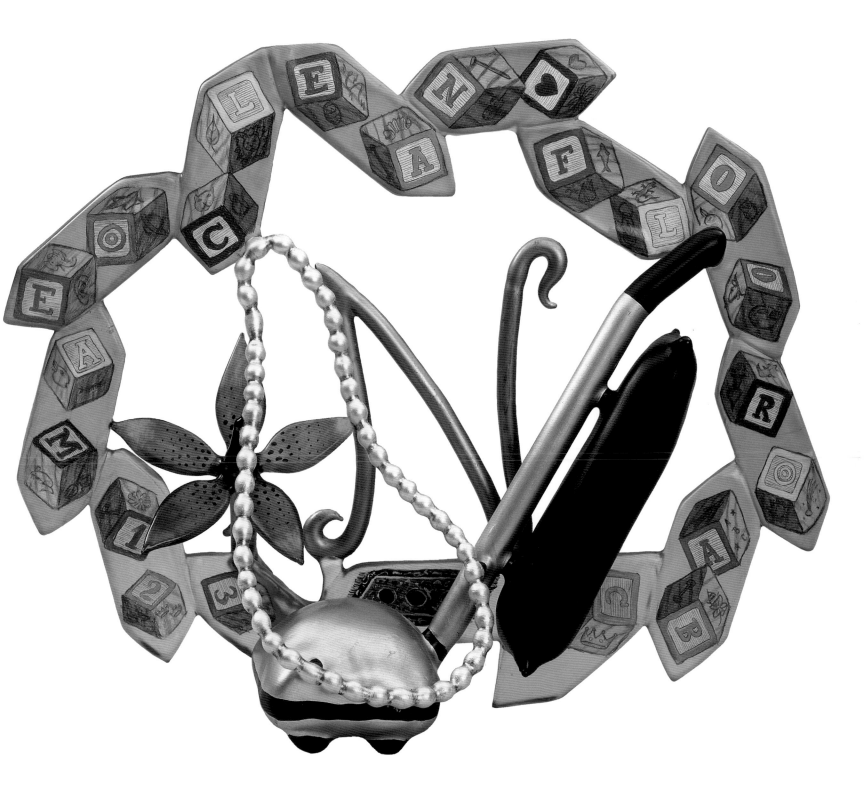

BERTIL VALLIEN *Untitled,* 1993
79 x 13½ x 13½ in.

Head 4ACM #979254, 1997
8⅛ in. high x 4½ in. diam.

(PAGE 96)
Head 28ACM #979273, 1997
8⅛ in. high x 4⅛ in. diam.

(PAGE 97)
Head 38ACM #969254, 1997
8 in. high x 4¾ in. diam.

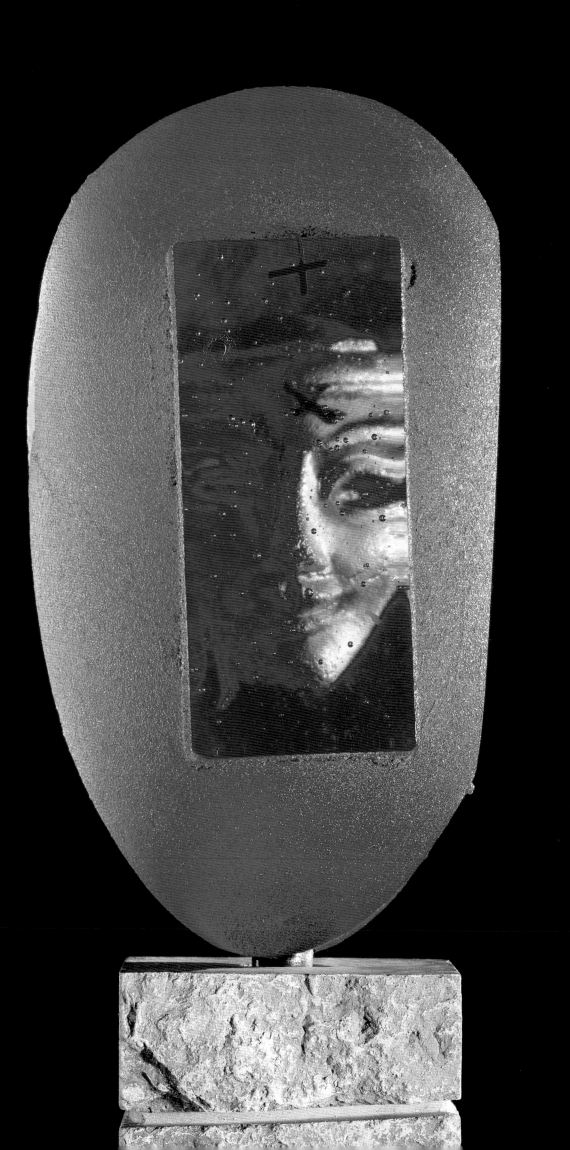

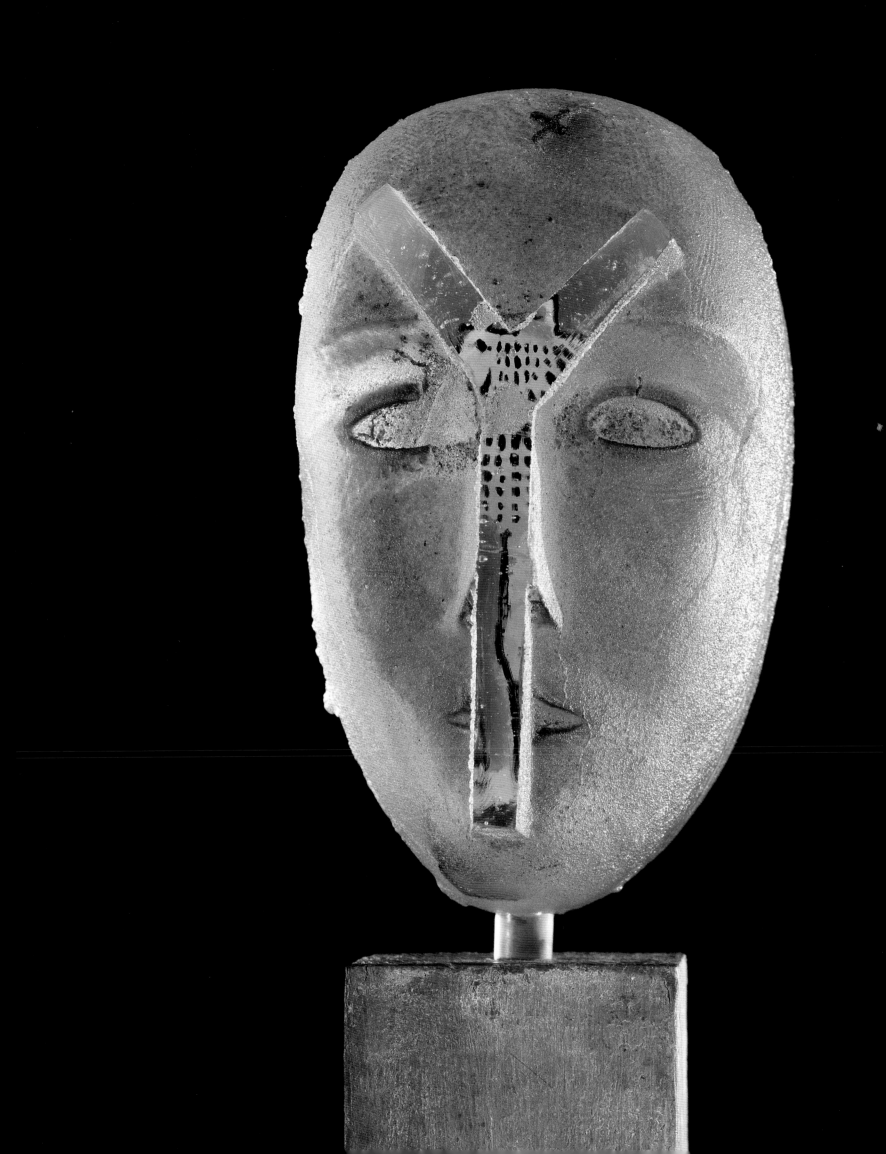

JANUSZ WALENTYNOWICZ *Crossing,* 2000
40 x 14 x 4 in.
(front view)

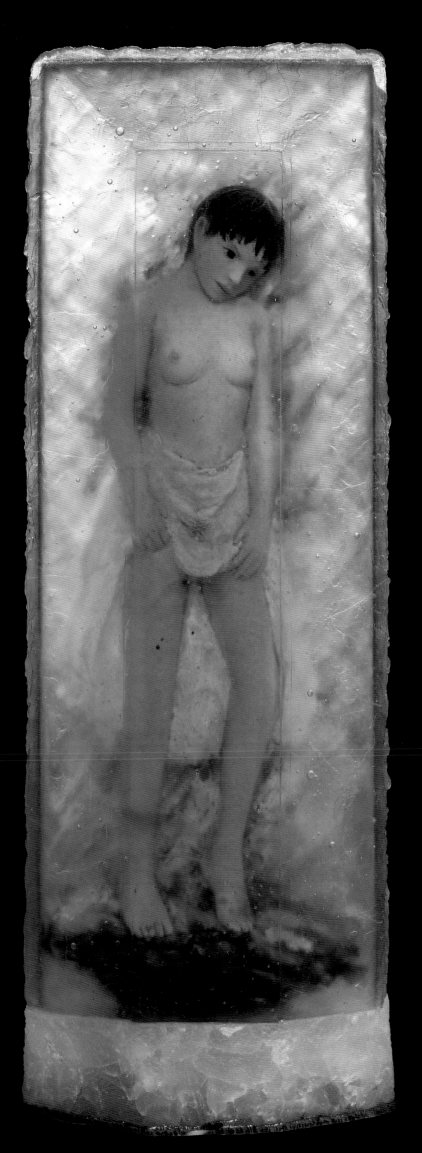

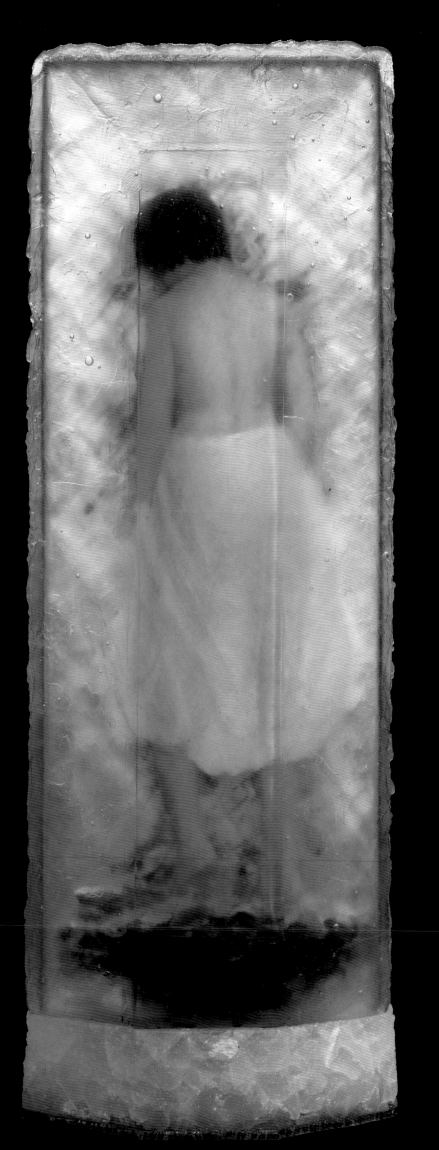

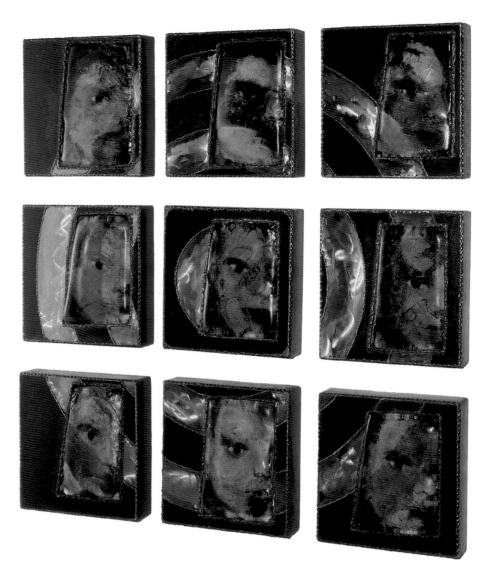

JANUSZ WALENTYNOWICZ

Crossing, 2000
40 x 14 x 4 in.
(back view)

Target, 1997
35½ x 35½ in.

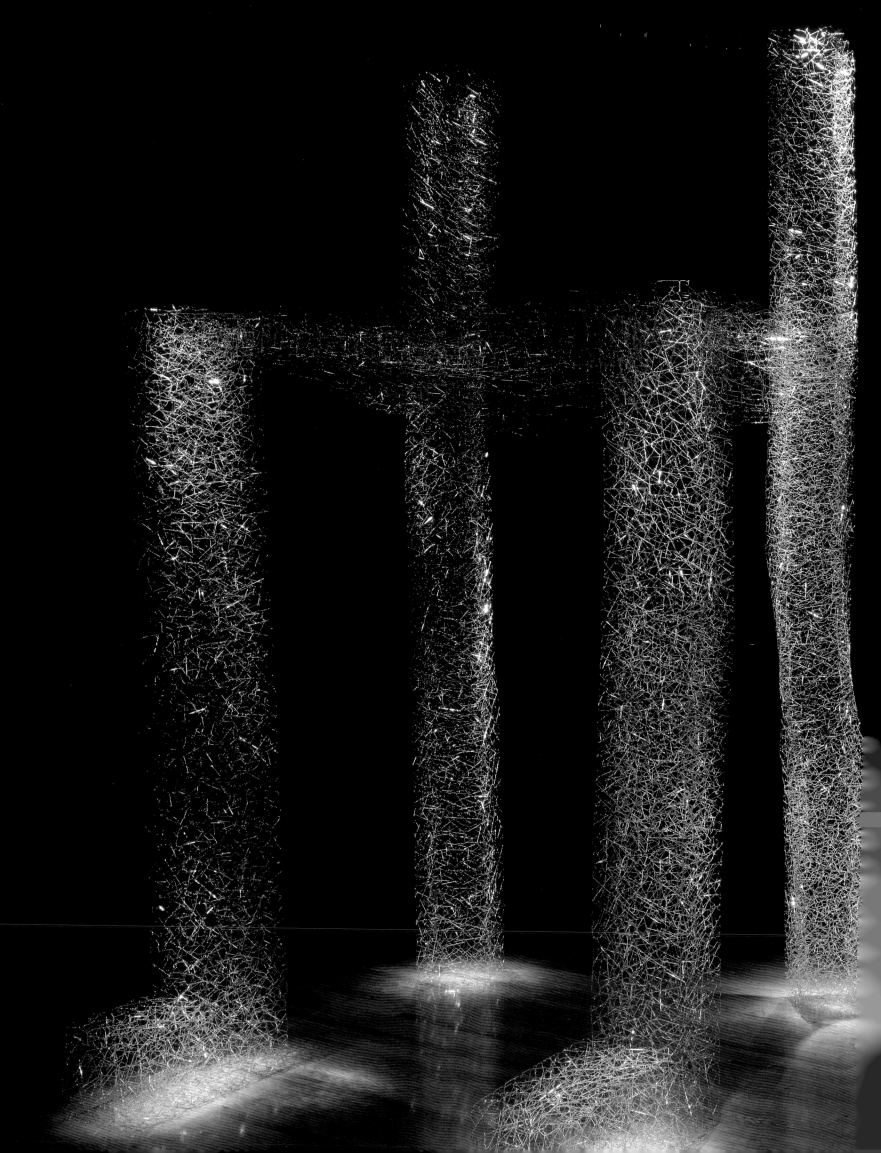

STAGECRAFT

All the world's a stage, and all the artists actors. Since Shakespeare, and more recently Jackson Pollock, this observation has become cliché. Glass lends itself to theatricality quite naturally and comfortably; after all, what could be more dramatic than the erupting volcano that made a cameo appearance in our first chapter as the earliest glass furnace? And the glassblowing studio—the stage upon which much studio glass is made—represents a sort of chamber theater that has all the warmth and intimacy generated by a communal campfire around which stories are told. Like actors or playwrights, the artists in this section take us into the realm of the theatrical as they carry glass into citadels, mount sculptures over canals, attach neon masts to cars and drive them around salt flats out West, re-create medieval stained-glass traditions, and replace pillars of stone with pillars of knitted glass.

Going back to ancient Egypt, where glassmaking emerged to answer the royal need for brilliantly colored, precious materials that reinforced status and signaled the presence of the pharaoh and his entourage, artists using glass scripted their "performances" for the maximum pleasure of their patrons and audiences. And throughout history, glass works have reflected the high drama of pleasure and politics, mystery and intrigue, of the palaces and cathedrals that housed the chief patrons for such works. If there is a unity to the approach of the four artists discussed in this chapter, it is a desire to activate an atmosphere that will bathe the audience in color and light, to give us actual physical access to mysterious and mesmerizing spaces that have more in common with the spirit of the great medieval cathedrals than with the art and atmosphere of the modern era. Some artists using glass today have styles anchored more deeply than the twentieth century, when academic theory took over as the major driving force of avant-garde painting and sculpture, sending them off on a trajectory that has since oscillated between the poles of Picasso and Duchamp—between formal cubism and intellectual conceptualism—and on to ever more esoteric aesthetic styles that are increasingly divorced from the spirit of object making.

It is crucial to remember, however, that the artist working with glass has always had to trek back to his or her rough, industrial studio, where the brilliant ideas discussed at court (or in academia or in the Chelsea galleries or in the art press) had to be sweated out if they were ever to be realized as art. This intimate connection with manual labor has, more than anything else, separated the artist using glass (or bronze or steel) from the painter, the writer, and now the video or Internet artist. And this gritty world of industriousness, of the physical act of building, is what forms the muscular structure of glassmaking as theater.

Against this backdrop, the artists discussed here recapitulate the subjects of the previous chapters: naturalism is represented by Fred Tschida and Dale Chihuly; abstraction by Anna Skibska and, again, Chihuly; and realism by Judith Schaechter. All of these artists are adept at working in glass and equally fluent in the ways of drama.

(OVERLEAF)

ANNA SKIBSKA
Sit down, please, 2001
Glass, 12½ x 8¼ x 6¾ ft.
Courtesy Seattle Art Museum
Photo: Paul Macapia

Dale Chihuly is a powerful artist whose blockbuster exhibitions are so well attended (more than a million people for one show in Jerusalem) that they border on inciting a popular art rebellion. Chihuly is about the amplification of all things, including his art, and he is not afraid to use some high drama or low theater to achieve those ends (pp. 108–9). As the late Henry Geldzahler, curator at the Metropolitan Museum of Art, wrote, "Chihuly challenges taste by not being concerned with it. His sole concerns are color, drawing, and form. He does go over the top at times, with pieces about which people say, 'This is really too much,' but perhaps not. Five or ten years later, it's no longer too much."[17] Witness some examples of Chihuly's intensification: the sculptures he mounted over the canals of Venice and in the Doge's Palace in 1996; the forty-eight-foot-tall *Blue Tower* (a remarkable color-field sculpture as well as a monument to gigantism in glass) that he erected within the ancient Citadel of Jerusalem in 1999–2000; and the highly theatrical Persian and Seaform installations, including the 2000 ceiling at the Bellagio Resort in Las Vegas. The Seaform ceiling Chihuly has created for the Norton Museum's new wing is intended to engulf the space—and the viewer with it—like the climactic scene in an opera. All of Chihuly's works throw down the gauntlet, challenging mere paint to compete with ambidextrous glass. Whereas paint is dry and flaky and *requires* beige canvas in a supporting role, glass is ever liquid, self-supporting, supremely and mesmerizingly colorful, and triumphant in spite of its resounding fragility—or at least that is the script Chihuly has so masterfully composed for the medium he loves so very much.

Incessant escalation can lead to gigantism and collapse, both in art and in opera. Chihuly's genius has been to establish a rhythm to his approach. Like the ocean tides, his art waxes and wanes in scale. He delights in the large and the small, reminding us that intensification can mean miniaturization, in which broad and sweeping artistic effects are distilled and made precious, as in the ceilings that are built up from hundreds of small components.

Anna Skibska takes this approach to heart, knitting together many small glass parts into powerful structures (pp. 114–15). She creates drawings suspended in space, joining the finite to the infinite and suggesting the ethereal architecture of tornadoes. For Skibska, glass supersedes stone as the ideal substance for suggesting architecture. When Skibska arrived in the United States from her native Poland, she saw Manhattan as a mountain of crystal and thought of America as one big stage set where "unreality defines America's originality, where we see everyday life reflected in buildings. But when the buildings are lost in the clouds, it is as if God is holding a mirror to the sky."[18] Skibska's observation reminds me of Nabokov's dictum that "the glory of god is to hide a thing and the glory of man is to find it." Our tall, glass-clad buildings "find" the face of the sky for pedestrians too busy to look directly up; Skibska seeks to reflect the essence of this proposition in her work, in which she knits

molten glass into solid things that are simultaneously clouds and architecture, mirror and mirrored.

Fred Tschida takes neon into natural and urban settings where unexpected juxtapositions create dramatic effects. In 1975 he harnessed 180 feet of neon and with twenty-eight friends in tow carried the glowing line of light four miles, passing over the Mississippi River and attracting crowds in a surreal action worthy of *The X-Files*. At the Bonneville Salt Flats in Utah, in 1980, Tschida mounted a twenty-two-foot-tall neon column atop his car because he "wanted to make light drawings, to create spaces while driving using the car as a moving platform for that vertical tube, so I could make planes of light in space, ribbons of light, walls of light."[19] According to Tschida, who studied with Chihuly, "My work is a series of experiments—research focused on isolating light phenomenon in everyday experience." Many of his creations involve neon-glass tubes filled with a gas that glows when an electrical current is passed through it. We are accustomed to common neon signs flashing from storefronts and motels. For the Norton Museum, Tschida has created a work inspired in part by the two pieces illustrated in this book (pp. 116–17): he creates an atmosphere of light by suspending many neon elements, each of which becomes a light projector. This cloud of light is intended to subtly overwhelm the space and us, but also to respond to our presence. Motion remains important to Tschida, and the elements of the neon cloud will tremble ever so slightly on the fluctuating thermals created by the shifting crowds of visitors.

Judith Schaechter gives us clotted, claustrophobic compositions in painted stained glass, with dark, gothic details that are "cured" by the lovely execution and refreshed by the light that streams in from behind and vivifies them (pp. 110–13). Light and subject matter—narrative—come precisely together in *Bigtop Flophouse Bedspins* (selected for the Whitney Biennial in 2001), which presents a world shrouded in a carnival atmosphere, with cartoony animals and a clown exhaling a sigh. The work is part indulgent nostalgia, part unbridled fantasy à la Hieronymus Bosch. Regarding her themes, Schaechter says: "I think I'm a fairly normal human specimen. My main interests are sex and death, with romance and violence the obvious runners-up."[20]

Answering Beauty

> And so each venture /Is a new beginning, a raid on the inarticulate /With shabby
> equipment always deteriorating /In the general mess of imprecision of feeling, /
> Undisciplined squads of emotion. /And what there is to conquer /By strength and
> submission, has already been discovered /Once or twice, or several times, by men
> whom one cannot hope /To emulate—but there is no competition— /There is only
> the fight to recover what has been lost /And found and lost again and again: and
> now, under conditions /That seem unpropitious. /But perhaps neither gain nor
> loss. /For us, there is only the trying. /The rest is not our business.
>
> —T. S. Eliot, "East Coker"

Glass is an optimistic and buoyant art. It amplifies color and light. It occupies a space in between the two states of liquid and solid, like dolphins jumping between water and air. Glassmakers themselves are often optimists, perhaps because glass-making is primarily a team activity in which enthusiasm is a virtue and there is always room to share new knowledge or help someone in the blowing of an especially difficult bubble of glass. The pleasure derived from this sense of community has spilled over to those collecting the new medium and is one of the main reasons that glass works diverged from the art world in general. And, of course, it has been a main source of criticism. Glass was seen as too brash, too beautiful, too well crafted, and ultimately too empty, much as one critic recently described the 007 movie series: "a creature of immaculate exterior and no core, and thus an ideal vessel of the fantastic."[21]

As if in answer to these excesses of spectacle and beauty, a trend developed to make glass as ugly as possible, as if that alone could lend the work artistic credibility and enable it to avoid the label of "kitsch." But there is ugly kitsch as well as cute kitsch. And glass is a stubborn medium. The beauty that the ancient Egyptians so admired kept asserting its birthright. It is a thesis of this book that over time artists have come to reconcile themselves with the realities and the limits of glass as a medium for art: it is very physical and very good-looking and it *has a history*. The works in this book represent the tangible assets of this struggle to recover the past, and they might just add a bit of spin to the verses by T. S. Eliot quoted above: that in the fight to recover what has been lost and found and lost again, the raid on the inar-ticulate can transform unpropitious conditions into works of art.

Notes

1. The critic Herbert Muschamp has been exploring the effects of desire and aggression in architecture in the pages of the *New York Times* since 2001.

2. Literally, "Ennion made [it]."

3. Donald B. Harden, *The Glass of the Caesars,* exh. cat. (Milan: Olivetti, 1987), p. 2.

4. For an overview of these and other developments, see the Selected Chronological Bibliography of Contemporary Glass on page 123.

5. Brian Boyd and Robert Michael Pyle, eds., *Nabokov's Butterflies: Unpublished and Uncollected Writings* (Boston: Beacon Press, 2000), p. 20. The quote is from Nabokov's "Bend Sinister."

6. D'Arcy Thompson, *On Growth and Form* (1917; reprint, Cambridge: Cambridge University Press, 1966), p. 287.

7. Clement Greenberg, *Homemade Aesthetics* (Oxford: Oxford University Press, 1999), p. 85.

8. Interview with the author, August 2002.

9. Conversation with the author, summer 2002.

10. John Brunetti, *Steven Weinberg* (Delle, France: Salon International de la Sculpture, 2000), p. 10.

11. Stankard, quoted in Ulysses Grant Dietz, *Paul J. Stankard: Homage to Nature* (New York: Harry N. Abrams, 1996), p. 25.

12. Arthur C. Danto, Mary Jane Jacob, and Patterson Sims, *Howard Ben Tré* (New York: Hudson Hills Press, in asso-ciation with Scottsdale Museum for Contemporary Art, 1999), pp. 78 and 89.

13. Quoted in Robert Kehlmann, *The Inner Light: Sculp-ture by Stanislav Libenský and Jaroslava Brychtová,* exh. cat. (Seattle: University of Washington Press; Tacoma, Wash.: Museum of Glass, International Center for Contemporary Art, 2002), pp. 83 and 84.

14. See Patricia B. Craddock, ed., *The English Essays of Edward Gibbon* (Oxford: Clarendon Press, 1972), p. 41.

15. Regina Hackett, "Old Tradition Shines with a Bold, New Identity at Tacoma's Museum of Glass," *Seattle Post-Intelligencer,* October 26, 2002.

16. E-mail conversation between the author and collector Doug Anderson.

17. Henry Geldzahler (1993), quoted in William Warmus, *The Essential Dale Chihuly* (New York: Harry N. Abrams, 2000), p. 10.

18. Skibska, quoted in Peter Slatin, "Anna Skibska: The Force of Delicacy," *Glass,* no. 52 (summer 1993), p. 28.

19. Tschida, quoted in William Warmus, "Everyone Will Be Illuminated for 15 Minutes: Tschida Stories," *Glass,* no. 62 (spring 1996), p. 31.

20. Schaechter, quoted in Judith Tannenbaum, *Judith Schaechter: Heart Attacks,* exh. cat. (Philadelphia: Insti-tute of Contemporary Art, University of Pennsylvania, 1995), p. 11.

21. Anthony Lane, "Mondo Bondo: Forty Years of 007," *The New Yorker,* November 4, 2002, pp. 78–82.

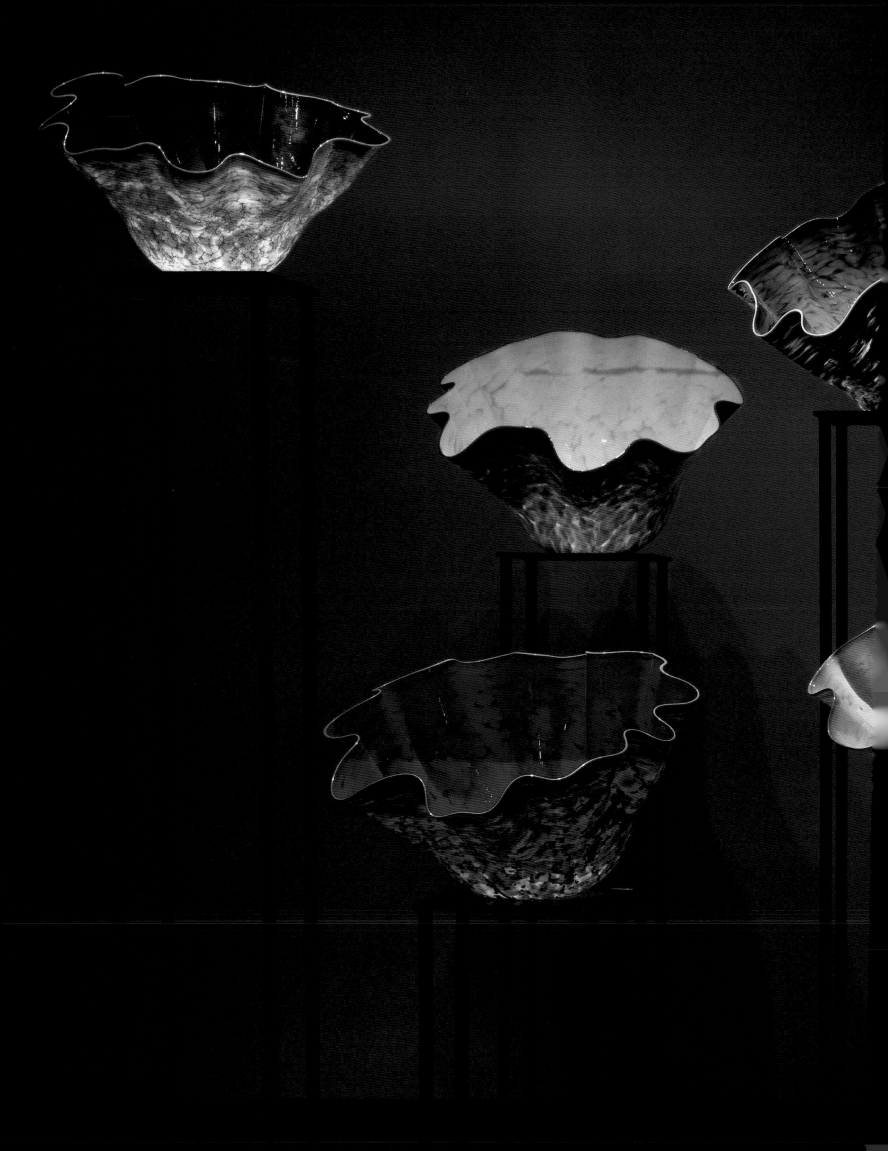

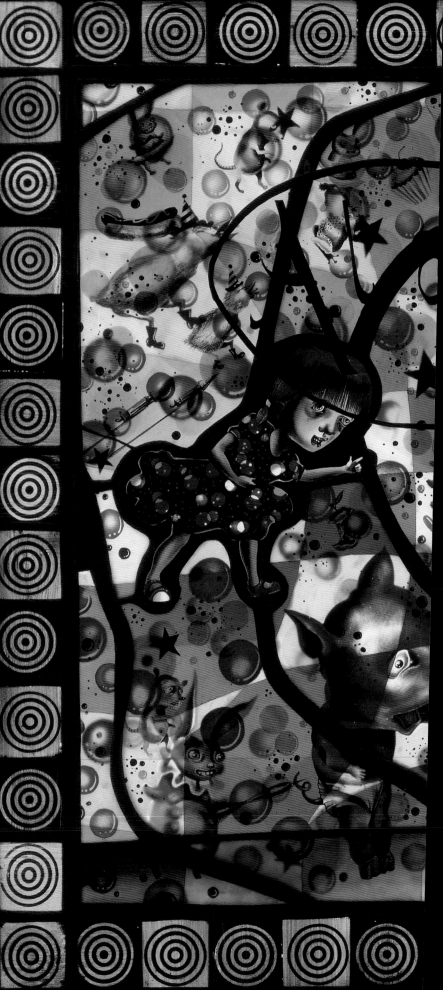

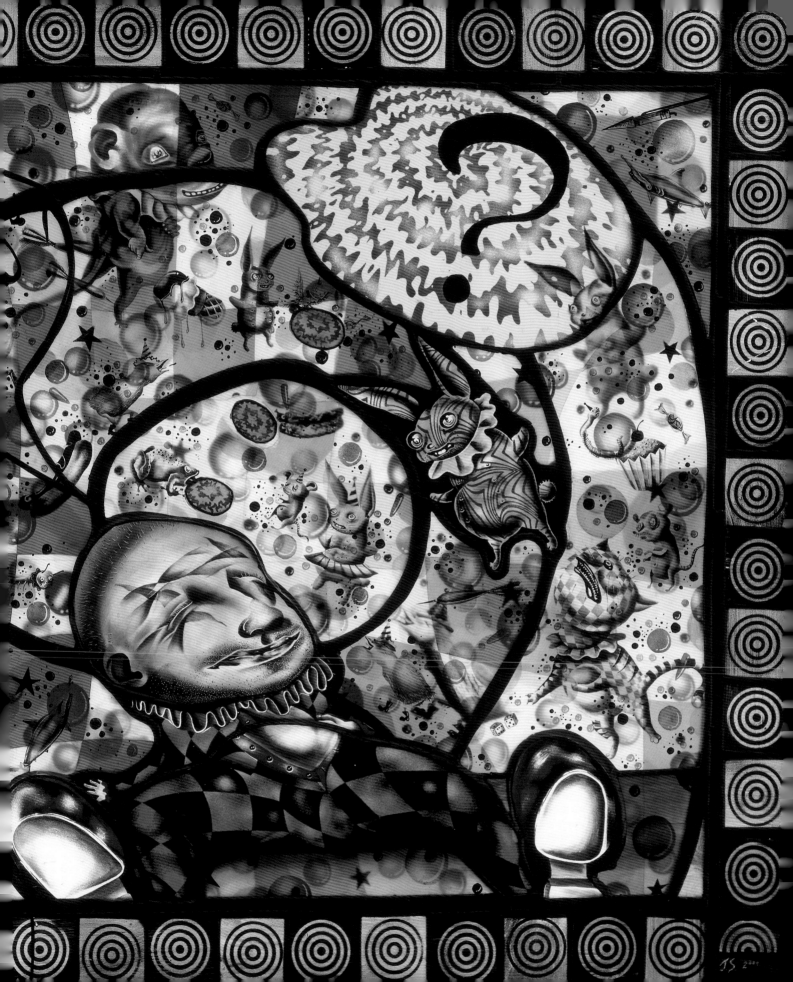

JUDITH SCHAECHTER *Cyclone and Cyclone Fence,* 1998
23 x 28 in.

Funeral for Elliot, 1999
19 x 26 in.

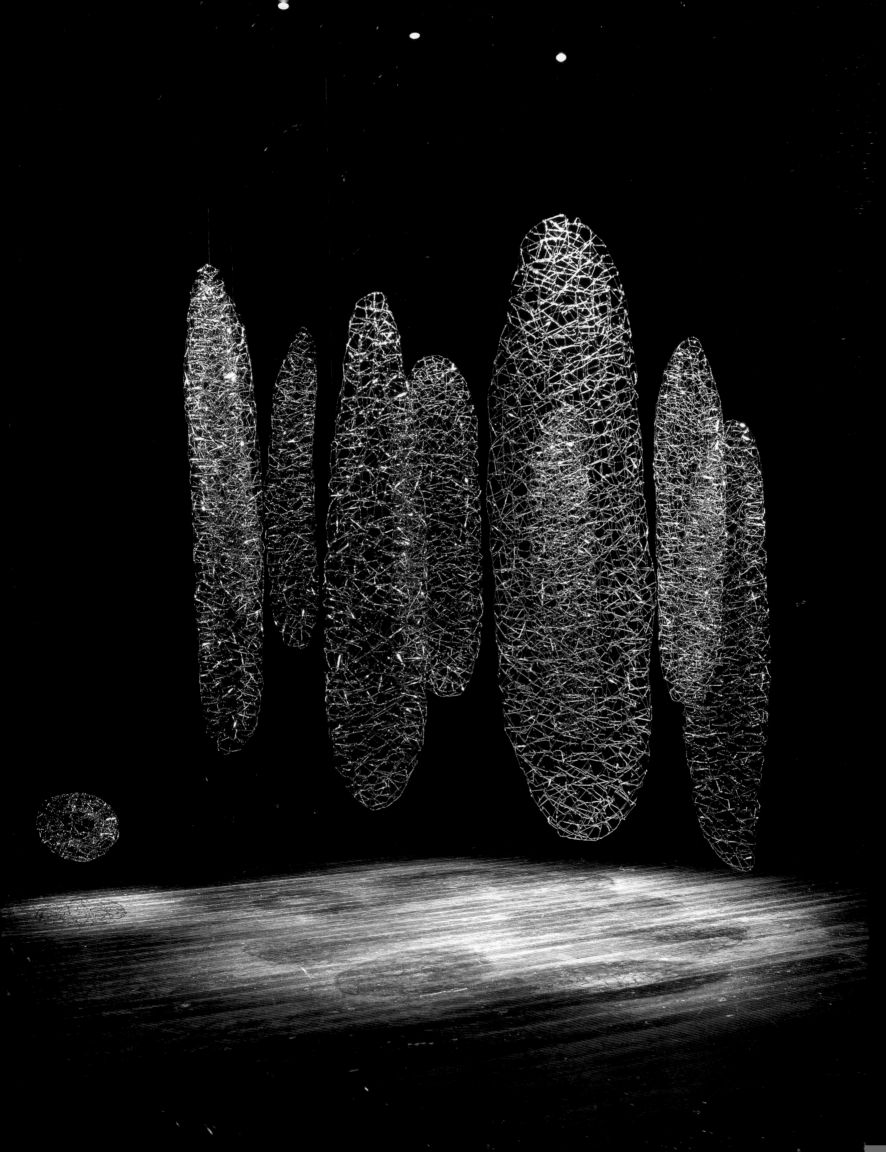

FRED TSCHIDA *Log Jam,* installation at DePree Art
Center, Hope College, Holland,
Michigan, 1984
Branches and neon, 60 x 30 ft.
Photo: Fred Tschida

Space Fruit, 1986
Wire cage constructions, Bondo,
light bulbs, 14 x 32 in. and 12 x 28 in.
Courtesy of the artist
Photo: Fred Tschida

Hank Murta Adams (American, b. 1956)
Val, 1992
Cast and blown glass, 31 in. high x 24 in. diam.
Collection of Sheldon and Myrna Palley

Birdie, 1996
Cast glass, patinated copper wire,
33½ x 15 x 12 in.
Collection of Sheldon and Myrna Palley
Page 73

Bomb Boy, 2000
Cast colorless glass, patinated copper
inclusions, 22 x 12 x 10½ in.
Collection of Fraeda and Bill Kopman
Pages 8–9 (detail), 75. Photo: © C. J. Walker

Nicolas Africano (American, b. 1948)
Patience (rose dress), 1999
Cast glass and marble, 22½ x 8 x 4 in.
Collection of Joan and Milton Baxt
Pages 72, 76 (detail)

Untitled (rose skirt and shirt), 2000
Cast glass, 42 x 14 x 10 in.
Collection of Debbie and Bud Menin
Page 77

Rose Figure with Long Dress, 2001
Cast glass cold-worked, 27 x 10 x 7 in.
Collection of Florence and Bob Werner

Howard Ben Tré (American, b. 1949)
Structure #14, 1984
Cast glass, copper, patina, 40 x 13 x 9 in.
Collection of Jean Heilbrunn

Boone Basin, 2002
Cast glass, lead, gold leaf, custom granite base
Sculpture: 31¾ x 20 x 15 in.
Base: 24 x 20 x 15 in.
Collection of Linda Boone
Page 45. Photo: Ric Murray

Dale Chihuly (American, b. 1941)
*Cadmium Yellow Macchia with Bright Red
Lip Wrap,* 1992
Blown glass, 20 in. high x 33 in. diam.
Collection of Norton Museum of Art, West Palm
Beach, Florida; purchased with funds from
Mr. and Mrs. Frederick Adler, Mr. and Mrs. Rand
Araskog, Mrs. Nanette Ross, Mrs. Frances Scaife,
and Mr. and Mrs. Robert Sterling, 98.45
Page 109

*Mineral Violet Macchia with Sky Blue
Lip Wrap,* 1992
Blown glass, 20 in. high x 32 in. diam.
Collection of Norton Museum of Art, West Palm
Beach, Florida; purchased with funds from
Mr. and Mrs. Frederick Adler, Mr. and Mrs. Rand
Araskog, Mrs. Nanette Ross, Mrs. Frances Scaife,
and Mr. and Mrs. Robert Sterling, 98.43
Page 108

*Cobalt Blue Macchia with Indian Yellow
Lip Wrap,* 1993
Blown glass, 20½ in. high x 30 in. diam.
Collection of Norton Museum of Art, West Palm
Beach, Florida; purchased with funds from
Mr. and Mrs. Frederick Adler, Mr. and Mrs. Rand
Araskog, Mrs. Nanette Ross, Mrs. Frances Scaife,
and Mr. and Mrs. Robert Sterling, 98.46
Page 108

*Cadmium Yellow Macchia with Red
Lip Wrap,* 1994
Blown glass, 24¼ in. high x 32 in. diam.
Collection of Norton Museum of Art, West Palm
Beach, Florida; purchased with funds from
Mr. and Mrs. Frederick Adler, Mr. and Mrs. Rand
Araskog, Mrs. Nanette Ross, Mrs. Frances Scaife,
and Mr. and Mrs. Robert Sterling, 98.42
Page 109

*Green Macchia with Lemon Yellow
Lip Wrap,* 1994
Blown glass, 23 in. high x 38 in. diam.
Collection of Norton Museum of Art, West Palm
Beach, Florida; purchased with funds from
Mr. and Mrs. Frederick Adler, Mr. and Mrs. Rand
Araskog, Mrs. Nanette Ross, Mrs. Frances Scaife,
and Mr. and Mrs. Robert Sterling, 98.47
Pages 108–9

*Vivid Orange Macchia with Moss Green
Lip Wrap,* 1994
Blown glass, 21 in. high x 34 in. diam.
Collection of Norton Museum of Art, West Palm
Beach, Florida; gift of Dale Chihuly, 98.39
Page 109

*Yellow Ochre Macchia with Viridian
Lip Wrap,* 1995
Blown glass, 20½ in. high x 33 in. diam.
Collection of Norton Museum of Art, West Palm
Beach, Florida; purchased with funds from
Mr. and Mrs. Frederick Adler, Mr. and Mrs. Rand
Araskog, Mrs. Nanette Ross, Mrs. Frances Scaife,
and Mr. and Mrs. Robert Sterling, 98.44
Page 108

Untitled, 1998
Acrylic on Arches paper, 4 drawings,
each 41½ x 29¼ in.
Collection of Dale & Doug Anderson
Page 1 (detail). Photo: © Sargent

Daniel Clayman (American, b. 1957)
Hearth, 1989
Cast glass, copper, gold leaf, 9 x 6⅞ x 2¼ in.
Collection of Joan and Milton Baxt
Page 46. Photo: © C. J. Walker

Untitled, 1989
Cast glass, copper, 14¼ x 12 x 3½ in.
Collection of Joan and Milton Baxt
Page 46. Photo: © C. J. Walker

Diverge, 2002
Glass, 96 x 17½ x 13¼ in.
Lent by the artist and Heller Gallery, New York
Page 47. Photo: Jessica Marcotte

Dan Dailey (American, b. 1947)
Nude on the Phone, 1985
Vitrolite wall sculpture, 42 x 36 in.
Collection of Miriam and Julius Zweibel
Pages 71, 78–79 (detail)

Cardinal, 1993
Red vitrolite body; transparent yellow wings and
tail; gold-plated brass; black, white, and gray
vitrolite base; anodized aluminum; handblown
purple flower with green chunks, 15 x 20 x 8 in.
Collection of Miriam and Julius Zweibel
Page 4. Photo: Bill Truslow

Geometrance, 2001
Blown glass and metal, 15 x 10 in.
Collection of Florence and Bob Werner

Michael M. Glancy (American, b. 1950)
Term Sinkronosity, 1983
Blown glass, industrial plate glass, copper, and
silver, 6½ x 10 x 10 in.
Collection of Jean Heilbrunn
Pages 20, 26–27 (detail)

Gold Lodestar, 1990
Blown glass, industrial plate glass, copper,
and gold, 7 x 17 x 8½ in.
Collection of Dani and Jack Sonnenblick
Pages 19, 24 (detail)

Vis Vitalis, 1999
Engraved (Pompeii cut) blown glass, engraved
(Pompeii cut) industrial plate glass, and copper,
13 x 18 x 18 in.
Collection of Fraeda and Bill Kopman
Pages 22–23

Contracting Expansion, 2000
Engraved (Battuto cut) blown glass, engraved
(Battuto cut) industrial plate glass, and copper,
9 in. high x 15 in. diam.
Collection of Florence and Bob Werner
Page 25

Joey Kirkpatrick (American, b. 1952) **and**
Flora Mace (American, b. 1949)
Untitled, 1981
Handblown glass with applied wire and glass
thread drawing, 7 in. high x 8 in. diam.
Collection of Dale & Doug Anderson
Pages 72, 81 (detail). Photo: © Sargent

Glass Wire Figure, 1982
Handblown glass and cast metal, 24½ x 9 x 4 in.
Collection of Sheldon and Myrna Palley

The Conversation, 1983
Handblown glass with applied wire and glass
thread drawing, 11¾ in. high x 6½ in. diam.
Collection of Dale & Doug Anderson
Page 80. Photo: Robert Vinnedge

Stanislav Libenský (Czech, 1921–2002) **and**
Jaroslava Brychtová (Czech, b. 1924)
Light Space, 1994
Mold-formed glass, 16 x 32½ x 5¾ in.
Collection of Fraeda and Bill Kopman
Page 51. Photo: © C. J. Walker

Taking Off, 1994–99
Mold-formed glass, 23½ x 47 x 19½ in.
Collection of Fraeda and Bill Kopman
Pages 48–49. Photo: © C. J. Walker

Through the Cone, 1995–97
Mold-formed glass, 36 x 49 x 10 in.
Collection of Fraeda and Bill Kopman
Page 50. Photo: C. J. Walker

Study for a Sculpture, 1997
Tempera and charcoal on paper, 29 x 41 in.
Collection of Fraeda and Bill Kopman

Marvin Lipofsky (American, b. 1938)
California Storm Series, 1982–83 #22, 1982–83
Glass blown into handmade wooden forms,
hand cut, ground, and polished in artist's studio,
10 x 11 x 8 in.
Made with assistance from Carol Schreitmueller;
blown at California College of Arts and Crafts,
Oakland
Collection of Dani and Jack Sonnenblick

Series IGS VI 1997–98 #1, 1997–98
Colored glass blown into handmade wooden forms,
cut, ground, hand-finished, sandblasted, and acid
polished, 12½ x 21 x 18 in.
Made with assistance from František Cejka and
team, Novy Bor, Czech Republic
Collection of Florence and Bob Werner
Pages 41, 52–53 (detail). Photo: M. Lee Fatherree

Kentucky Series 2000–01 #5, 2000–2001
Colored glass Murrini blown into handmade
wooden forms, cut, ground, hand-finished, and
sandblasted, 15 x 14 x 15½ in.
Made with assistance from Brooke, Paul, Brent
(students), and Steve Powell, Centre College,
Danville, Kentucky
Collection of Barbara and Howard First
Pages 41, 52 (detail). Photo: M. Lee Fatherree

Harvey K. Littleton (American, b. 1922)
Lemon/Orange/Blue Hemisphere Quarters, 1980
Blown glass, each 3½ x 4 in.
Collection of Dale & Doug Anderson
Pages 41, 54 (detail). Photo: © Sargent

Yellow Ruby Sliced Descending Forms, 1985
Blown glass, approx. 20 x 14 x 15½ in.
Courtesy of The Littleton Collection
Page 55

Dante Marioni (American, b. 1964)
Untitled Set, 1993
Three blown-glass forms, 26 x 9½ in.;
30 x 7½ in.; 35 x 10 in.
Private collection

Yellow Mosaic Vase, 1997
Blown glass, 35½ in. high x 8 in. diam.
Collection of Peggy and Rick Katz, Jr.
Page 28. Photo: © C. J. Walker

Gambo, 2000
Blown glass, 36¼ in. high x 7½ in. diam.
Collection of Nina and Leon Nissenfeld
Pages 5 (detail), 29. Photo: © C. J. Walker

Richard Marquis (American, b. 1945)
American Acid Capsule with Cloth Container,
1969–70
Made at Venini Fabbrica, Murano, Italy
Cloth case by Nirlam Kaur (Barbara Brittell), c. 1970
Solid worked glass, murrine, a canne, and incalmo
techniques, 4 in. wide x 1¼ in. diam.
Collection of Dale & Doug Anderson
Page 85. Photo: © Sargent

Retro Stuff: Stars and Stripes Teapot, 1997
Bullseye glass, 6 x 5¾ x 5 in.
Collection of Nicki and Ira Harris
Page 84. Photo: © C. J. Walker

Stars and Stripes, 1997
Blown glass, 6 x 5¾ x 5 in.
Collection of Florence and Bob Werner
Page 84. Photo: © C. J. Walker

Stars and Stripes Teapot #12, 1997
Blown glass, murrine technique,
4⅛ in. high x 6 in. diam.
Collection of Dale & Doug Anderson
Page 84. Photo: © Sargent

Granulare Elephant #9, 1998
Murrini glass, 10½ x 8 x 4 in.
Private collection
Page 82. Photo: © C. J. Walker

Marquiscarpa #98–9, 1998
Fused, slumped, blown, and wheel-carved
glass, 15⅜ x 17⅜ x 4 in.
Collection of Florence and Bob Werner
Page 83. Photo: © C. J. Walker

William Morris (American, b. 1957)
Canopic Jar: Fawn, 1992
Handblown and formed glass,
27 in. high x 11 in. diam.
Collection of Norton Museum of Art, West Palm
Beach, Florida; gift of Dale & Doug Anderson, 96.10

Canopic Jar: Elk (Cow), 1993
Blown glass, 30½ in. high x 12 in. diam.
Collection of The Metropolitan Museum of Art,
New York; gift of Dale & Doug Anderson, 1995
Pages 69 (detail), 86. Photo: Rob Vinnedge

Canopic Jar: Elk (Spike), 1993
Blown glass, 35½ in. high x 14¼ in. diam.
Collection of The Metropolitan Museum of Art,
New York; gift of Dale & Doug Anderson, 1995
Pages 68 (detail), 86. Photo: Rob Vinnedge

Jay Musler (American, b. 1949)
Sinister Series, 1993
Lampworked glasses, sandblasted, and oil paint,
each approx. 9¼ in. high x 4¼ in. diam.
Collection of Dale & Doug Anderson
Pages 71, 88–89 (detail). Photo: © Sargent

Tom Patti (American, b. 1943)
Ascending Red, 1990
Fused, hand-shaped, ground, and polished glass,
5¾ x 4⅜ x 2¾ in.
Collection of Nicki and Ira Harris
Pages 56 (detail), 57

Red Lumina Echo, 1991
Fused and laminated glass, expanded, 5 x 4 x 3 in.
Collection of Sheldon and Myrna Palley
Pages 42, 58–59 (detail)

Division of Fifty Luminated Particles for Doug, 1993
Fused, hand-formed, ground, and polished glass,
tallest 6⅝ x 5⅞ in.
Collection of Dale & Doug Anderson
Pages 38–39

Ginny Ruffner (American, b. 1952)
The Drive-In of My Motivations, 1989
Glass and mixed media, 13 x 23 x 8 in.
Collection of Barbara and Howard First
Page 90

Mae Clean Floor, 1996
Lampworked glass and paint, 15 x 18 x 7 in.
Collection of Dale & Doug Anderson
Page 91. Photo: © Sargent

Norton Palm Trees, 1997
Painted glass, 17 x 21 x 16 in.
Collection of Norton Museum of Art, West Palm
Beach, Florida; gift of Dale & Doug Anderson, 98.48
Page 90

Laura de Santillana (Italian, b. 1955)
C5 (Lacrime), 2001
Handblown and shaped glass, 11¼ x 8¾ x 1½ in.
Courtesy of Barry Friedman Ltd., New York

Two Reds, 2001
Handblown and shaped glass, 15¾ x 18½ x 1¹⁵⁄₁₆ in.
Collection of Natalie Pelavin
Pages 60–61. Photo: © C. J. Walker

Judith Schaechter (American, b. 1961)
Cyclone and Cyclone Fence, 1998
Stained glass in lightbox, 23 x 28 in.
Collection of Judy and Peter Leone
Page 112

Funeral for Elliot, 1999
Stained glass in lightbox, 19 x 26 in.
Collection of Marc and Diane Grainer
Page 112

Bigtop Flophouse Bedspins, 2001
Stained glass in lightbox, 28½ x 37½ in.
Courtesy COFA/Claire Oliver Fine Art
Pages 110–11

The Student Gynecologist, 2001
Stained glass in lightbox, 36 x 62 in.
Courtesy Dr. and Mrs. J. Gretzula and COFA/
Claire Oliver Fine Art
Pages 112–13

Anna Skibska
Ten, 2002
Glass, dimensions variable
Installation

Paul Stankard (American, b. 1943)
Botanical, 2000
Flame-worked glass, 6 x 2⅞ x 2¾ in.
Collection of Jane and George Kaiser

The Rose Bouquet Diptych with Seed Pods
and Damselfly, 2000
Flame-worked glass, 6 x 5¼ x 4 in.
Collection of Jane and George Kaiser

Morning Glory and Orchids Orb, 2002
Flame-worked glass, 5½ in. diam.
Collection of Jane and George Kaiser
Pages 31, 32. Photo: © C. J. Walker

Therman Statom (American, b. 1953)
The Chair, 1989
Painted glass and wood, 55 x 32 x 40 in.
Collection of Norton Museum of Art, West Palm
Beach, Florida; gift of Phyllis Doane, 99.103

9 Tries, 1993
Glass, 76 x 48 x 4 in.
Collection of Natalie Pelavin
Pages 92 (detail), 93. Photo: Courtesy Maurine Littleton Gallery

Lino Tagliapietra (Italian, b. 1934)
Drakkar, 1998
Glass, 63 x 15½ x 5 in.
Private collection

Tholtico, 1998
Blown glass, 18 x 8 x 8 in.
Collection of Fraeda and Bill Kopman

Samba do Brasil, 2000
Blown-glass vessels on fabricated metal table,
83 x 70 x 22 in.
Collection of the artist
Pages 13, 34–35 (detail). Photo: Russell Johnson

Fred Tschida (American, b. 1949)
Atmospheric Form Studies, 2003
Neon, approx. 25 ft. long
Installation for the Norton Museum

Bertil Vallien (Swedish, b. 1938)
Untitled, 1993
Glass, metal, 79 x 13½ x 13½ in.
Private collection
Page 94. Photo: © C. J. Walker

Head 4ACM #979254, 1997
Cast glass head, 8⅛ in. high x 4½ in. diam.
(72 in. high with stand)
Collection of Fraeda and Bill Kopman
Page 95. Photo: © C. J. Walker

Head 10ACM #979260, 1997
Cast glass head, 7⅜ in. high x 4¼ in. diam.
(72 in. high with stand)
Collection of Dale & Doug Anderson

Head 11ACM #979261, 1997
Cast glass head with metal inclusions,
7¹⁵⁄₁₆ in. high x 4½ in. diam. (72 in. high with stand)
Collection of Dale & Doug Anderson

Head 17ACM #979179, 1997
Cast glass head with mouth projection,
7¹⁵⁄₁₆ in. high x 4½ in. diam. (72 in. high with stand)
Collection of Dale & Doug Anderson

Head 28ACM #979273, 1997
Cast glass head, 8⅛ in. high x 4⅛ in. diam.
(72 in. high with stand)
Collection of Fraeda and Bill Kopman
Page 96. Photo: © C. J. Walker

Head 38ACM #969254, 1997
Cast glass head, 8 in. high x 4¾ in. diam.
(72 in. high with stand)
Collection of Fraeda and Bill Kopman
Page 97. Photo: © C. J. Walker

František Vízner (Czech, b. 1936)
Blue Bowl, 1971
Cut, sandblasted, and polished glass,
3 in. high x 11½ in. diam.
Courtesy of Barry Friedman Ltd., New York
Frontispiece

Turquoise Bowl, 2000
Cut, sandblasted, and polished glass,
4½ in. high x 11 in. diam.
Courtesy of Barry Friedman Ltd., New York
Pages 62–63

Janusz Walentynowicz (Polish, b. 1956)
Anna's Choice, 1997
Cast glass, steel, oil paint, 52 x 50 in. open,
52 x 25 in. closed
Collection of Linda Boone

Target, 1997
Cast and painted glass, steel, 35½ x 35½ in.
Collection of Sheldon and Myrna Palley
Page 101

Crossing, 2000
Cast glass, steel, 40 x 14 x 4 in.
Collection of Joan and Milton Baxt
Pages 99, 100. Photo: © C. J. Walker

Steven Weinberg (American, b. 1954)
Gloucester Lobster Pot Buoy, 2001
Cast crystal, lower half: spray metalized
oxidized steel exterior, 16 x 8 in.
Collection of Bernard and Ina Wasserman,
Palm Beach, Florida

Brant Point Lobster Pot Buoy, 2002
Cast crystal, spray metalized copper with patina
and oxidized steel exterior, lens ground in side
and top, 16 x 8 in.
Collection of Sharon Oleksiak Weinberg
Pages 16–17 (detail), 20, 21 (top view), 36–37 (detail)

York Maine Buoy, 2002
Cast crystal, spray metalized copper with patina
and oxidized steel exterior, 17 x 8 x 6 in.
Collection of Myrna & David Leven, Palm Beach
Gardens, Florida

Toots Zynsky (American, b. 1951)
Untitled, from *Chaos* series, c. 1992–95
Filet-de-verre (fused and thermo-formed color
glass threads), 6¾ x 10 x 9 in.
Collection of Norton Museum of Art, West Palm
Beach, Florida; gift of Dale & Doug Anderson, 96.11

Dreaming Chaos, 1998
Filet-de-verre (fused and thermo-formed color
glass threads), 11 x 18 x 11½ in.
Collection of Miriam and Julius Zweibel
Page 64

Passagero Nuovo Serena, 1999
Filet-de-verre (fused and thermo-formed color
glass threads), 10¹⁄₁₆ x 20½ x 10¼ in.
Collection of Peggy and Rick Katz, Jr.
Page 65

Cantica Serena, 2001
Filet-de-verre (fused and thermo-formed color
glass threads), 9¼ x 16¹⁵⁄₁₆ x 13³⁄₁₆ in.
Private collection
Pages 66–67

Hank Murta Adams

The Glass Skin. Corning, N.Y.: The Corning Museum of Glass, 1997, pp. 18–23.

Hank Murta Adams Sculpture. Cullowhee, N.C.: Western Carolina University, 1986. Catalogue for the exhibition held at Chelsea Gallery, Hinds University Center, Western Carolina University, September 23–October 16, 1986.

Warmus, William. "Castings: Hank Murta Adams." *Glass,* no. 66 (spring 1997), pp. 34–39. Also available online at ‹www.warmus.com/hank_adams_essay_by_warmus.htm›.

Nicolas Africano

"In Context: Nicolas Africano and Amanda Pierce." *Glass,* no. 52 (summer 1993), pp. 44–47.

Long, Andrew. "Openings." *Art and Antiques* 21, no. 5 (May 1998), p. 32. Review of exhibition at Meyerson and Nowinski Art Associates, Seattle, through May 24, 1998.

Howard Ben Tré

Danto, Arthur C., Mary Jane Jacob, and Patterson Sims. *Howard Ben Tré.* New York: Hudson Hills Press, in association with Scottsdale Museum of Contemporary Art, 1999. Published on the occasion of the traveling exhibition *Howard Ben Tré: Interior/Exterior* organized by the Scottsdale Museum of Contemporary Art, Scottsdale, Arizona.

David Winton Bell Gallery and Norton Gallery of Art. *Howard Ben Tré: New Work.* Providence, R.I.: Brown University, 1993. Catalogue for the exhibition held at the David Winton Bell Gallery, List Art Center, Brown University, August 28–October 3, 1993; and Norton Gallery of Art, West Palm Beach, Florida, January 8–February 20, 1994. Texts by Diana L. Johnson and Donald Kuspit.

Dale Chihuly

Chihuly, Dale. *Chihuly Projects.* Seattle: Portland Press; New York: distributed by Harry N. Abrams, 2000. Texts by Barbara Rose and Dale Lanzone.

Kuspit, Donald B. *Chihuly.* 2d ed. New York: Harry N. Abrams, 1998. Text by Donald Kuspit with an introduction by Jack Cowart.

Warmus, William. *The Essential Dale Chihuly.* New York: Harry N. Abrams, 2000.

Daniel Clayman

Habatat Galleries. *Daniel Clayman: Reaches.* Pontiac, Mich.: Habatat Galleries, 1999. Catalogue for the exhibition held November 12–27, 1999.

Kangas, Matthew. "Daniel Clayman: The Object Is the Image." *Glass,* no. 75 (summer 1999), pp. 38–43, ill.

Dan Dailey

Dan Dailey, Linda MacNeil: Art in Glass and Metal. N.p.: Exeter Press, 1999. Catalogue for the exhibition held at the Art Center in Hargate, St. Paul's School, Concord, New Hampshire, January 15–February 12, 1999.

Riley/Hawk Galleries. *Dan Dailey: Vases from the Archives, 1974–1988.* Columbus, Ohio: Riley/Hawk Galleries, 1998. Texts by Karen Chambers, Peggy Gilges, and Dan Dailey.

Warmus, William, and Henry Geldzahler. *Dan Dailey: Simple Complexities in Drawings and Glass, 1972–1987.* Seattle: University of Washington Press, 1987. Catalogue for the exhibition organized by the Rosenwald-Wolf Gallery, Philadelphia College of Art, Philadelphia, February 27–March 30, 1987; traveled to Renwick Gallery, National Museum of American Art, Smithsonian Institution, Washington, D.C., June 26–October 25, 1987.

Michael M. Glancy

Barry Friedman Ltd. *Beyond Vessels: Recent Glass Work by Michael Glancy.* New York: Barry Friedman Ltd., 1997. Catalogue for the exhibition held May 1–July 11, 1997. Text by Alastair Duncan.

———. *Infinite Obsessions: Maurice Marinot and Michael Glancy.* New York: Barry Friedman Ltd., 1999. Catalogue for the exhibition held November 4, 1999–January 8, 2000. Text by Dan Klein.

Constellations: An Alternative Galaxy, Glass by Michael Glancy. Basel: Edition von Bartha, c. 1995. Texts by Miklos von Bartha, Dan Klein, Dale Chihuly, and Erik Bottschalk.

Joey Kirkpatrick and Flora Mace

Brunnier Gallery and Museum. *Kirkpatrick/Mace.* Ames, Iowa: Brunnier Gallery and Museum, Iowa State University, 1993. Catalogue for the exhibition *Joey Kirkpatrick and Flora C. Mace: Recent Sculpture* held April 15–August 15, 1993.

Brunsman, Laura, and Ruth Askey, eds. *Modernism and Beyond: Women Artists of the Pacific Northwest.* New York: Midmarch Arts Press, 1993. See Margery Aronson, "Translucent and Opaque: Women and Glass," pp. 47–58. Includes Sonja Blomdahl, Ginny Ruffner, Flora Mace, and Joey Kirkpatrick.

Chambers, Karen. "Dual Action Artistry: Flora Mace and Joey Kirkpatrick Combine Their Passions and Their Skills in an Acclaimed Partnership." *American Style* 4, no. 4 (summer 1998), pp. 62–69.

Stanislav Libenský and Jaroslava Brychtová

Frantz, Susanne K., ed. *Stanislav Libenský, Jaroslava Brychtová: A 40-Year Collaboration in Glass.* Munich and New York: Prestel Verlag, 1994. Catalogue for the exhibition organized by the Corning Museum of Glass, Corning, New York, and the Umûleckoprûmyslové Muzeum v Praze, Prague, and held at the Corning Museum of Glass, April 23–October 16, 1994. Texts by Thomas S. Buechner, Sylvá Petrová, and Jiri Setlik.

Kehlmann, Robert. *The Inner Light: Sculpture by Stanislav Libenský and Jaroslava Brychtová.* Seattle: University of Washington Press; Tacoma, Wash.: Museum of Glass, International Center for Contemporary Art, 2002. Published in conjunction with the exhibition held at the Museum of Glass, International Center for Contemporary Art, Tacoma, July 6–October 27, 2002.

Marvin Lipofsky

Holsten Galleries. *Five Masters of Contemporary Glass.* Stockbridge, Mass.: Holsten Galleries, 2002. Catalogue for the exhibition held in spring 2002. Includes works by Dale Chihuly, Marvin Lipofsky, William Morris, Tom Patti, and Lino Tagliapietra.

Toso Fei, Alberto. *Marvin Lipofsky: un "muranese" in California/A "Muranese" in California.* Murano (Venice): Centro Studio Vetro, 2000. Text in Italian and English. Also published in *Vetro,* no. 9 (2001).

Harvey K. Littleton

Glasmuseum Frauenau. *Harvey K. Littleton zum 70. Geburtstag 14. Juni '92.* Frauenau, Germany: Glasmuseum, 1992. Texts by Alfons Hannes and Erwin Eisch.

High Museum of Art. *Harvey K. Littleton: A Retrospective Exhibition.* Atlanta, Ga.: High Museum of Art, 1984. Catalogue for the exhibition held at Renwick Gallery, National Museum of American Art, Smithsonian Institution, Washington, D.C., March 30–September 3, 1984; American Craft Museum II, New York, November 16, 1984–January 12, 1985; Brunnier Gallery and Museum, Iowa State University, Ames, February 10–April 7, 1985; High Museum of Art, April–June 1985; Milwaukee Art Museum, Milwaukee, Wisconsin, September 15–October 30, 1985; and Portland Museum of Art, Portland, Maine, November 20, 1985–January 5, 1986. Text by Joan Falconer Byrd.

Mint Museum of Craft and Design. *Harvey K. Littleton: Reflections, 1946–1994.* Charlotte, N.C.: Mint Museum of Craft and Design, 1999. Text by Mary F. Douglas.

Dante Marioni

Klein, Dan. "Dante Marioni." *Neues Glas/New Glass*, no. 3 (fall 2001), pp. 28–35.

Oldknow, Tina. *Dante Marioni: Blown Glass.* New York: Hudson Hills Press, 2000.

Richard Marquis

Frantz, Susanne K. "Marquis at the Caffe Florian." *American Craft* 59, no. 1 (February–March 1999), pp. 74–75, ill. Review of 1998 Venice exhibition.

Marquis, Richard Charles. "The Making of Canne and Murrini and Their Use in Blown Glass Forms." Master's thesis, University of California, Berkeley, 1972.

Oldknow, Tina. *Richard Marquis: Objects.* Seattle: University of Washington Press, 1997. Published on the occasion of a retrospective exhibition at the Seattle Art Museum.

Wichert, Geoffrey. "Preview: A Marquis Milestone." *Glass*, no. 68 (fall 1997), pp. 36–43. Review of retrospective exhibition at the Seattle Art Museum.

William Morris

Blonston, Gary. *William Morris: Artifacts—Glass.* New York: Abbeville Press, 1996.

William Morris: Cinerary Urn Installation. Seattle: Marquand Books, Inc., 2002. Catalogue for the exhibition held at the Chrysler Museum, Norfolk, Virginia, June 28–August 18, 2002; and American Craft Museum, New York, January 17–June 8, 2003. Text by Gary Baker.

Yood, James, and Tina Oldknow. *William Morris: Animal/Artifact.* New York: Abbeville Press, 2000.

Jay Musler

The Boat Show: Fantastic Vessels, Fictional Voyages. [Portland, Maine: Portland Museum of Art], 1990. Catalogue for the exhibition organized by the Renwick Gallery, National Museum of American Art, Smithsonian Institution, Washington, D.C.; traveled to Portland Museum of Art, Portland, Maine, August 21–October 28, 1990. Includes glass works by Jay Musler, Robert Shay, and Bertil Vallien.

Marx-Saunders Gallery. *Jay Musler and the Nature of Disquiet.* Chicago: Marx-Saunders Gallery, 1998. Catalogue for the exhibition held October 9–November 2, 1998. Text by Bruce W. Pepich.

———. *Jay Musler: Visions.* Chicago: Marx-Saunders Gallery, 2001. Catalogue for the exhibition held April 20–May 22, 2001. Text by James Yood.

Tom Patti

Heller Gallery. *Tom Patti—Glass: A Spatial Boundary, Large and Small Works, 1981–2001.* New York: Heller Gallery, 2001. Catalogue for the exhibition held September 8–30, 2001.

Holsten Galleries. *Five Masters of Contemporary Glass.* Stockbridge, Mass.: Holsten Galleries, 2002. Catalogue for the exhibition held in spring 2002. Includes works by Dale Chihuly, Marvin Lipofsky, William Morris, Tom Patti, and Lino Tagliapietra.

Ginny Ruffner

Meyerson and Nowinski Art Associates. *Ginny Ruffner: Venice Works, 1989.* Seattle: Meyerson and Nowinski Art Associates, 1997. Catalogue for the exhibition held December 5, 1996–January 5, 1997. Text by Tina Oldknow.

Miller, Bonnie J. *Why Not?: The Art of Ginny Ruffner.* Tacoma, Wash.: Tacoma Art Museum; Seattle: University of Washington Press, 1995. Published concurrently with the exhibition *Garden of Delights* curated by Barbara Johns and organized by the Tacoma Art Museum, December 15, 1995–March 24, 1996. Text by Arthur C. Danto.

Laura de Santillana

Barry Friedman Ltd. *New Traditions in Glass from Venice: Christiano Bianchin, Yoichi Ohira, Laura de Santillana.* New York: Barry Friedman Ltd., 1998. Catalogue for the exhibition held October 29–December 5, 1998. Texts by Rosa Barovier Mentasti and Susanne Frantz.

Dorigato, Attilia, ed. *Laura de Santillana: Works.* Venice: Musei Civici Veneziani; Milan: Silvana Editoriale [distributor], c. 2001. Catalogue for the exhibition at Musei Civici Veneziani, Venice. Texts by Janet Koplos, Attilia Dorigato, and Tina Oldknow. Text in English and Italian.

Judith Schaechter

The Rhode Island Connection: Fifteen Contemporary Glass Masters. Newport, R.I.: Newport Art Museum, 1993. Catalogue for the exhibition curated by Virginia Lynch held July 31–September 19, 1993. Text by Ronald J. Onorato.

Tannenbaum, Judith. *Judith Schaechter: Heart Attacks.* Philadelphia: Institute of Contemporary Art, University of Pennsylvania, 1995. Catalogue for the exhibition held February 3–April 16, 1995. Texts by Rick Moody and Maria Porges.

Anna Skibska

Anna Skibska at Bullseye Glass. Portland, Ore.: Bullseye Glass Co., 1999. Published in conjunction with the artist's residency at Bullseye Glass. Texts by Lloyd Herman and Susanne Frantz.

Radzicka, Jolanta Kruszyna, ed. *Anna Skibska.* [Poland: n.p., 1997]. Chiefly illustrations; biographical and caption information in Polish and English.

Paul Stankard

Bergstrom-Mahler Museum. *Paul J. Stankard, Poetry in Glass: A 20-Year Retrospective.* Neenah, Wis.: Bergstrom-Mahler Museum, 1990. Catalogue for the exhibition held May 6–September 9, 1990.

Dietz, Ulysses G. *Paul Stankard: Homage to Nature.* New York: Harry N. Abrams, 1996.

Marx-Saunders Gallery. *Paul J. Stankard.* Chicago: Marx-Saunders Gallery, 2001. Text by James Yood.

Therman Statom

Maurine Littleton Gallery. *Therman Statom.* Washington, D.C.: Maurine Littleton Gallery, 2002. Catalogue for the exhibition held April 23–May 15, 2002.

Tampa Museum of Art. *River Myth: An Installation by Therman Statom for the Tampa Museum of Art.* Tampa, Fla.: Tampa Museum of Art, 2002. Catalogue for the exhibition held January 17–April 7, 2002.

Toledo Museum of Art. *Art to Art: Albert Paley, Jim Dine, Therman Statom Respond to Toledo's Treasures.* Toledo, Ohio: Toledo Museum of Art, 1996. Catalogue for the exhibition held March 17–June 19, 1996.

Lino Tagliapietra

Barovier, Marino, ed. *Tagliapietra: A Venetian Glass.* Dublin: Vitrum, c. 1998. Texts by Thomas S. Buechner and Susanne Frantz.

Sarpellon, Giovanni. *Lino Tagliapietra: vetri/Glass/verres/Glas.* Venice: Arsenale, c. 1994. Text in Italian, English, French, and German.

William Traver Gallery. *Lino Tagliapietra, "La ballata del vetro soffiato": An Exhibition Marking the Italian Maestro's Achievement in the World of Studio Glass.* Seattle: William Traver Gallery, 2002. Text by Daniel Kany.

Fred Tschida

Tschida, Fred. "Artist Presentations." *The Glass Art Society Journal* (1997), p. 63, ill.

"'Vessels' Show Offers Toast to Art of Drink." *Antiques and the Arts Weekly* 18, no. 51 (December 1990), p. 24. Review of American Craft Museum exhibition including glass works by Fred Tschida and William Bernstein.

Warmus, William. "Everyone Will Be Illuminated for 15 Minutes: Tschida Stories." *Glass*, no. 62 (spring 1996), pp. 28–35.

Bertil Vallien

Bertil Vallien. [Kosta, Sweden]: Kosta Boda, [2001]. Catalogue for an exhibition curated by Börge Kamras; text by Gunnar Lindqvist. Text in Swedish and English.

Kangas, Matthew. *Bertil Vallien: Somna/Vakna.* Seattle: University of Washington Press; Chesham: Combined Academic, 2002.

Lindqvist, Gunnar. *Bertil Vallien.* Rev. ed. Trans. Angela Adegren. Stockholm: Carlssons, 1994. Text in Swedish and English.

———. *Bertil Vallien: glas äter ljus/Glass Eats Light.* Trans. Angela Adegren. Stockholm: Carlssons, 1999.

František Vízner

Holesovsky, Karel. *Sklo, 1962–1982: František Vízner.* Brno, Czechoslovakia: Moravská Galerie, 1983. Catalogue for the exhibition held at Moravská Galerie, Brno, and three other locations. Summary in English and Russian.

Petrová, Sylvá. "Nekolik poznámek k tvorbe Frantiska Víznera." *Bulletin Moravské Galerie v Brne*, no. 53 (1997), pp. 161–63, ill. English summary.

Warmus, William. *František Vízner: Sklo/Glass, 1951–2001.* New York: Barry Friedman Ltd., 2001.

Janusz Walentynowicz

Art of Janusz Walentynowicz. Chicago: n.p., 1996. Catalogue for the exhibition at the Polish Museum of America, Chicago, May 3–17, 1996. Marx-Saunders Gallery and Riley/Hawk Galleries were also involved in the exhibition's organization.

Marx-Saunders Gallery. *Janusz Walentynowicz.* Chicago: Marx-Saunders Gallery, 1999. Catalogue for the exhibition held July 9–August 31, 1999. Text by James Yood.

Steven Weinberg

Habatat Galleries. *Carlson/Weinberg.* Boca Raton, Fla.: Habatat Galleries, 1990.

Marx-Saunders Gallery. *Strong Currents: Steven Weinberg.* Chicago: Marx-Saunders Gallery, 2000. Catalogue for the exhibition held March 24–April 24, 2000. Text by John Brunetti.

Salon International de la Sculpture. *Steven Weinberg.* Delle, France: Salon International de la Sculpture, 2000. Texts by John Brunetti and Serge Lechaczynski.

Toots Zynsky

Stedelijk Museum. *Toots Zynsky: Tierra del Fuego Series.* Amsterdam: Stedelijk Museum, 1989. Catalogue for the exhibition held May 20–June 30, 1989. Text by Dan Klein. Text in English, Dutch, and German.

Tognon, Paola. "Capelli di vetro/Glass Hair." *Vetro* 4, no. 11 (April–June 2001), pp. 18–22, ill. Text in Italian and English.

Note: Books and journals are arranged by year, along with selected historical events. Chronological notes are provided to help orient the nonspecialist reader and have been chosen to complement the essay and place the artworks in this book in greater context.

The history of contemporary glass is discussed thoroughly in many of the books listed below. This chronological bibliography does not attempt to repeat their stories; instead, it provides a brief overview of larger trends and a selection of key events and details. It has been edited and interpreted to fit the limited space available in this book, and the bias is toward American furnace glass, paralleling the choice of artists in the exhibition. In addition to exhibition catalogues and survey books, technical publications are interspersed to highlight the development of technical knowledge, to illustrate the dissemination of information about techniques, and to direct readers who wish to learn more about glassmaking. For books, catalogues, and articles related to individual artists in this exhibition, see the Artists' Selected Bibliographies on page 121.

Readers are referred to the Checklist in *New Glass Review* for a more complete overview of the period. Another useful resource is the Art Alliance for Contemporary Glass Web site, ‹www.contempglass.org/index.html›, which provides information about local contemporary glass collectors' groups and a calendar of exhibitions, as well as links to artists, galleries and museums, organizations, publications, schools, and more.

1940S–60S

1942
■ Harvey K. Littleton creates a small glass sculpture representing a nude female torso, slipcast from Vycor Multiform glass, at Corning Glass Works, Corning, New York.

1946
Glass Review (Czech), vol. 1 (1946). Continues through vol. 51 (1996); continued online at ‹www.glassrevue.com/›.

1957
American Craftsmen's Council. *Asilomar.* New York: American Craftsmen's Council, 1957. Report of the First Annual Conference of the American Craftsmen's Council, June 1957, Asilomar, California. Includes discussions of glass and enamels by Edris Eckhardt, Michael Higgins, Ellamarie and Jackson Woolley, and others.

1958
■ Littleton melts glass in a ceramic kiln and initiates some rough blowing experiments.

Stennett-Wilson, Ronald. *The Beauty of Modern Glass.* London: Studio, 1958.

1959
■ Robert Willson works with artisans in Murano, Italy, including Fratelli Toso, to make glass sculptures within the factory setting.

■ *Glass 1959* exhibition of modern glass at the Corning Museum of Glass, Corning, New York.

■ Littleton presents findings to the Third Annual Conference of the American Craftsmen's Council, Lake George, New York, and exhibits glass shapes he has made.

American Craftsmen's Council. *The Craftsman's World.* New York: American Craftsmen's Council, 1959. Report of the Third Annual Conference of the American Craftsmen's Council, June 1959, Lake George. Discussions about glass include Maurice Heaton, Michael Higgins, Harvey Littleton, Earl McCutchen, Paul Perrot, and others.

Corning Museum of Glass. *Glass 1959: A Special Exhibition of International Contemporary Glass.* Corning, N.Y.: Corning Museum of Glass, 1959.

1960
■ Thomas Stearns becomes guest designer for Venini Glass, Murano, Italy.

1961
■ Fourth National Conference of the American Craftsmen's Council held August 26–29 at the University of Washington, Seattle. A panel including Kenneth Wilson, curator at the Corning Museum of Glass, Paul Perrot, and Littleton considers the future possibilities of glass for craftsmen. Glass artists Michael Higgins, Edris Eckhardt, and John Burton discuss their own work. Russell Day (*dalle de verre* and kiln forming) and Frederic Schuler (scientist at Corning Glass Works) also take part. Many consider these the founding events of the studio glass movement.

American Craftsmen's Council. *Research in the Crafts.* New York: American Craftsmen's Council, 1961. Papers delivered at the Fourth National Conference of the American Craftsmen's Council by Burton, Eckhardt, Day, Higgins, Littleton, Perrot, and Schuler.

1962
■ Littleton holds two workshops in March and June at the Toledo Museum of Art, experimenting with melting glass in a small furnace and creating blown pieces with the help of Dominick Labino and others. These workshops made molten glass available to artists working in private studios for the first time.

■ Littleton meets glassmaker Erwin Eisch in Frauenau, Germany, while making a survey of glass educational opportunities in Europe.

Polak, Ada. *Modern Glass.* London: Faber & Faber, 1962.

Toledo Museum of Art. *Glass Workshop Report, June 1962.* Toledo, Ohio: Toledo Museum of Art, 1962. Texts by Harvey K. Littleton, Harvey Leafgreen, and Dominick Labino.

1963
■ Littleton teaches glassblowing at the University of Wisconsin, Madison, the first such class to be part of the permanent curriculum of an American university.

■ Joel Philip Myers hired as director of design for Blenko Glass Co., Milton, West Virginia. He will leave in 1970 to establish a glass program at Illinois State University, Normal.

Beguin, Jean, ed. *Verrerie Européene 1958–1963: catalogue de l'exposition des dons faits au Musée du Verre de la Ville de Liège par les verreries exposants.* Liège: Musée du Verre, 1963.

Raban, J. *Modern Bohemian Glass.* Prague: Artia, 1963.

1964
■ Labino plans and builds a furnace for glassblowing demonstrations at Columbia University during the World Congress of Craftsmen in New York; glassmaking demos include Littleton and his students; Erwin Eisch; and Sybren Valkema.

■ Littleton holds a four-week seminar at the University of Wisconsin in Madison. Marvin Lipofsky helps with demos, and Robert Fritz and Russell Day attend the seminar. They will later start glassblowing programs at American universities.

1965
■ The Museum of Modern Art, New York, acquires a studio glass sculpture by Littleton.

Late 1960s–70s

■ Emphasis on technology and education.

■ Experimental discovery of the material through trial and error.

■ Self-expression (not sales) most important.

■ Male-dominated.

■ Primarily hot (furnace) glass; some slumping plate glass, laminating pieces of blown forms, fusing, etc.

■ Few critics; limited interest by museums and galleries.

■ Equipment: furnaces, tools, glass.

■ Long-standing techniques, such as the "fuming" and "feathering" popular during the Art Nouveau period, are continually reinvented and updated, even to this day.

Bibliography
by Beth Hylen

Chronology
by Beth Hylen and William Warmus

- Part of broader international craft movement of the 1960s in which clay, fiber, wood, and metal are used for creative expression.
- Dichotomy exists between the sculptor in search of form (the "technique is cheap" attitude) vs. the craftsman striving to create a perfectly executed functional object.

1966

Toledo Museum of Art. *Toledo Glass National 1–3*. Toledo, Ohio: Toledo Museum of Art, 1966, 1968, and 1970. A series of national competitive exhibitions for designer-craftsmen in glass. A selection was circulated by the Smithsonian Institution Traveling Exhibition Service in 1969–70 and 1970–71.

1966–67

- Sybren Valkema and Willem Heesen melt glass at Gerrit Rietveld Acadamie, The Netherlands; their glass program will officially begin in 1969.

1967

- The Czech pavilion at Expo 67 Montreal includes glass work by Stanislav Libenský and Jaroslava Brychtová.
- Sam Herman and William Michael Harris conduct the first glass workshop at the Royal College of Art, London.
- John Burton continues to explore lampworking, experiments with color formulas, and teaches at Pepperdine College (now University), Malibu, California. He would teach and influence many lampworkers including Suellen Fowler and Jeff Spencer.

Burton, John. *Glass: Philosophy and Method, Hand-blown, Sculptured, Colored*. Philadelphia: Chilton Book Co., 1967.

Glassexport. *Cristal de Bohême uniquement de Tchécoslovaquie: Expo 67*. Prague: Glassexport, 1967.

University of Texas at Austin, University Art Museum. *First Survey of Contemporary American Crafts*. Austin: University Art Museum, c. 1967. Catalogue for the exhibition held April 9–May 14, 1967. Includes works by Edris Eckhardt, Maurice Heaton, Frances Stewart Higgins, Michael Higgins, Frank L. Kulasiewicz, Dominick Labino, Marvin B. Lipofsky, Harvey K. Littleton, Richard Marquis, Earl McCutchen, Joel Philip Myers, Zora Norris, James M. Wayne, and others. Although this exhibition may indeed have been the first survey presented at the University Art Museum, it was not the first such survey to be shown in the United States.

1968

- Dale Chihuly in Italy on Fulbright Scholarship; is the first American glassblower to work at Venini.
- Asa Brant establishes the first small glassmaking studio in Sweden.
- Labino sculpture commissioned by Toledo Museum of Art.

Hammesfahr, James, and Clair I. Strong. *Creative Glass Blowing*. San Francisco: W. H. Freeman, 1968.

International Congress on Glass. *Studies in Glass History and Design: Papers Read to Committee B Sessions of the VIII International Congress on Glass, Held in London, 1st–6th July 1968*. Eds. R. J. Charleston (history), Wendy Evans (design), and A. E. Werner (scientific aspects of historical studies). Sheffield, England: Society of Glass Technology, 1970.

Labino, Dominick. *Visual Art in Glass*. Dubuque, Iowa: William Brown Company, 1968.

1969

- The Glasshouse is established in London by Sam Herman.
- Richard Marquis awarded a Fulbright-Hayes fellowship to work in Murano at Venini.
- Chihuly heads Rhode Island School of Design program.
- First European exhibition of studio glass, *Vrij Glas,* organized by Sybren Valkema for the Museum Boymans-van Beuningen, Rotterdam.

International Commission on Glass. *Eighth International Congress on Glass*. Sheffield, England: Society of Glass Technology, 1969. Sponsored by the International Commission on Glass. Contains review lectures and abstracts of papers presented during seminars at Eighth International Congress on Glass in London held July 1–6, 1968. Littleton and others participate.

Lee Nordness Galleries. *Harvey K. Littleton: Glass Sculpture*. New York: Lee Nordness Galleries, Inc., 1969. Introduction by Tracy Atkinson.

Museum Boymans-van Beuningen. *Vrij Glas: Erwin Eisch, Sam Herman, Harvey Littleton, Marvin Lipofsky*. Rotterdam: Museum Boymans-van Beuningen, 1969. Text by Sybren Valkema.

1970s

- Studio glass survey exhibitions and galleries devoted to glass begin to appear.
- The studio movement creates a new industry for glassmaking-related products. Equipment, tools, and materials become increasingly available to studio artists (Kugler color rods, Norstar borosilicate colors, new furnace designs). Changes in glass composition from 475 marbles in the early 1960s to clear Coke bottles used by schools in the 1970s to West Virginia glass companies selling artists their cullet and, finally, batch companies, such as Littleton Batch Co., making glass specifically for studio glass artists.
- Paoli Clay Co. is among the first to sell glassmaker's tools in the United States; previously tools were imported from Germany.
- Explosion of glass schools and studios in the 1970s and 1980s paves the way for a new industry of glass tools and equipment.

1970

Nordness, Lee. *Objects: USA*. New York: Viking Press (A Studio Book), 1970. Published in conjunction with the landmark traveling exhibition organized by S. C. Johnson Company that opened at the Smithsonian Institution in 1969. It focuses on the "new crafts movement" that elevates the "handcrafted object . . . to a new status," including studio glass.

1971

- Habatat Gallery opens in Lathrup Village, Michigan.
- Contemporary Glass Group opens in New York City (becomes Heller Gallery in 1973).
- Pilchuck Glass Center, Seattle, established by Dale Chihuly with John Hauberg and Anne Gould Hauberg.
- Glass Art Society established; first conference held in Penland, North Carolina.

Littleton, Harvey K. *Glassblowing: A Search for Form*. New York: Van Nostrand Reinhold, 1971. Brief history of twentieth-century glass, composition of glass, tools, techniques, safety.

1972

- National Sculpture Conference in Lawrence, Kansas; Littleton introduces his phrase "Technique is cheap."

American Glass Now. Toledo, Ohio: Toledo Museum of Art, 1972. Catalogue for the traveling exhibition organized by the Toledo Museum of Art and the Museum of Contemporary Glass of the American Crafts Council. Also shown at the Carnegie Institute Museum of Art, Pittsburgh; the Corning Museum of Glass, Corning, New York; Renwick Gallery, National Museum of American Art, Smithsonian Institution, Washington, D.C.; San Francisco Museum of Art; and Santa Barbara Museum of Art.

International Glass Symposium. *Report on the First International Glass Symposium Held at Museum Bellerive, from June 4–9, 1972*. Zürich: Museum Bellerive, 1972.

Museum Bellerive. *Glas Heute: Kunst oder Handwerk?* Zürich: Museum Bellerive, 1972. Catalogue for the exhibition held June 4–August 13, 1972 in conjunction with the First International Glass Symposium. Text by Erika Billeter.

1973

- Heller Gallery opens in New York City (formerly called the Contemporary Glass Group).

Glass Art Magazine (Oakland, Calif.), vol. 1 (1973). Continues through vol. 4 (1976); becomes *Glass* in 1977; suspends publication in 1983.

1974

Ball State University Art Gallery. *Glass Works*. Muncie, Ind.: Ball State University Art Gallery, 1974. Catalogue for the exhibition held October 6–31, 1974. Includes works by Henry Halem, Audrey Handler, Dominick Labino, Harvey Littleton, Tom McGlauchlin, Joel Philip Myers, Kim Newcomb, and Eriks Rudans.

Belk Art Gallery. *North Carolina Glass '74*. Cullowhee, N.C.: Western Carolina University, 1974. Exhibitions and catalogues continue every two years through 1986; additional exhibitions are held in 1990 and 1995.

Flavell, Ray, and Claude Smale. *Studio Glassmaking*. New York: Van Nostrand Reinhold, 1974.

Kulasiewicz, Frank. *Glassblowing*. New York: Watson-Guptill Publications, 1974.

1975

Brooks Memorial Art Gallery. *Harvey K. Littleton: Glass Sculpture, Prints from Glass*. Memphis, Tenn.: Brooks Memorial Art Gallery, 1975. Catalogue for the exhibition held March 29–April 27, 1975.

Crafts Board of the Australia Council. *Glass*. N.p.: Crafts Board of the Australia Council, 1975. Catalogue for the traveling exhibition of contemporary American glass by W. Bernstein, Billeci, Carpenter, Chihuly, Halem, Hoard, Lipofsky, Littleton, Marquis, Myers, and Zandhuis.

Grover, Ray, and Lee Grover. *Contemporary Art Glass*. New York: Crown Publishers, 1975.

Lynggaard, Finn. *Glas Handbogen*. Copenhagen: Clausens Forlag, 1975.

1976

Beard, Geoffrey. *International Modern Glass*. London: Barrie & Jenkins, 1976.

Contemporary Glass, 1976–1978. 3 vols. Corning, N.Y.: Corning Museum of Glass, 1976–78. Catalogues for annual competitions. Becomes *New Glass Review* in 1980.

Glass Art Society Newsletter (Oakland, Calif.), 1976–78. Becomes *Glass Art Society Journal* in 1979.

Museum Bellerive. *Transparente Formen: 4 Glasmacher aus Prag*. Zürich: Museum Bellerive, 1976. Catalogue for the exhibition held December 2, 1976–February 13, 1977. Includes Václav Cigler, Pavel Hlava, Stanislav Libenský, František Vízner.

Museum für Kunsthandwerk. *Modernes Glas aus Amerika, Europa und Japan*. Frankfurt am Main: Museum für Kunsthandwerk, 1976. Catalogue for the exhibition held May 15–June 27, 1976; traveled to Staatliche Museen Preussischer Kulturbesitz, Berlin, August 13–September 26, 1976; and Museum für Kunst und Gewerbe, Hamburg, October 6–November 14, 1976.

1977

Giberson, Dudley F., Jr. *Joppa Glassworks Catalogue of Fact and Knowledge*. Warner, N.H.: Joppa Glassworks, 1977.

Kunstsammlungen der Veste Coburg. *Glaspreis 1977 für moderne Glasgestaltung in Europa/Coburg Glass Prize 1977 for Modern European Studio Glass/Prix de Coburg 1977 pour l'art du verre contemporain de l'Europe*. Coburg, Germany: Heino Maedebach, 1977. Catalogue for first studio glass competition in Europe; planned and executed by Heino Maedebach.

Newman, Harold. *An Illustrated Dictionary of Glass*. London: Thames and Hudson, 1977. Includes introductory survey of glassmaking by Robert J. Charleston.

1978

Glass Studio (Portland, Ore.), no. 1 (January–February 1978); continues through no. 46 (December 1985).

Huntington Galleries. *New American Glass, Focus West Virginia: Invitational Exhibition, 1978.* Huntington, W.Va.: Huntington Galleries, 1978. Five catalogues were published for annual invitational exhibitions, 1978–84; each volume focuses on the work of four studio glass artists.

Japan Glass Artcrafts Association. *Glass '78 in Japan.* [Tokyo]: Asahi Shinbun, 1978. Catalogue for the exhibition at Odakyu Department Store Grand Gallery, Tokyo, September 8–20, 1978; held in conjunction with the Eighth World Crafts Council Conference, Kyoto, September 11–15, 1978. The first triennial exhibition and catalogue sponsored by Japan Glass Artcrafts Association.

Leigh Yawkey Woodson Art Museum. *Americans in Glass.* Wausau, Wis.: Leigh Yawkey Woodson Art Museum, 1978. Catalogue for the exhibition held December 2, 1978–January 14, 1979; three-year national tour sponsored by the Western Association of Art Museums. Subsequent catalogues published for exhibitions in 1981 and 1984; the first *Americans in Glass* exhibition was in 1976.

Preble, Duane, and Sarah Preble. *Artforms.* San Francisco: Canfield Press, 1978. Art history textbook showing glass sculpture.

1979

■ Lino Tagliapietra, Italian maestro, teaches at Pilchuck.

Adlerová, Alena. *Contemporary Bohemian Glass.* Prague: Odeon, 1979.

Bruce, Jane. *Glassblowing: A Manual of Basic Techniques.* London: Crafts Council, 1979.

Corning Museum of Glass. *New Glass: A Worldwide Survey.* Corning, N.Y.: Corning Museum of Glass, 1979. Catalogue for the traveling exhibition presented during 1979–82 at the Corning Museum of Glass; the Toledo Museum of Art, Toledo, Ohio; Renwick Gallery, National Museum of American Art, Smithsonian Institution, Washington, D.C.; the Metropolitan Museum of Art, New York; the Fine Arts Museums of San Francisco; Victoria and Albert Museum, London; Musée des arts décoratifs, Paris; and Seibu Museum of Art, Tokyo. Introduced the American studio movement to American, European, and Japanese audiences.

Glass Art Society Journal (Oakland, Calif.), 1979–.

Stern, Rudi. *Let There Be Neon.* New York: Harry N. Abrams, 1979. Revised and expanded edition, 1996.

Studio Glas: Pionere der Glaskunst. Eds. Charlotte von Finckenstein, Pavel Molnar, and Gundi Molnar. N.p., 1979. Catalogue for the exhibition held at Rittersaal, Barsbüttel, November 1979; Galerie L, Hamburg, December 1979; and SM Galerie, Frankfurt, February–March 1980. Includes works by Erwin Eisch, Raoul Goldoni, Pavel Hlava, Dominick Labino, Marvin Lipofsky, Harvey Littleton, Joel Philip Myers, and Sybren Valkema.

1980s

■ Artists pursue narrative, political, gender issues.

■ More multimedia work, combining glass with other materials (wood, metal, paint, stone).

■ "Art vs. craft" debate pushes aside technical issues.

■ New interest in alternatives to hot glass: *pâte de verre*, lampworking, kilnworking, coldworking, even microwaved glass jewelry.

■ Women play increasingly prominent role.

■ Art museums begin to exhibit glass in contemporary art sections, not only in decorative arts galleries.

1980

■ Glass magazines flourish.

Craft and Folk Art Museum. *Four Leaders in Glass: Dale Chihuly, Richard Marquis, Therman Statom, Dick Weiss.* Los Angeles: Craft and Folk Art Museum, 1980. Catalogue for the exhibition held January 29–March 23, 1980.

Cummings, Keith. *The Technique of Glass Forming.* London: B. T. Batsford, 1980.

Elskus, Albinus. *The Art of Painting on Glass.* New York: Scribner, 1980.

Neues Glas/New Glass (Düsseldorf), no. 1 (April) 1980–. Four issues yearly. Published by Verlagsanstalt Handwerk. Available online at ‹www.glpnews.com/TP/NeuesGlas.html›.

New Glass Review, no. 1, 1980–. Published by the Corning Museum of Glass, Corning, New York. Journal includes checklist of publications relating to glass made from 1945 to the present. Available online at ‹www.cmog.org/›.

New Work, no. 1 (1980). Continues through no. 38 (1989). Published by the New York Experimental Glass Workshop. Becomes *Glass,* published by the New York Experimental Glass Workshop/Urban Glass, in 1990.

Vízner, František. "Poznámky k pochopení jednoho vztahu." *Umení a Remesla,* no. 4 (1980), pp. 9–10, ill. Relationship of glass artists to designers and craftsmen-producers. English summary.

1981

Corning Museum of Glass. *Czechoslovakian Glass: 1350–1980.* Corning, N.Y.: Corning Museum of Glass; New York: Dover, 1981. Catalogue for the exhibition organized by the Corning Museum of Glass and the Museum of Decorative Arts, Prague; held at the Corning Museum of Glass, May 2–November 1, 1981. Text by Dagmar Hejdová, Olga Drahtová, Jarmila Brozová, and Alena Adlerová.

Glaskunst '81: Internationale Ausstellung zur Studioglasbewegung der Gegenwart. Kassel: Orangerie, 1981.

Lynggaard, Finn. *La verrerie artisanale.* Paris: Dessain et Tolra, 1981.

National Museum of Modern Art, Kyoto. *Contemporary Studio Glass: An International Collection.* New York, Tokyo, and Kyoto: Weatherhill/Tankosha, 1981.

Voronov, Nikita, ed. *Sovetskoe Khudozhestvennoe Stekloe/Soviet Glass.* Leningrad: Aurora Art Publishers, 1981.

Wagga Wagga City Art Gallery. *Contemporary Australian Glass: First Wagga Wagga National Contemporary Australian Glass Exhibition.* Wagga Wagga, Australia: City Art Gallery, 1981. Catalogue for the National Glass Biennial; the exhibition often traveled to other Australian cities.

1982

Art Gallery of Western Australia. *International Directions in Glass Art.* Perth: Australian Consolidated Industries and Art Gallery of Western Australia, 1982. Catalogue for the exhibition; toured in Australia. Texts by Robert Bell, Penelope Hunter-Stiebel, Stanislav Libenský, and Michael Esson.

Australian Association of Glass Artists (Ausglas). *Dictionary of Hot Glass Circumstance.* N.p.: Underdale South Australian College of Advanced Education, 1982.

Bizot, Chantal, Yvonne Brunhammer, and Jean-Luc Olivié. *Verriers français contemporains: art et industrie.* Paris: Musée des arts décoratifs, 1982. Catalogue for the exhibition organized for the French presentation of *New Glass: A Worldwide Survey* held April 2–July 5, 1982.

Castle Gallery, College of New Rochelle. *Glass: Artist, Designer, Industry.* New Rochelle, N.Y.: College of New Rochelle, 1982. Catalogue for the exhibition curated by Don Shepherd and Douglas Heller.

Chelsea Gallery. *Dominick Labino: Glass Retrospective.* Cullowhee, N.C.: Western Carolina University, 1982. Catalogue for the exhibition held at Chelsea Gallery, Hinds University Center, Western Carolina University, October 10–November 10, 1982. Text by Joan Falconer Byrd; autobiographical narrative by Labino.

Glass Now. Hamamatsu: Nihon Gakki Seizo Kabushiki Kaisha, [1982–95]. Catalogues for the traveling exhibitions organized by Takako Sano and Nihon Gakki Seizo Kabushiki Kaisha and held annually at various places in Japan.

Hokkaidoritsu Kindai Bijutsukan. *World Glass Now '82.* Sapporo: Hokkaido Museum of Modern Art, 1982. Catalogue for the World Glass Now Triennial exhibition; also held in 1985, 1988, 1991, and 1994.

Matcham, Jonathan, and Peter Dreiser. *The Techniques of Glass Engraving.* London: Batsford, 1982.

1983

■ The Creative Glass Center of America, a division of Wheaton Village, Inc., is formed to provide fellowships to emerging artists working in glass.

■ The Metropolitan Contemporary Glass Group, the first continuous collector's glass group, is founded.

Cappa, Giuseppe. *Cent ans d'art verrier en Europe: de l'art nouveau à l'art actuel.* Brussels: Société Générale de Banque, 1983. Catalogue for the exhibition held at Société Générale de Banque, Brussels, March 24–May 20, 1983; and Banque Générale du Luxembourg, June 2–July 8, 1983.

Lundstrom, Boyd, and Dan Schwoerer. *Glass Fusing.* Portland, Ore.: Vitreous Publications, 1983. The authors also wrote books about advanced fusing and kilnworking techniques.

Ricke, Helmut, Jochem Poensgen, and Hans Gottfried von Stockhausen. *Neues Glas in Deutschland/New Glass in Germany.* Düsseldorf: Verlagsanstalt Handwerk, 1983. Catalogue for the exhibition organized by the Kunstmuseum Düsseldorf.

Sunderland Arts Centre. *British Studio Glass.* Sunderland, England: Sunderland Arts Centre, 1983. Catalogue for the exhibition touring in Scandinavia 1983–84. Text by Charles Bray.

Tucson Museum of Art. *Sculptural Glass.* Tucson, Ariz.: Tucson Museum of Art, 1983. 2 vols. Catalogue for the exhibition, held in connection with the Glass Art Society conference, at the Tucson Museum of Art, February 13–April 3, 1983; traveled to Owens-Illinois World Headquarters Building, Toledo, Ohio, May 15–June 30, 1983.

1984

Hampson, Ferdinand, ed. *Glass: State of the Art I.* Huntington Woods, Mich.: Elliot Johnston, 1984. Publication inspired by Habatat Gallery's Twelfth Annual National Glass Invitational, Lathrup Village, Michigan, 1984.

High Museum of Art. *Harvey K. Littleton: A Retrospective Exhibition.* Atlanta, Ga.: High Museum of Art, 1984. Text by Joan Falconer Byrd.

Klein, Dan, and Ward Lloyd, eds. *The History of Glass.* London: Orbis, 1984.

Willard, David. *Contemporary Glass: A Decade Apart.* Boise, Idaho: Boise Gallery of Art, 1984. Catalogue for the exhibition held May 19–June 24, 1984. Preface by William Warmus. Artists included Dale Chihuly, Jon F. Clark, Dan Dailey, David R. Huchthausen, Robert Kehlmann, Marvin B. Lipofsky, Paul Marioni, Richard Marquis, Mark Peiser, Richard Posner, Narcissus Quagliata, and Michael Taylor.

Mid-1980s

■ "Craft vs. art" debate heats up.

■ Glass Art Society places technical articles in a separately bound journal.

- Move toward professionalism; artists concentrate on the business of running a studio and developing marketing strategies to create a stable livelihood.
- Production of technically assured, confident works.
- Greater interest in content, using glass as a contemporary sculpture medium.
- Collectors build collections based less on investment value and more on the inherent worth of the artworks. Camaraderie of collectors and friendly competition for the most beautiful artworks lead to a relatively stable market and the development of a glass community.
- Use of glass as a fine-art medium.
- Reaction against the "beauty" of glass.
- Auctions of contemporary glass begin at Sotheby's and Christie's.

1985
- Glass Weekend begins at Wheaton Village, Millville, New Jersey. The biennial seminar brings together leading contemporary glass artists, collectors, galleries, and museum curators.
- Craft Emergency Relief Fund (CERF) formed; begins giving loans in 1987 to professional craftspeople suffering career-threatening emergencies.

Kunstsammlungen der Veste Coburg. *Zweiter Coburger Glaspreis für moderne Glasgestaltung in Europa/Second Coburg Glass Prize for Modern Studio Glass in Europe/ Deuxième prix de Coburg de l'art du verre contemporain en Europe.* Coburg, Germany: Kunstsammlungen der Veste Coburg, [1985]. Catalogue for the exhibition held July 14–October 13, 1985. Texts by Joachim Kruse, Minni Maedebach, and Susanne Netzer.

Patterson, Alan J. *How Glass Is Made.* New York: Facts on File, 1985. Children's book introducing basic glassmaking.

1986
- Glasmuseum Ebeltoft, Denmark, founded by glass artist Finn Lynggaard for presentation of international contemporary glass.
- First annual Rakow Commission awarded by the Corning Museum of Glass. The commission is established to encourage fine glassmaking and the development of new works of art in glass.

Interglas Symposium Ceskoslovensko. Novy Bor, Czechoslovakia: Crystalex, n.d. Catalogue for both the first symposium held October 18–24, 1982, and the second held October 21–27, 1985. Text by Antonin Langhamer.

Musée des arts décoratifs de la Ville de Lausanne. *Expressions en verre: 200 sculptures contemporaines, Europe, USA, Japan.* Lausanne: Musée des arts décoratifs de la Ville de Lausanne, 1986. Catalogue for the exhibition held September 26, 1986–January 4, 1987.

Oakland Museum. *Contemporary American and European Glass from the Saxe Collection.* Oakland, Calif.: Oakland Museum, 1986.

Philippe, Joseph. *Contemporary Western European Sculptures in Crystal and Glass, 1983–1986.* Liège: Générale de Banque, 1986. Catalogue for the triennial exhibition; includes works by thirty-eight glass artists from eleven Western European countries. The 1989 exhibition will include ninety-four glass artists and firms from twenty European countries.

1987
- Dominick Labino dies (1910–1987).
- The Art Alliance for Contemporary Glass (AACG) is established for collectors of contemporary glass.

Contemporary Glass: The Collection of Jean and Hilbert Sosin: Twenty-five Years of Studio Glass. Dearborn: University of Michigan, 1987. Catalogue for the exhibition held April 3–June 15, 1987. Texts by C. Edward Wall and Davira S. Taragin.

Glasmuseum Ebeltoft. *Young Glass '87: An International Competition.* Ebeltoft, Denmark: Glasmuseum Ebeltoft, 1987. Catalogue for the exhibition held July 5–September 13, 1987.

Glass Focus, no. 1, 1987–. Published by the Art Alliance for Contemporary Glass (AACG).

Glass in the Environment Conference. *Report on Proceedings.* Ed. Michael Wigginton. London: Crafts Council, 1987. Report on *Glass Today*, an international conference held at the Royal College of Art, the Royal Institute of British Architects, and Pilkington Glass Ltd., London, 1986.

Philbrook Museum of Art. *The Eloquent Object: The Evolution of American Art in Craft Media since 1945.* Eds. Marcia Manhart and Tom Manhart. Tulsa, Okla.: Philbrook Museum of Art; Seattle: University of Washington Press, 1987. Catalogue for the exhibition organized by the Philbrook Museum of Art; travels nationally 1987–89 and to Japan 1989–90.

1988
Bloch-Dermant, Janine. *Le verre en France les années 80.* Paris: Les Éditions de l'Amateur, 1988.

Glasmuseum Frauenau. *III. Internationales Glas-Symposium, 11.–15. Mai 1988; Internationales Glas '88 Sonderausstellung im Glasmuseum Frauenau 15. Mai–25. Juli 1988.* Frauenau, Germany: Glasmuseum, 1988. Catalogue for the third international glass symposium in Frauenau. Includes Harvey K. Littleton, "Studioglasbewegung Gestern—Heute—Morgen" [Studio glass movement yesterday—today—tomorrow]. Text in German and English.

Heineman, Ben. *Contemporary Glass: A Private Collection.* Chicago: Falcon II Press, 1988.

Hessisches Landesmuseum. *Bildwerke in Glas: 25 Jahre New Glass in Amerika.* Darmstadt: Hessisches Landesmuseum Darmstadt, 1988.

The Independent Glassblower, no. 1 (1988). Continues through no. 55 (September–November 1999). Published in West Barnet, Vermont, by D. Gruenig and B. Dugger; intended as a forum for "hot glass information exchange."

International Exhibition of Glass Craft. *The International Exhibition of Glass Craft '88.* Kanazawa, Japan: Executive Committee of the International Exhibition of Glass Craft, 1988. Catalogue for the exhibition held at Ishikawa Industrial Exhibition Hall, Kanazawa, May 1–5, 1988, in conjunction with the third International Exhibition of Glass Craft. Text in English and Japanese. This was the first time the exhibition was a juried competition; no catalogues were issued for the first two exhibitions in 1984 and 1986.

Moderne internationale Glaskunst. Ebeltoft, Denmark: Glasmuseum, 1988. A brief guide to the Glasmuseum, a private institution operated by the Collection of Modern International Glass Art.

Sano, Takako. *A Decade with Studio Glass.* N.p., 1988. Text in Japanese.

1989
- First overviews of studio glass movement by major publishers.

Frantz, Susanne K. *Contemporary Glass: A World Survey from the Corning Museum of Glass.* New York: Harry N. Abrams, 1989.

Hampson, Ferdinand, ed. *Glass: State of the Art II.* Huntington Woods, Mich.: Elliot Johnson, 1989. Survey of the studio glass movement since 1984.

Klein, Dan. *Glass: A Contemporary Art.* New York: Rizzoli International, 1989.

Musée des arts décoratifs de la Ville de Lausanne. *Expressions en verre II: 140 sculptures de verre contemporaines d'artistes européens, américains, canadiens, japonais, australiens de la Collection du Musée des arts décoratifs, Lausanne.* Lausanne: Musée des arts décoratifs de la Ville de Lausanne, 1989. Catalogue for the exhibition *Les univers de la transparence,* June 21–September 30, 1989.

Warmus, William. *The Venetians: Modern Glass, 1919–1990.* New York: Muriel Karasik Gallery, 1989.

1990–2002
- Surge in art museum exhibitions and catalogues devoted to studio glass.
- Collectors lend/donate their collections to museums.
- Schools for glassmaking multiply throughout the United States and worldwide, as tracked in the Glass Art Society membership list, "Education Roster," and the Steinert Industries Web site, <www.steinertindustries.com/>.
- Influence of Venetian and Czech glass strengthens throughout the 1990s.
- Levels of technical skill reach an apogee.
- Studio glass workshops range from one-person workshops to one person directing assistants who produce the glass; teamwork becomes an accepted procedure.
- Opening up of former Soviet-bloc countries, notably the CSSR, increases exchange of information.
- Internet resources related to contemporary glass emerge, including journals such as *Glass Line* at <www.hotglass.com/> (for lampworkers and other glassmakers) and *Hot Bits* at <ourworld.compuserve.com/homepages/MikeFirth/> (for "molten glassworkers"); Internet books such as Robert Mickelson and Jennifer Zamboli, *Mondo Fiamma: A Global Overview of Flameworked Glass Art* at <www.global-flamework.com/contents.htm>; and numerous chat sites.

1990
Davenport Museum of Art. *Contemporary Developments in Glass: A Season of Light.* Davenport, Iowa: Davenport Museum of Art, 1990. Brochure for the exhibition held October 26–December 28, 1990. Text by Daniel E. Stetson.

Glass, no. 39, 1990–. Published by the New York Experimental Glass Workshop/Urban Glass.

Glass Fantasy: From Art Nouveau to the Present Day. Kyoto: Kyoto Shoin Co., 1990. Text by Kimihiro Kurata, Toshio Kitazawa, Masaaki Iseki, Atsushi Takeda, Kiyoshi Suzuki, and Yoriko Mizuta. Objects are part of the collections of the Kitazawa Art Museum (Art Nouveau glass) and the Hokkaido Museum of Modern Art (contemporary glass). In Japanese and English.

John Michael Kohler Arts Center. *Structure and Surface: Beads in Contemporary American Art.* Sheboygan, Wis.: John Michael Kohler Arts Center, 1990. Catalogue for the exhibition held December 4, 1988–February 12, 1989; traveled to the Renwick Gallery, National Museum of American Art, Smithsonian Institution, Washington, D.C., July 27, 1990–January 13, 1991.

Netzer, Susanne. *Museum für modernes Glas/Museum of Modern Glass.* Ed. Joachim Kruse. Coburg, Germany: Kunstsammlungen der Veste Coburg, 1990. Catalogue for a collection located at the Orangerie at Schloss Rosenau, outside Coburg.

Petrová, Sylvá, and Jean-Luc Olivié, eds. *Bohemian Glass: 1400–1989.* Trans. Lysa Hochroth. New York: Abrams, 1990. English-language catalogue for the exhibition *Verres de Bohême, 1400–1989: chefs d'oeuvre des musées de Tchécoslovaquie,* organized by the Musée des arts décoratifs, Paris, and the Museum of Decorative Arts, Prague, October 1989–January 1990.

Ricke, Helmut. *Neues Glas in Europa/New Glass in Europe: 50 Kunstler, 50 Konzepte/50 Artists, 50 Concepts.* Düsseldorf: Verlagsanstalt Handwerk, 1990. Catalogue for the exhibition at Kunstmuseum Düsseldorf.

1978

Glass Studio (Portland, Ore.), no. 1 (January–February 1978); continues through no. 46 (December 1985).

Huntington Galleries. *New American Glass, Focus West Virginia: Invitational Exhibition, 1978.* Huntington, W.Va.: Huntington Galleries, 1978. Five catalogues were published for annual invitational exhibitions, 1978–84; each volume focuses on the work of four studio glass artists.

Japan Glass Artcrafts Association. *Glass '78 in Japan.* [Tokyo]: Asahi Shinbun, 1978. Catalogue for the exhibition at Odakyu Department Store Grand Gallery, Tokyo, September 8–20, 1978; held in conjunction with the Eighth World Crafts Council Conference, Kyoto, September 11–15, 1978. The first triennial exhibition and catalogue sponsored by Japan Glass Artcrafts Association.

Leigh Yawkey Woodson Art Museum. *Americans in Glass.* Wausau, Wis.: Leigh Yawkey Woodson Art Museum, 1978. Catalogue for the exhibition held December 2, 1978–January 14, 1979; three-year national tour sponsored by the Western Association of Art Museums. Subsequent catalogues published for exhibitions in 1981 and 1984; the first *Americans in Glass* exhibition was in 1976.

Preble, Duane, and Sarah Preble. *Artforms.* San Francisco: Canfield Press, 1978. Art history textbook showing glass sculpture.

1979

■ Lino Tagliapietra, Italian maestro, teaches at Pilchuck.

Adlerová, Alena. *Contemporary Bohemian Glass.* Prague: Odeon, 1979.

Bruce, Jane. *Glassblowing: A Manual of Basic Techniques.* London: Crafts Council, 1979.

Corning Museum of Glass. *New Glass: A Worldwide Survey.* Corning, N.Y.: Corning Museum of Glass, 1979. Catalogue for the traveling exhibition presented during 1979–82 at the Corning Museum of Glass; the Toledo Museum of Art, Toledo, Ohio; Renwick Gallery, National Museum of American Art, Smithsonian Institution, Washington, D.C.; the Metropolitan Museum of Art, New York; the Fine Arts Museums of San Francisco; Victoria and Albert Museum, London; Musée des arts décoratifs, Paris; and Seibu Museum of Art, Tokyo. Introduced the American studio movement to American, European, and Japanese audiences.

Glass Art Society Journal (Oakland, Calif.), 1979–.

Stern, Rudi. *Let There Be Neon.* New York: Harry N. Abrams, 1979. Revised and expanded edition, 1996.

Studio Glas: Pionere der Glaskunst. Eds. Charlotte von Finckenstein, Pavel Molnar, and Gundi Molnar. N.p., 1979. Catalogue for the exhibition held at Rittersaal, Barsbüttel, November 1979; Galerie L, Hamburg, December 1979; and SM Galerie, Frankfurt, February–March 1980. Includes works by Erwin Eisch, Raoul Goldoni, Pavel Hlava, Dominick Labino, Marvin Lipofsky, Harvey Littleton, Joel Philip Myers, and Sybren Valkema.

1980s

■ Artists pursue narrative, political, gender issues.

■ More multimedia work, combining glass with other materials (wood, metal, paint, stone).

■ "Art vs. craft" debate pushes aside technical issues.

■ New interest in alternatives to hot glass: *pâte de verre,* lampworking, kilnworking, coldworking, even microwaved glass jewelry.

■ Women play increasingly prominent role.

■ Art museums begin to exhibit glass in contemporary art sections, not only in decorative arts galleries.

1980

■ Glass magazines flourish.

Craft and Folk Art Museum. *Four Leaders in Glass: Dale Chihuly, Richard Marquis, Therman Statom, Dick Weiss.* Los Angeles: Craft and Folk Art Museum, 1980. Catalogue for the exhibition held January 29–March 23, 1980.

Cummings, Keith. *The Technique of Glass Forming.* London: B. T. Batsford, 1980.

Elskus, Albinus. *The Art of Painting on Glass.* New York: Scribner, 1980.

Neues Glas/New Glass (Düsseldorf), no. 1 (April) 1980–. Four issues yearly. Published by Verlagsanstalt Handwerk. Available online at ‹www.glpnews.com/TP/NeuesGlas.html›.

New Glass Review, no. 1, 1980–. Published by the Corning Museum of Glass, Corning, New York. Journal includes checklist of publications relating to glass made from 1945 to the present. Available online at ‹www.cmog.org/›.

New Work, no. 1 (1980). Continues through no. 38 (1989). Published by the New York Experimental Glass Workshop. Becomes *Glass,* published by the New York Experimental Glass Workshop/Urban Glass, in 1990.

Vízner, František. "Poznámky k pochopení jednoho vztahu." *Umení a Remesla,* no. 4 (1980), pp. 9–10, ill. Relationship of glass artists to designers and craftsmen-producers. English summary.

1981

Corning Museum of Glass. *Czechoslovakian Glass: 1350–1980.* Corning, N.Y.: Corning Museum of Glass; New York: Dover, 1981. Catalogue for the exhibition organized by the Corning Museum of Glass and the Museum of Decorative Arts, Prague; held at the Corning Museum of Glass, May 2–November 1, 1981. Text by Dagmar Hejdová, Olga Drahtová, Jarmila Brozová, and Alena Adlerová.

Glaskunst '81: Internationale Ausstellung zur Studioglasbewegung der Gegenwart. Kassel: Orangerie, 1981.

Lynggaard, Finn. *La verrerie artisanale.* Paris: Dessain et Tolra, 1981.

National Museum of Modern Art, Kyoto. *Contemporary Studio Glass: An International Collection.* New York, Tokyo, and Kyoto: Weatherhill/Tankosha, 1981.

Voronov, Nikita, ed. *Sovetskoe Khudozhestvennoe Stekloe/Soviet Glass.* Leningrad: Aurora Art Publishers, 1981.

Wagga Wagga City Art Gallery. *Contemporary Australian Glass: First Wagga Wagga National Contemporary Australian Glass Exhibition.* Wagga Wagga, Australia: City Art Gallery, 1981. Catalogue for the National Glass Biennial; the exhibition often traveled to other Australian cities.

1982

Art Gallery of Western Australia. *International Directions in Glass Art.* Perth: Australian Consolidated Industries and Art Gallery of Western Australia, 1982. Catalogue for the exhibition; toured in Australia. Texts by Robert Bell, Penelope Hunter-Stiebel, Stanislav Libenský, and Michael Esson.

Australian Association of Glass Artists (Ausglas). *Dictionary of Hot Glass Circumstance.* N.p.: Underdale South Australian College of Advanced Education, 1982.

Bizot, Chantal, Yvonne Brunhammer, and Jean-Luc Olivié. *Verriers français contemporains: art et industrie.* Paris: Musée des arts décoratifs, 1982. Catalogue for the exhibition organized for the French presentation of *New Glass: A Worldwide Survey* held April 2–July 5, 1982.

Castle Gallery, College of New Rochelle. *Glass: Artist, Designer, Industry.* New Rochelle, N.Y.: College of New Rochelle, 1982. Catalogue for the exhibition curated by Don Shepherd and Douglas Heller.

Chelsea Gallery. *Dominick Labino: Glass Retrospective.* Cullowhee, N.C.: Western Carolina University, 1982. Catalogue for the exhibition held at Chelsea Gallery, Hinds University Center, Western Carolina University, October 10–November 10, 1982. Text by Joan Falconer Byrd; autobiographical narrative by Labino.

Glass Now. Hamamatsu: Nihon Gakki Seizo Kabushiki Kaisha, [1982–95]. Catalogues for the traveling exhibitions organized by Takako Sano and Nihon Gakki Seizo Kabushiki Kaisha and held annually at various places in Japan.

Hokkaidoritsu Kindai Bijutsukan. *World Glass Now '82.* Sapporo: Hokkaido Museum of Modern Art, 1982. Catalogue for the World Glass Now Triennial exhibition; also held in 1985, 1988, 1991, and 1994.

Matcham, Jonathan, and Peter Dreiser. *The Techniques of Glass Engraving.* London: Batsford, 1982.

1983

■ The Creative Glass Center of America, a division of Wheaton Village, Inc., is formed to provide fellowships to emerging artists working in glass.

■ The Metropolitan Contemporary Glass Group, the first continuous collector's glass group, is founded.

Cappa, Giuseppe. *Cent ans d'art verrier en Europe: de l'art nouveau à l'art actuel.* Brussels: Société Générale de Banque, 1983. Catalogue for the exhibition held at Société Générale de Banque, Brussels, March 24–May 20, 1983; and Banque Générale du Luxembourg, June 2–July 8, 1983.

Lundstrom, Boyd, and Dan Schwoerer. *Glass Fusing.* Portland, Ore.: Vitreous Publications, 1983. The authors also wrote books about advanced fusing and kilnworking techniques.

Ricke, Helmut, Jochem Poensgen, and Hans Gottfried von Stockhausen. *Neues Glas in Deutschland/New Glass in Germany.* Düsseldorf: Verlagsanstalt Handwerk, 1983. Catalogue for the exhibition organized by the Kunstmuseum Düsseldorf.

Sunderland Arts Centre. *British Studio Glass.* Sunderland, England: Sunderland Arts Centre, 1983. Catalogue for the exhibition touring in Scandinavia 1983–84. Text by Charles Bray.

Tucson Museum of Art. *Sculptural Glass.* Tucson, Ariz.: Tucson Museum of Art, 1983. 2 vols. Catalogue for the exhibition, held in connection with the Glass Art Society conference, at the Tucson Museum of Art, February 13–April 3, 1983; traveled to Owens-Illinois World Headquarters Building, Toledo, Ohio, May 15–June 30, 1983.

1984

Hampson, Ferdinand, ed. *Glass: State of the Art I.* Huntington Woods, Mich.: Elliot Johnston, 1984. Publication inspired by Habatat Gallery's Twelfth Annual National Glass Invitational, Lathrup Village, Michigan, 1984.

High Museum of Art. *Harvey K. Littleton: A Retrospective Exhibition.* Atlanta, Ga.: High Museum of Art, 1984. Text by Joan Falconer Byrd.

Klein, Dan, and Ward Lloyd, eds. *The History of Glass.* London: Orbis, 1984.

Willard, David. *Contemporary Glass: A Decade Apart.* Boise, Idaho: Boise Gallery of Art, 1984. Catalogue for the exhibition held May 19–June 24, 1984. Preface by William Warmus. Artists included Dale Chihuly, Jon F. Clark, Dan Dailey, David R. Huchthausen, Robert Kehlmann, Marvin B. Lipofsky, Paul Marioni, Richard Marquis, Mark Peiser, Richard Posner, Narcissus Quagliata, and Michael Taylor.

Mid-1980s

■ "Craft vs. art" debate heats up.

■ Glass Art Society places technical articles in a separately bound journal.

- Move toward professionalism; artists concentrate on the business of running a studio and developing marketing strategies to create a stable livelihood.
- Production of technically assured, confident works.
- Greater interest in content, using glass as a contemporary sculpture medium.
- Collectors build collections based less on investment value and more on the inherent worth of the artworks. Camaraderie of collectors and friendly competition for the most beautiful artworks lead to a relatively stable market and the development of a glass community.
- Use of glass as a fine-art medium.
- Reaction against the "beauty" of glass.
- Auctions of contemporary glass begin at Sotheby's and Christie's.

1985
- Glass Weekend begins at Wheaton Village, Millville, New Jersey. The biennial seminar brings together leading contemporary glass artists, collectors, galleries, and museum curators.
- Craft Emergency Relief Fund (CERF) formed; begins giving loans in 1987 to professional craftspeople suffering career-threatening emergencies.

Kunstsammlungen der Veste Coburg. *Zweiter Coburger Glaspreis für moderne Glasgestaltung in Europa/Second Coburg Glass Prize for Modern Studio Glass in Europe/ Deuxième prix de Coburg de l'art du verre contemporain en Europe.* Coburg, Germany: Kunstsammlungen der Veste Coburg, [1985]. Catalogue for the exhibition held July 14–October 13, 1985. Texts by Joachim Kruse, Minni Maedebach, and Susanne Netzer.

Patterson, Alan J. *How Glass Is Made.* New York: Facts on File, 1985. Children's book introducing basic glassmaking.

1986
- Glasmuseum Ebeltoft, Denmark, founded by glass artist Finn Lynggaard for presentation of international contemporary glass.
- First annual Rakow Commission awarded by the Corning Museum of Glass. The commission is established to encourage fine glassmaking and the development of new works of art in glass.

Interglas Symposium Ceskoslovensko. Novy Bor, Czechoslovakia: Crystalex, n.d. Catalogue for both the first symposium held October 18–24, 1982, and the second held October 21–27, 1985. Text by Antonin Langhamer.

Musée des arts décoratifs de la Ville de Lausanne. *Expressions en verre: 200 sculptures contemporaines, Europe, USA, Japan.* Lausanne: Musée des arts décoratifs de la Ville de Lausanne, 1986. Catalogue for the exhibition held September 26, 1986–January 4, 1987.

Oakland Museum. *Contemporary American and European Glass from the Saxe Collection.* Oakland, Calif.: Oakland Museum, 1986.

Philippe, Joseph. *Contemporary Western European Sculptures in Crystal and Glass, 1983–1986.* Liège: Générale de Banque, 1986. Catalogue for the triennial exhibition; includes works by thirty-eight glass artists from eleven Western European countries. The 1989 exhibition will include ninety-four glass artists and firms from twenty European countries.

1987
- Dominick Labino dies (1910–1987).
- The Art Alliance for Contemporary Glass (AACG) is established for collectors of contemporary glass.

Contemporary Glass: The Collection of Jean and Hilbert Sosin: Twenty-five Years of Studio Glass. Dearborn: University of Michigan, 1987. Catalogue for the exhibition held April 3–June 15, 1987. Texts by C. Edward Wall and Davira S. Taragin.

Glasmuseum Ebeltoft. *Young Glass '87: An International Competition.* Ebeltoft, Denmark: Glasmuseum Ebeltoft, 1987. Catalogue for the exhibition held July 5–September 13, 1987.

Glass Focus, no. 1, 1987–. Published by the Art Alliance for Contemporary Glass (AACG).

Glass in the Environment Conference. *Report on Proceedings.* Ed. Michael Wigginton. London: Crafts Council, 1987. Report on *Glass Today,* an international conference held at the Royal College of Art, the Royal Institute of British Architects, and Pilkington Glass Ltd., London, 1986.

Philbrook Museum of Art. *The Eloquent Object: The Evolution of American Art in Craft Media since 1945.* Eds. Marcia Manhart and Tom Manhart. Tulsa, Okla.: Philbrook Museum of Art; Seattle: University of Washington Press, 1987. Catalogue for the exhibition organized by the Philbrook Museum of Art; travels nationally 1987–89 and to Japan 1989–90.

1988
Bloch-Dermant, Janine. *Le verre en France les années 80.* Paris: Les Éditions de l'Amateur, 1988.

Glasmuseum Frauenau. *III. Internationales Glas-Symposium, 11.–15. Mai 1988; Internationales Glas '88 Sonderausstellung im Glasmuseum Frauenau 15. Mai– 25. Juli 1988.* Frauenau, Germany: Glasmuseum, 1988. Catalogue for the third international glass symposium in Frauenau. Includes Harvey K. Littleton, "Studioglasbewegung Gestern—Heute—Morgen" [Studio glass movement yesterday—today—tomorrow]. Text in German and English.

Heineman, Ben. *Contemporary Glass: A Private Collection.* Chicago: Falcon II Press, 1988.

Hessisches Landesmuseum. *Bildwerke in Glas: 25 Jahre New Glass in Amerika.* Darmstadt: Hessisches Landesmuseum Darmstadt, 1988.

The Independent Glassblower, no. 1 (1988). Continues through no. 55 (September–November 1999). Published in West Barnet, Vermont, by D. Gruenig and B. Dugger; intended as a forum for "hot glass information exchange."

International Exhibition of Glass Craft. *The International Exhibition of Glass Craft '88.* Kanazawa, Japan: Executive Committee of the International Exhibition of Glass Craft, 1988. Catalogue for the exhibition held at Ishikawa Industrial Exhibition Hall, Kanazawa, May 1–5, 1988, in conjunction with the third International Exhibition of Glass Craft. Text in English and Japanese. This was the first time the exhibition was a juried competition; no catalogues were issued for the first two exhibitions in 1984 and 1986.

Moderne internationale Glaskunst. Ebeltoft, Denmark: Glasmuseum, 1988. A brief guide to the Glasmuseum, a private institution operated by the Collection of Modern International Glass Art.

Sano, Takako. *A Decade with Studio Glass.* N.p., 1988. Text in Japanese.

1989
- First overviews of studio glass movement by major publishers.

Frantz, Susanne K. *Contemporary Glass: A World Survey from the Corning Museum of Glass.* New York: Harry N. Abrams, 1989.

Hampson, Ferdinand, ed. *Glass: State of the Art II.* Huntington Woods, Mich.: Elliot Johnson, 1989. Survey of the studio glass movement since 1984.

Klein, Dan. *Glass: A Contemporary Art.* New York: Rizzoli International, 1989.

Musée des arts décoratifs de la Ville de Lausanne. *Expressions en verre II: 140 sculptures de verre contemporaines d'artistes européens, américains, canadiens, japonais, australiens de la Collection du Musée des arts décoratifs, Lausanne.* Lausanne: Musée des arts décoratifs de la Ville de Lausanne, 1989. Catalogue for the exhibition *Les univers de la transparence,* June 21–September 30, 1989.

Warmus, William. *The Venetians: Modern Glass, 1919–1990.* New York: Muriel Karasik Gallery, 1989.

1990–2002
- Surge in art museum exhibitions and catalogues devoted to studio glass.
- Collectors lend/donate their collections to museums.
- Schools for glassmaking multiply throughout the United States and worldwide, as tracked in the Glass Art Society membership list, "Education Roster," and the Steinert Industries Web site, ‹www.steinertindustries.com/›.
- Influence of Venetian and Czech glass strengthens throughout the 1990s.
- Levels of technical skill reach an apogee.
- Studio glass workshops range from one-person workshops to one person directing assistants who produce the glass; teamwork becomes an accepted procedure.
- Opening up of former Soviet-bloc countries, notably the CSSR, increases exchange of information.
- Internet resources related to contemporary glass emerge, including journals such as *Glass Line* at ‹www.hotglass. com/› (for lampworkers and other glassmakers) and *Hot Bits* at ‹ourworld.compuserve.com/homepages/ MikeFirth/› (for "molten glassworkers"); Internet books such as Robert Mickelson and Jennifer Zamboli, *Mondo Fiamma: A Global Overview of Flameworked Glass Art* at ‹www.global-flamework.com/contents.htm›; and numerous chat sites.

1990
Davenport Museum of Art. *Contemporary Developments in Glass: A Season of Light.* Davenport, Iowa: Davenport Museum of Art, 1990. Brochure for the exhibition held October 26–December 28, 1990. Text by Daniel E. Stetson.

Glass, no. 39, 1990–. Published by the New York Experimental Glass Workshop/Urban Glass.

Glass Fantasy: From Art Nouveau to the Present Day. Kyoto: Kyoto Shoin Co., 1990. Text by Kimihiro Kurata, Toshio Kitazawa, Masaaki Iseki, Atsushi Takeda, Kiyoshi Suzuki, and Yoriko Mizuta. Objects are part of the collections of the Kitazawa Art Museum (Art Nouveau glass) and the Hokkaido Museum of Modern Art (contemporary glass). In Japanese and English.

John Michael Kohler Arts Center. *Structure and Surface: Beads in Contemporary American Art.* Sheboygan, Wis.: John Michael Kohler Arts Center, 1990. Catalogue for the exhibition held December 4, 1988–February 12, 1989; traveled to the Renwick Gallery, National Museum of American Art, Smithsonian Institution, Washington, D.C., July 27, 1990–January 13, 1991.

Netzer, Susanne. *Museum für modernes Glas/Museum of Modern Glass.* Ed. Joachim Kruse. Coburg, Germany: Kunstsammlungen der Veste Coburg, 1990. Catalogue for a collection located at the Orangerie at Schloss Rosenau, outside Coburg.

Petrová, Sylvá, and Jean-Luc Olivié, eds. *Bohemian Glass: 1400–1989.* Trans. Lysa Hochroth. New York: Abrams, 1990. English-language catalogue for the exhibition *Verres de Bohême, 1400–1989: chefs d'oeuvre des musées de Tchécoslovaquie,* organized by the Musée des arts décoratifs, Paris, and the Museum of Decorative Arts, Prague, October 1989–January 1990.

Ricke, Helmut. *Neues Glas in Europa/New Glass in Europe: 50 Kunstler, 50 Konzepte/50 Artists, 50 Concepts.* Düsseldorf: Verlagsanstalt Handwerk, 1990. Catalogue for the exhibition at Kunstmuseum Düsseldorf.

1991

■ The Art Alliance for Contemporary Glass (AACG) Annual Award begins, honoring an organization for its contributions to the contemporary glass movement.

Cappa, Giuseppe. *L'Europe de l'art verrier: des précurseurs de l'art nouveau à l'art actuel, 1850–1990.* Liège: Mardaga, 1991.

Miller, Bonnie J. *Out of the Fire: Contemporary Glass Artists and Their Work.* San Francisco: Chronicle Books, 1991. Book on Northwest glass.

Museum of Fine Arts. *Collecting American Decorative Arts and Sculpture, 1971–1991.* Boston, Mass.: Museum of Fine Arts, 1991. Catalogue for the exhibition held January 10– April 14, 1991. Includes studio glass by Dan Dailey as well as historical pieces. Introduction by Jonathan L. Fairbanks; texts by Edward S. Cooke Jr. and others.

Tacoma Art Museum. *Glass: Material in the Service of Meaning.* Tacoma, Wash.: Tacoma Art Museum; Seattle: University of Washington Press, 1991. Catalogue for the exhibition held November 2, 1991–January 26, 1992. Introduction by Ginny Ruffner; texts by Ron Glowen and Kim Levin.

Tait, Hugh. *Five Thousand Years of Glass.* London: British Museum Press, 1991. Includes illustrations of techniques of glassmaking and decoration by William Gudenrath.

Vaudour, Catherine. *Le verre: exposition internationale du verre contemporain/International Exhibition of Contemporary Glass.* Rouen: Conseil Regional de Haute-Normandie, 1991. Catalogue for the exhibition held at Espace Duchamp-Villon, Centre Saint-Sever, December 18, 1991–March 1, 1992.

1992

Borowsky, Irvin J. *Artists Confronting the Inconceivable: Award Winning Glass Sculpture.* Philadelphia: American Interfaith Institute, 1992.

Herman, Lloyd E. *Clearly Art: Pilchuck's Glass Legacy.* Bellingham, Wash.: Whatcom Museum of History and Art, 1992. Introduction by Dale Chihuly.

Kehlmann, Robert. *20th Century Stained Glass.* Kyoto, Japan: Kyoto Shoin, 1992.

Morris Museum. *Glass from Ancient Craft to Contemporary Art, 1962–1992.* Morristown, N.J.: Morris Museum, 1992.

1993

■ The Society of Glass Beadmakers (SGB) is formed by a small group of American beadmakers brought together by an exhibition of contemporary glass bead artists at the Bead Museum in Prescott, Arizona. In the first five years, membership rises from 60 to 450. Web site: ‹www.isgb.org/index.shtml›.

Crafts Council of Great Britain. *Contemporary British Glass.* London: Crafts Council, 1993. Catalogue for the exhibition *The Glass Show,* a Crafts Council touring exhibition.

Halem, Henry. *Glass Notes: A Reference for the Glass Artist.* Kent, Ohio: Franklin Mills Press, 1993. Revised and updated editions published in 1994 and 1996.

Ricke, Helmut, ed. *Neues Glas in Japan/New Glass in Japan.* Düsseldorf: Kunstmuseum Düsseldorf im Ehrenhof, Glasmuseum Hentrich, 1993. Catalogue for the traveling exhibition shown in 1993–94 at the Kunstmuseum Düsseldorf im Ehrenhof, Glasmuseum Hentrich; Museum Boymans-van Beuningen, Rotterdam; Museum für Kunst und Gewerbe, Hamburg; Musée des arts décoratifs de la Ville de Lausanne; Kunstsammlungen der Veste Coburg.

San Francisco Craft and Folk Art Museum. *Nine Decades: The Northern California Craft Movement, 1907 to the Present.* San Francisco: San Francisco Craft and Folk Art Museum, 1993. Texts by Carole Austin, Ted Cohen, Dyana Curreri-Chadwick, and Kenneth Trapp. Artists include C. Fritz Dreisbach, Marvin Lipofsky, Paul Marioni, Mark McDonnell, Clifford Rainey, Ruth Tamura, and Mary White.

Schmid, Edward T. *Ed's Big Handbook of Glassblowing.* Jamestown, Colo.: Glass Mountain Press, 1993. Followed by *Advanced Glassworking Techniques,* 1997; *Beginning Glassblowing,* 1998.

Taragin, Davira Spiro. *Contemporary Crafts and the Saxe Collection.* New York: Hudson Hills Press; Toledo, Ohio: Toledo Museum of Art, 1993.

Vaudour, Catherine. *The Art of Contemporary Glass.* Paris: Armand Colin, 1993.

Whitehouse, David. *Glass: A Pocket Dictionary of Terms Commonly Used to Describe Glass and Glassmaking.* Corning, N.Y.: Corning Museum of Glass, 1993.

Who's Who in Contemporary Glass Art: A Comprehensive World Guide to Glass Artists, Craftsmen, Designers 1993/94. Munich: Joachim Waldrich Verlag, 1993.

1994

■ SOFA (Sculpture Objects and Functional Art) exhibitions begin in Chicago.

DuBois, Alan. *Objects and Drawings 2: Working in Other Dimensions.* Little Rock, Ark.: Arkansas Arts Center Decorative Arts Museum, 1994. Catalogue for the exhibition held October 2–November 13, 1994. Text by Tony Hepburn. Includes drawings and glass by Dale Chihuly and Marvin Lipofsky.

Museum at Blackhawk. *Breaking Traditions: Contemporary Artists Who Use Glass.* Danville, Calif.: University of California at Berkeley Museum, 1994. Catalogue for the exhibition, curated by Marvin Lipofsky, held February 18– May 22, 1994.

SOFA Chicago: Sculpture Objects and Functional Art. Chicago: Expressions of Culture, Inc., 1994–. Catalogue for annual exhibition held three times a year, once in each of these cities: Miami, New York, and Chicago. Includes glass from many glass and craft galleries.

1995

Barovier Mentasti, Rosa. *New Glass a Venezia.* Venice: n.p., 1995. Texts by Barovier Mentasti and Dan Klein.

Bray, Charles. *Dictionary of Glass: Materials and Techniques.* London: A & C Black; Philadelphia: University of Pennsylvania Press, 1995. (2d ed., 2001.) A reference source for the small glass workshop with studio background information on the materials, processes, and techniques relating to glassmaking.

Dunham, Bandhu Scott. *Contemporary Lampworking: A Practical Guide to Shaping Glass in the Flame.* Prescott, Ariz.: Salusa Glassworks and Hohm Press, 1995. Includes techniques, a brief history of lampworking, properties of glass, beadmaking, use of color, annealing, health hazards, further study, suppliers. (Revised and updated editions published in 1997 and 2002.)

Galleria Marina Barovier. *A Venetian Love Affaire.* Venice: Galleria Marina Barovier, 1995. Catalogue for the exhibition held October 7–31, 1995. Includes Philip Baldwin, Dale Chihuly, Dan Dailey, Monica Guggisberg, Dorothy Hafner, and Lino Tagliapietra.

Ioannou, Noris. *Australian Studio Glass: The Movement, Its Makers, and Their Art.* Roseville East, New South Wales: Craftsmen House, 1995.

Monroe, Michael W. *The White House Collection of American Crafts.* New York: Harry N. Abrams, 1995. Catalogue for the exhibition at the National Museum of American Art, Smithsonian Institution, Washington, D.C., April 28– September 4, 1995. Text by Barbaralee Diamonstein; foreword by Elizabeth Broun.

Wagga Wagga City Art Gallery. *National Art Glass Collection: From the Collection of City Art Gallery Wagga Wagga.* Wagga Wagga, Australia: City Art Gallery, 1995. Catalogue for the national touring exhibition *Visions of Australia,* covering studio glass made in Australia 1973–94. Texts by Robert Bell, Judy Le Lievre, and Noris Ioannou. Includes a list of exhibitions initiated by the City Art Gallery (1981–96).

1996

Dorigato, Attilia, and Dan Klein, eds. *International New Glass: Venezia aperto vetro.* Venice: Arsenale, 1996. Catalogue for the exhibition *Venezia aperto vetro* held in Venice September 13–November 10, 1996, at the Palazzo Ducale, Museo Correr, Ca' Pesaro, Museo vetrario Murano, and Palazzo Franchetti. Texts by Susanne Frantz, Sylvá Petrová, Dan Klein, Helmut Ricke, Jean-Luc Olivié, and Attilia Dorigato on American, Czech, British, German, French, and Murano glass.

Layton, Peter. *Glass Art.* London: A & C Black; Seattle: University of Washington Press, 1996.

Metropolitan Museum of Art. *Studio Glass in the Metropolitan Museum of Art.* New York: The Metropolitan Museum of Art, 1996. Catalogue for the exhibition held April 8–October 6, 1996. Introduction by Jane Adlin.

Nouvel objet/nubel obuje. 6 vols. Seoul: Design House, 1996–. Variant title: *NO.* Each volume begins with profiles of selected artists of "object art" and concludes with articles on the subject. (Articles in vols. 1–2 are in Korean only.)

Oldknow, Tina. *Pilchuck: A Glass School.* Seattle: Pilchuck Glass School in association with the University of Washington Press, 1996.

Wigginton, Michael. *Glass in Architecture.* London: Phaidon Press Limited, 1996. Includes history and architectural context, glass technology, twentieth-century individual buildings, and appendices with technical information.

1997

■ Major glass collections exhibited in art museums.

Cummings, Keith. *Techniques of Kiln-formed Glass.* London: A & C Black; Philadelphia: University of Pennsylvania Press, 1997.

Fairbanks, Jonathan L., et al. *Glass Today by American Studio Artists.* Boston: Museum of Fine Arts, 1997.

Four Acts in Glass: Installations by Chihuly, Morris, Powers, and Vallien. Ed. Barbara Ross. Seattle: Bryan Ohno Gallery, 1997. Catalogue for an exhibition curated by Ursula Ilse-Neuman at the American Craft Museum, New York, November 11, 1997–January 18, 1998.

Hawley, Henry H. *Glass Today: American Studio Glass from Cleveland Collections.* Cleveland, Ohio: Cleveland Museum of Art, 1997.

Liefkes, Reino. *Glass.* London: Victoria and Albert Museum, 1997. A history of glassware, primarily vessels and twentieth-century art glass, based on the collections of the Victoria and Albert Museum.

Lynn, Martha Drexler. *Masters of Contemporary Glass: Selections from the Glick Collection.* Indianapolis: Indianapolis Museum of Art; Indiana University Press, 1997.

Mann, Audrey. *Recent Glass Sculpture: A Union of Ideas.* Milwaukee, Wis.: Milwaukee Art Museum, 1997.

Moor, Andrew. *Architectural Glass Art: Form and Technique in Contemporary Glass.* New York: Rizzoli, 1997.

Museum für Glaskunst Lauscha. *V. Internationales Glassymposium Lauscha.* Ed. Helena Horn. Lauscha im Thüringer Wald, Germany: Museum für Glaskunst Lauscha, 1997. Catalogue for the exhibition held July 23–27, 1997, in conjunction with the fifth Internationales Glassymposium Lauscha, supported and organized by the Förderkreis des Museums für Glaskunst Lauscha. (The fourth symposium in Lauscha was held in 1989; the fifth symposium should not be confused with the V. Internationales Glassymposium Frauenau, 1995.)

Ricke, Helmut, and Eva Schmitt. *Italian Glass: Murano– Milan, 1930–1970, the Collection of the Steinberg Foundation.* New York and Munich: Prestel Verlag, 1997. Catalogue for the exhibition held at Kunstmuseum Düsseldorf im Ehrenhof, Glasmuseum Hentrich; the Corning Museum of Glass, Corning, New York; Hokkaido Museum of Modern Art, Sapporo, Japan; and other sites in Japan, 1996–98.

Stuhr, Joanne. *Cálido!: Contemporary Warm Glass*. Tucson, Ariz.: Tucson Museum of Art, 1997. Catalogue for the exhibition held at Tucson Museum of Art, April 11–June 8, 1997; Mississippi Museum of Art, September 13–November 30, 1997; and Leigh Yawkey Woodson Art Museum, Wausau, Wisconsin, January 9–March 20, 1999.

Taylor, Gay LeCleire. *Contemporary Flameworked Glass*. Millville, N.J.: Wheaton Cultural Alliance, Wheaton Village, 1997. Catalogue for the exhibition held at the Museum of American Glass at Wheaton Village, May 24–October 26, 1997; Paul J. Stankard, guest curator.

1998

■ Dale and Doug Anderson conceive and sponsor an annual program at the Pilchuck Glass School to introduce contemporary curators to glass as an art medium. The first session is held May 20–24, 1998.

Cappa, Giuseppe. *Le génie verrier de l'Europe: témoignages de l'historicisme à la modernité, 1840–1998*. Liège: Mardaga; Luxembourg: Banque Générale du Luxembourg, 1998. Glass companies and artists in Germany, Austria, Belgium, Bohemia and Czechoslovakia, Denmark, Finland, France, Great Britain, Italy, Luxembourg, The Netherlands, and Sweden. More coverage is devoted to firms than to individual artists. Includes bibliographical references and index.

Dorigato, Attilia, Dan Klein, and Rosa Barovier Mentasti, eds. *International New Glass: Venezia aperto vetro*. Milan: Electa, 1998. See also the 1996 catalogue.

Fike, Bonita. *A Passion for Glass: The Aviva and Jack A. Robinson Studio Glass Collection*. Detroit, Mich.: Detroit Institute of Arts, 1998.

Giberson, Dudley F., Jr. *A Glassblower's Companion: A Compilation of Studio Equipment Designs, Essays, and Glassmaking Ideas*. Warner, N.H.: Joppa Press, 1998.

The Glass Skin. Corning, N.Y.: Corning Museum of Glass; Düsseldorf: Kunstmuseum Düsseldorf im Ehrenhof; Sapporo, Japan: Hokkaido Museum of Modern Art, 1998. Catalogue for the exhibition held at the Corning Museum of Glass, May 16–October 18, 1998; traveled through 1999 to Kunstmuseum Düsseldorf im Ehrenhof; Kunstsammlungen der Veste Coburg; and three sites in Japan. Texts by Helmut Ricke, Susanne Frantz, and Yoriko Mizuta.

Herman, Lloyd E. *American Glass: Masters of the Art*. Washington, D.C.: Smithsonian Institution Traveling Exhibition Service, in association with University of Washington Press, Seattle and London, 1998.

Knapp, Stephen. *The Art of Glass: Integrating Architecture and Glass*. Gloucester, Mass.: Rockport Publishers, 1998.

Kohler, Lucartha. *Glass: An Artist's Medium*. Iola, Wis.: Kraus Publications, 1998.

Korach, Alice, and Kathlyn Moss. *Bead Art*. Waukesha, Wis.: Kalbach Publishing Co., 1998.

Lynggaard, Finn. *The Story of Studio Glass: The Early Years, a Historic Documentation Told by the Pioneers*. Copenhagen: Rhodos International Science and Art Publishers, 1998.

Skilled Work: American Craft in the Renwick Gallery, National Museum of American Art, Smithsonian Institution. Washington, D.C.: National Museum of American Art, 1998. Foreword by Elizabeth Brown; texts by Kenneth Trapp and Henry Risatti.

Stop Asking: We Exist. Twenty-five African-American Craft Artists. Pittsburgh, Penn.: Society for Contemporary Crafts, 1998. Catalogue for the exhibition organized by the Society for Contemporary Crafts, Pittsburgh; Joyce Scott, guest curator.

Vetro, no. 1, 1998–. Published by Centro Studi Vetro, Murano-Venice.

1999

Austin Museum of Art–Laguna Gloria. *Holding Light: Contemporary Glass Sculpture*. Austin, Tex.: Austin Museum of Art, 1999. Catalogue for the exhibition held September 18–December 31, 1999.

Chambers, Karen S., and Tina Oldknow. *Clearly Inspired: Contemporary Glass and Its Origins*. San Francisco: Pomegranate, 1999. Catalogue for the exhibition at Tampa Museum of Art, Tampa, Florida.

Eleven Glass Sculptures. Corning, N.Y.: Corning Inc., 1999. Sculptures by seven contemporary glass artists designed for the Corning Inc. headquarters building. Foreword by Susanne K. Frantz.

Global Art Glass. Ed. Barbro Kamras. Borgholm, Sweden: Ölandstryckarna AB, 1999. Catalogue for the first *Global Art Glass Triennial*, held June 19–August 29, 1999, Borgholm, Sweden; curated by Barbro and Börge Kamras. Texts by Kiki Lundh, Susanne K. Frantz, Mailis Stensman, and Kerstin Wickman.

Jenkins Johnson Gallery. *Masters of Contemporary Glass*. San Francisco: Jenkins Johnson Gallery, 1999. Catalogue for the exhibition, curated by Karen Jenkins-Johnson, held October 9–November 4, 1999. Text by William Warmus.

Kervin, James. *More Than You Ever Wanted to Know about Glass Beadmaking*. Livermore, Calif.: GlassWear Studios, 1999.

Takeda, Atsushi. *Gendai garasu no hy–ogen/Expressions of Contemporary Glass*. Yokohama: Yurindo Co., 1999.

Wooley, Frank E. *Glass Technology for the Studio*. Corning, N.Y.: The Studio of the Corning Museum of Glass, 1999.

2000

Bray, Charles. *Ceramics and Glass: A Basic Technology*. Sheffield, England: Society of Glass Technology, 2000.

Glasmuseum Frauenau. *Internationales Glassymposium 2000: Glas im Kontext*. Grafenau, Germany: Morsak-Verlag, 2000. Catalogue for an exhibition honoring the twenty-fifth anniversary of the Glasmuseum Frauenau held June 22–October 31, 2000, in connection with the symposium held June 22–25, 2000.

Il vetro progettato: architetti e designer a confronto con il vetro quotidiano [Designer glass: architects, designers, and everyday glass work]. Ed. Marco Romanelli. Milan: Electa, 2000. Catalogue for the exhibition held at Museo Correr, Venice, October 15, 2000–January 14, 2001.

Lowe Art Museum. *Taking Form in Glass: Contemporary Works from the Palley Collection*. Coral Gables, Fla.: Lowe Art Museum, University of Miami, 2000. Catalogue for the exhibition *Splendor in the Glass*.

Millennium Glass: An International Survey of Studio Glass. Louisville: Kentucky Art and Craft Foundation, 2000. Catalogue for the exhibition, curated by Brion Clinkingbeard, Adele Leight, and Stephen Rolfe Powell, held at Kentucky Art and Craft Foundation, April 28–July 8, 2000; Montgomery Museum of Fine Arts, Montgomery, Alabama, January 13–March 10, 2001; Hunter Museum of American Art, Chattanooga, Tennessee, June 15–September 2, 2001.

Musée des arts décoratifs de la Ville de Lausanne. *Expressions en verre III: sculptures de verre contemporaines d'artistes européens, américains, canadiens, australiens de la Collection du Musée des arts décoratifs, Lausanne: acquisitions 1989–2000*. Lausanne: Musée de design et d'arts appliqués contemporains, 2000.

Studio Glass: From the Gerard L. Cafesjian Collection. Scottsdale, Ariz.: Scottsdale Museum of Contemporary Art, 2000. Catalogue for the exhibition held February 14–September 3, 2000. Foreword by Robert E. Knight; text by Debra L. Hopkins.

Yelle, Richard. *Glass Art*. Atglen, Penn.: Schiffer, 2000. A review of the work of 175 late twentieth-century artists and designers.

2001

The Glass Guide 2001: An International Directory of Galleries and Museums. Ed. Annette Rose-Shapiro. Brooklyn, N.Y.: Urban Glass, 2001.

Klein, Dan. *Artists in Glass: Late 20th Century Masters in Glass*. London: Mitchell Beazley, 2001.

Leier, Ray, Jan Peters, and Kevin Wallace. *Contemporary Glass: Color, Light, and Form*. Madison, Wis.: Guild Publishing, 2001.

Objects for Use: Handmade by Design. Ed. Paul J. Smith. New York: Harry N. Abrams, 2001. Catalogue for an exhibition in the Defining Craft series held at the American Craft Museum. Texts by Smith and Akiko Busch.

Petrová, Sylvá. *Czech Glass*. Prague: Gallery, 2001. Preface by Stanislav Libenský. An analysis of twentieth-century Czech glass with an emphasis on the postwar period to the present.

2002

Holsten Galleries. *Five Masters of Contemporary Glass*. Stockbridge, Mass.: Holsten Galleries, 2002. Catalogue for the exhibition held spring 2002. Includes Dale Chihuly, Marvin Lipofsky, William Morris, Tom Patti, and Lino Tagliapietra.

Nichols, Sarah C. *Contemporary Directions: Glass from the Maxine and William Block Collection*. Pittsburgh, Penn.: Carnegie Museum of Art; Toledo, Ohio: Toledo Museum of Art, 2002. Catalogue for the exhibition organized by and presented at the Carnegie Museum of Art, April 6–July 7, 2002; and the Toledo Museum of Art, November 21, 2003–February 15, 2004. Texts by Nichols and Davira S. Taragin.

This bibliography is based on materials found in the Rakow Research Library of the Corning Museum of Glass. Their online public catalog is expected to be available on the museum's Web site, ‹www.cmog.org›, by the end of 2003.

Thanks to Audrey Handler, Sylvia Vigiletti, Sally Prasch, Bandhu Scott Dunham, Joan Falconer Byrd, Elmerina Parkman, and Paul Parkman for their thoughtful contributions and ideas.